THE ROYAL PAVILION
Brighton

John Dinkel

The Vendome Press

First published in the USA in 1983 by The Vendome Press
515 Madison Avenue, New York, NY 10022

Distributed in the United States by
The Viking Press
Distributed in Canada by Methuen Publications

ISBN 0-86565-035-7

First published in 1983 by Philip Wilson Publishers Ltd
and Summerfield Press Ltd

Designed by Richard Johnson
Edited by Philip Wilson Publishers Ltd
Series Editor: Kathy Elgin

Produced by Scala Istituto Fotografico Editoriale, Firenze
Phototypeset by Modern Text Typesetting, Essex, England.
Printed in Italy

Library of Congress cataloging in publication data
Dinkel, John, 1942-
 The Royal Pavilion, Brighton.
 1. Royal Pavilion, Art Gallery, and Museums.
I. Title.
N1214.7.D56 1983 728.8'2'0942256 83-14676

Note: some of the pieces of furniture originally in the Royal Pavilion are now in Buckingham Palace. These are indicated in the captions by the letters (BP).

Contents

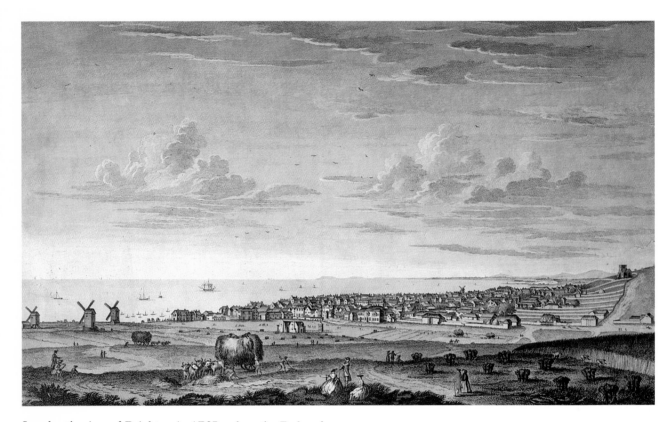

Lambert's view of Brighton in 1765, when the Duke of
Gloucester, uncle of the Prince, became the first royal
visitor to favour the newly fashionable fishing town. The
barn seen above, and slightly to the left of, the figure
in red is on the site of the later Pavilion; it may have been
converted to form the farmhouse that was to become
the Pavilion's nucleus.

Introduction

Brighton's flat central valley reaches its broadest point just before it slopes down to the long pebbled beach. To the west, on slightly higher ground, can still be seen the shape of the old fishing town with its warren of narrow passages or twittens; to the east begins the long series of chalk cliffs which abruptly terminate the rolling and often inhospitable Sussex Downs. This spreading ground has been known as the Steine since Saxon times, and up to the days of Brighton's hionable zenith in the early nineteenth century was used as a drying ground for fishermen's nets. It is flanked on both sides by buildings in irregular groups and blocks—many of them, with their bow windows and pretty balconies, survivors from the Regency—which disguise the conformation of the land. Here, not quite in sight of the sea, sits the Royal Pavilion, the extraordinary building whose outline is recognizable throughout the world, and whose air of festivity, brilliance, and pleasurable distraction has made it the symbol of England's most distinctive seaside town.

Many who see it for the first time are surprised by its location. The grounds are not large (and never were), nor does high ground give it an imposing setting: in all its forms, from its origins as a modest farmhouse to the extravaganza it became, it was fundamentally a seaside house in the company of others, rather than a palace standing aloof upon a deserted strand. Its luxury and strangeness set it apart, but George IV was incapable of building in a diffident manner. Just as the thatched Royal Lodge at Windsor was the largest and most richly appointed of all *cottages ornés,* so was the 'Marine Pavilion' the most splendid of seaside houses. To this day, seaside architecture has provided many an excuse for a holiday from conventional styles.

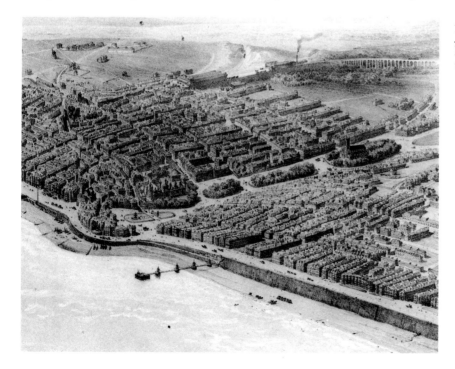

Aerial view of Brighton, 1846, by Jules Arnout. The relationship of the Pavilion (then a Royal Palace) to the town is clearly seen.

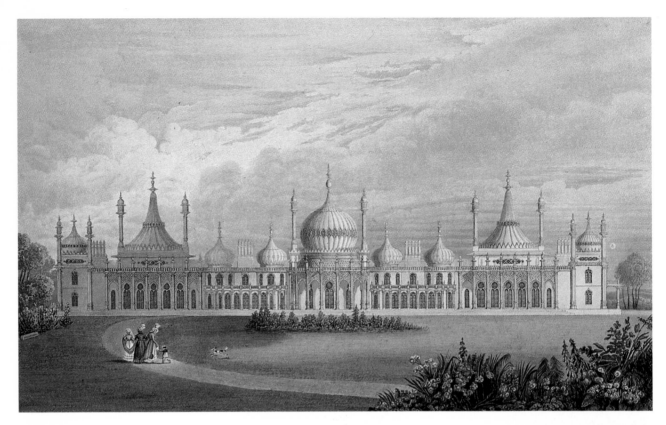

The East, or Steine Front, on its
completion in 1822, from an aquatint
in the sumptuous volume *Views of
the Royal Pavilion, Brighton*
published by John Nash in 1826
at the King's command. Preparatory
watercolours and pencil drawings
of exceptional quality were done by
Augustus Charles Pugin, Nash's
former chief draughtsman. These and
the plates form one of the most
detailed visual records of any great
house before the invention of
photography.

Nash's design had thoroughly
romantic aims. He sought out the 'rich
and picturesque combinations' to
which Eastern (no less than Gothic)
forms lent themselves.

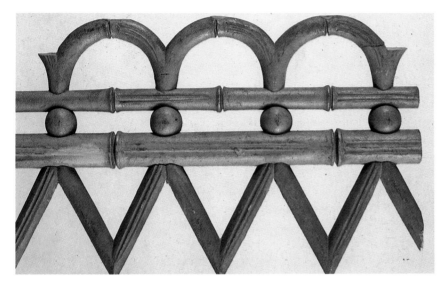

Simulated bamboo trellis from the Corridor—beechwood painted in such a way as to present the colour and fibrous texture of pliable bamboo, the commonest of oriental structural materials.

The eighteenth and early nineteenth centuries were the great age of architectural follies and scenic make-believe. Those essentially ornamental eye-stoppers, the innumerable sham Gothic ruins, pyramids, Turkish tents, pagodas, and Chinese tea-houses that sprinkled gentlemen's estates, were all fashionable expressions of the impulse to break the established rules of classical taste. The same impulse underlay the picturesque movement and the various essays in a multitude of styles—Gothic, Norman, Elizabethan, Egyptian, Doric —which reached a peak during the gestation of the Pavilion and in whose context it must be seen.

The building which has come down to us, however individual and at times even obsessive, is nevertheless neither a landscape folly nor the product of a whim, as William Beckford's Fonthill Abbey, a towering Gothic fantasy 300 feet high, might be described. The thirty-five years between the leasing of Brighton House and the completion of George IV's oriental palace show a gradual and even cautious development from romantic simplicity, through French-inspired neo-classicism in Henry Holland's enlargement then the exciting strangeness of full-blooded chinoiserie in the interior, to John Nash's final remodelling of the exterior in a picturesque Indian style. The final stage gave the Pavilion its position as one of the great monuments of the picturesque, with a skyline as romantic as Barry's later, Gothic, Houses of Parliament. In the end there was virtually nothing in England with which the Pavilion could be compared, outside or in.

It was George IV's remarkable achievement to have cultivated with such tenacity the exotic seeds sown long before, to the point where a unique flowering took place, while the enthusiasm of others had already been spent. The Royal Pavilion in its own mature confederation of styles is the last and most thoroughgoing expression of the aristocratic fascination with an idealized Eastern world that blossomed with the rococo and that withered when exposed to the disillusionment of the nineteenth century. In the Pavilion appeared a great European interior where 'the Chinese taste' was truly dominant. Even so, there was no strong grasp of the complex iconography of Chinese decoration; the aims were of quite a different nature.

A detail of the Dragon wallpaper in the Red Drawing Room. Chinese and other Eastern motifs, perhaps derived from textiles, were used to create a rich, assertive pattern. The creation of the Royal Pavilion coincided with a high point in the status of wallpaper as a major component of interior decoration. Brilliant printing techniques had been developed in France, though, as here, some examples were hand painted.

7

Original gilded wall decoration on linen canvas from the North Drawing Room, outlined with graded shades to achieve a three-dimensional effect.

For George IV the allure of Chinese civilization had much to do with its capacity to provide a model of a stable escapist world, where everything could be sumptuous, colourful, tinged with magic, and, best of all, different from familiar reality. It was a paradigm of fairy-land; an illusion maybe, but illusion and fantasy are potent ingredients of art, often allied to wit. The Pavilion is full of examples of the joys of illusion and imitation, the finesse at which later moralists tended to look askance—*trompe l'œil* decorative painting, in which trellises or even serpents appear solid, bamboo simulated in materials from cast iron to satinwood, stucco scored and stained to resemble blocks of stone, and all the varieties of marbling and graining which late eighteenth-century French decorators had revived.

The period covered by George IV's lifetime derives much of its flavour from an astonishing high-spiritedness running like a colourful streak through every kind of endeavour, from Byron's poetry to swashbuckling commercial enterprise, the glorification of military feats, theatrical spectacle, and social behaviour. In the Pavilion this characteristic is to be seen in a concentrated form, where trained sensibilities were applied to some of the myriad new possibilities that streamed in from every point of the enlarged horizon and were added to the old: non-classical styles, the better to stimulate the imagination, new techniques and materials clamouring to be used. The new resources were like a richly-stocked toybox: a famous squib directed at George IV and the Royal Pavilion, 'The Great Joss and his playthings', conveys the idea well.

The river of eighteenth-century consensus taste had split into many rapid currents by the turn of the century. Never before had an individual more opportunity to show his quality as a 'Man of Taste' by creating something strange and personal, to which a select band of connoisseurs would apply their immense knowledge. To be in the vanguard of a fashion, a Beau Brummell in dress or a Thomas Hope in interior decoration, was to be recognized and perhaps admired as a style-maker. Nevertheless, the fantasy-world interiors created by Beckford, Hope

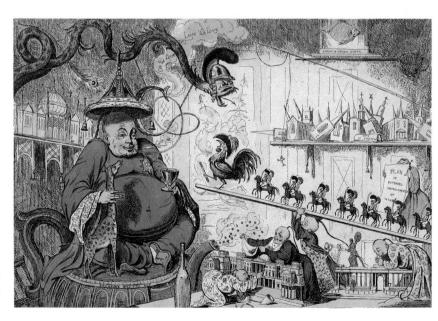

The Great Joss and his Playthings, by Robert Seymour (1829). His palaces, a splendidly accoutred army, his infatuation for Lady Conyngham (her initial is formed by the pipe)—all obsessions of the voluptuary King and paid for by the nation's treasury, here spouting gold to order.

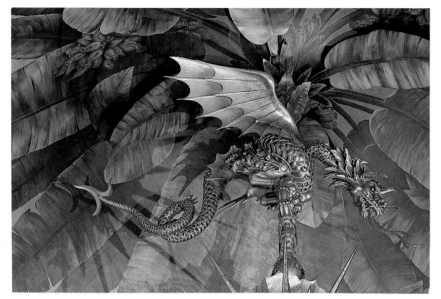

The succulent leaf borders of the Music Room murals are heightened with gilding to enhance the impression of depth achieved by *trompe l'œil* techniques and to catch the light from candles and jets of gas.

and Soane, hungry for thrilling sensations evoked by ancient and Eastern artefacts, were intensely personal in inspiration. The Pavilion taste, with these, was a forerunner of the dandy aestheticism cultivated by Baudelaire or Barbey d'Aurevilly, Brummell's biographer, which culminated in Huysman's *A Rebours* (Against Nature), itself the cult book of the circle of Oscar Wilde and Brighton's own son Aubrey Beardsley. Nevertheless, although the Pavilion, after its fashionable neo-classical beginnings, developed highly idiosyncratic features, its roots in the wider culture of its own time remained strong and deep. It owed a continuous debt to France; even in its middle, most intensively 'Chinese' phase, much of the furniture and decorations owed something to *Louis Seize* models, and in the final years many of the new pieces and those transferred from Carlton House, whether of orthodox or chinoiserie appearance, were conspicuously French in inspiration or in origin. Among the fashionable ideals of the day which found favour in the Pavilion was the use of furniture which was both easy to rearrange and compatible with changing decorative schemes. And the striking displays of new technology — gas lighting, cast iron, patent stoves — though strange at the time, simply placed the building in the mainstream of progress towards modern comfort (the close-carpeting was another aspect) in which England enjoyed the leading position.

The Pavilion's oriental *character* is in fact the greatest of its illusions. Inside and out, beneath the selected oriental *characteristics* which, by evoking appropriate associations, suggest the Far East (as Gothic windows and pinnacles were made to suggest the Middle Ages) it is thoroughly European in function and in general shape. A romantic yearning for exotic excitement is there, but against the background of social ferment there was an even more powerful force at work, a growing nostalgia for the old order and the glories, privilege, and separateness of monarchy, which George IV considered that his dynasty had never fully claimed, and which were seen to be struggling against extinction in Europe while they thrived in China.

In the story of the Royal Pavilion which follows, it may be seen that George IV's adoption of assertive aesthetic styles for his buildings

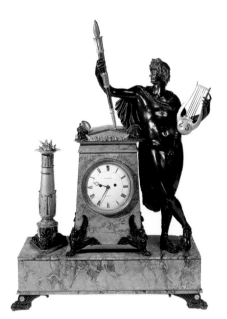

Many of the works of art were superb French pieces, often of a classical character. This superb Apollo clock, brought from Paris in 1803 (a year of peace), adorned the chimneypiece in the King's Library ante-room. (BP)

9

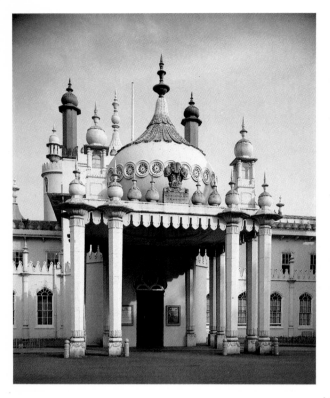

left
The porte-cochère, here in the form of an Indian shrine, was an up-to-date and practical device. Visitors by carriage or chair could alight under cover and there is not a single step at the entrance, or indeed throughout the ground floor — a boon to the incapacitated.

right
One of the four doors and overdoors in the Music Room, an English version of Chinese ornamental fantasy in carved gilded and painted wood. The use of rich, red colours was always expensive.

was abetted by his cultural and political persuasions. An equally important factor was the temperament of a man who could write (to Isabella Pigot, Mrs Fitzherbert's companion, in 1808) 'I am a different Animal from any other in the whole Creation . . . my feelings, my dispositions, . . . everything that is me, is in all respects different . . . to any other Being . . . that either is now . . . or in all probability that ever will exist in the whole Universe.' The hostility aroused by the ostentation he thought fitting to his dignity deterred him not at all. He made a virtue of it by increasing the ceremonial and architectural grandeur of the Crown. We can see this clearly now, but even in his own time some could see in perspective the Imperial diadem that the Pavilion had become. John Evans in *An Excursion to Brighton* (1822) recalled that 'England has been reproached by travellers for a want of palaces on a scale commensurate with the grandeur of the monarchy. The Thuilleries (sic) of Paris and the *Escurial* of Madrid have their celebrity. The Pavilion is only a winter residence, but in proportion to its extent it may be said to exceed any other of the palaces in the Kingdom.' It suggested to Evans that Britain was 'now taking the lead in proud array among the nations of the earth.'

Slightly later, Parry's *Coast of Sussex* (1833) compared the Pavilion with the oriental architectural excursions of other European monarchs, and asked why, in addition to the Gothic and classical palaces of the British Crown there should not be, for the sake of variety, an *oriental* marine pavilion. 'The Pavilion,' he said, rebutting a common jibe, 'is enriched with the most magnificent ornaments and the gayest and most splendid colours, yet all is in keeping and well relieved. There is positively nothing glaring or gaudy, and the person who might quarrel with its richness might as reasonably do so with the flowers of the parterre — the lively carnation or painted tulip.'

The Prince

The man who was to place himself among the ranks of the great royal builders of history was heir-apparent, as none of his predecessors since Charles II had been, from the moment of his birth on 12 August 1762. His father, crowned only two years before and still in his twenties, was the first of the Hanoverian kings to have been born in England. It seemed to be the beginning of a new era, with a stable dynasty truly identified with the national interests of the most dynamic country in the world. Great Britain's political system and economic prowess were the envy of those high-minded Europeans in whose countries liberty did not thrive and prosperity declined. Her rapidly growing wealth from commerce and manufacture and her military success overseas were equipping her for a role of substance, responsibility, and glory in the affairs of the world.

The education of the heir to the throne has always been a challenging task, since expectations are raised which require more than ordinary qualities to fulfil. George III approached the task with high seriousness. It is perhaps impossible to say whether the careful regime he instituted for his son from the age of four was misguided, or whether, the boy's nature would inevitably have unfolded as it did. Two things, however, stand out; the traditional failure of sympathy, sometimes amounting to hostility, between Hanoverian father and eldest son, and the deliberately sheltered background provided for the prince. 'In these unprincipled days the outside world,' said George III, 'must be veiled from him.' Continuous moral admonition from both his parents, a wide but rigorous syllabus of lessons from his tutors, and floggings for his sins — an educational formula that an intelligent, emotional, somewhat undiligent boy might well think tedious. On the other hand, the world of masked-balls, horse-racing, bibulous conviviality, and before long amorous adventures, beckoned him to a glamour which was intensified by his father's very determination to protect him from its dangers.

He entered manhood a spirited and accomplished prince. His person was elegant, his manners exceptionally engaging. He had attained a facility in languages both classical and modern. He was given encouragement to develop his tastes in music and all the arts, and to become a practitioner of some of them. Crosdill had taught him the cello, Alexander Cozens drawing. He could sing, and he could also fence, box, and ride. These were gentlemanly skills, but he was quick to learn others. While it could be excused him that he was fond of practical jokes, his father observed with undisguised pain his tendency to 'duplicity' and his susceptibility to flattery and dissipation. The Prince himself admitted to being 'rather too fond of wine and women'. It was becoming clear that the Prince was not to be forced into the mould of conscience and high principle designed for him, and that he craved excitement and loved everything to do with display. When the Duke of York, the brother with whom he had been schooled, was in Germany for military training in 1781 their letters dwell upon matters of fashion in dress and fine weapons. The Prince's love of the theatre

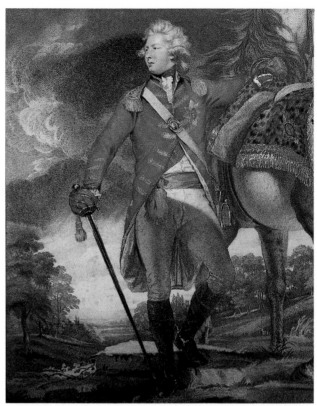

The Japan Room, lined with lacquer panels, in the Prince's sisters' establishment at Frogmore (Pyne's *Royal Residences*). A similar room of mid-eighteenth-century origin existed in the Queen's House. A fondness for oriental things was pronounced among the female members of the Royal Family.

The Prince of Wales, after Sir Joshua Reynolds (*c.*1784). The Prince's extraordinary ability always to appear graceful and poised disguised a seriously overweight physique.

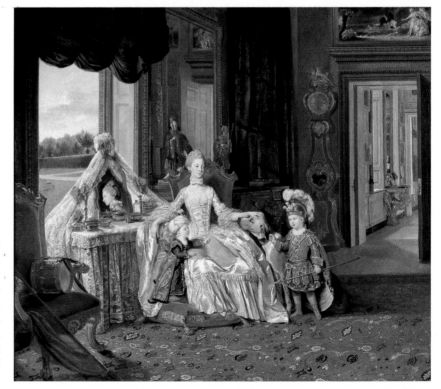

Queen Charlotte with her two eldest sons (the young Prince of Wales and Prince Frederick, Duke of York), by Zoffany. A Chinese figure similar to those in the Royal Pavilion is part of the furnishings of this room at the Queen's House (now Buckingham Palace). A delight in the excitement of 'dressing up' continued throughout George IV's life.

was intense and enduring. In this he was Queen Charlotte's son; the King's theatrical taste was mainly for farce.

His mother set him an example, too, in her love for the decorative arts. Mrs Lybbe Powys, describing the Queen's House (later extended

as Buckingham Palace) in 1767, said the King's apartments 'are fitted up rather neatly elegant than profusely ornamental. The library consists of three rooms... The Queen's apartments are ornamented with curiosities from every nation that can deserve her notice. The most capital pictures, the finest Dresden and other China; cabinets of more minute curiosities.' Queen Charlotte had a collector's instinct of considerable refinement, and it is significant that she was particularly partial to oriental works of art.

At eighteen the Prince was given his own apartment in the Queen's House. Characteristically, he indulged in an outburst of expenditure on its furnishings, paying scrupulous attention to the design of the furniture he commissioned. His relationship with his father, always tense, became increasingly strained. The King was continually warning him, often in writing, about his choice of friends and his extravagance, and the recklessness and indiscretion of his love life was a perpetual source of concern. 'Nothing you do can be long a secret; the very companions of your follies ever repeat what happens,' wrote the King. He was willing to arrange balls for the Prince, but not that he should go to 'balls or Assemblies at private houses'. Masquerades, at the Pantheon or Ranelagh and Vauxhall Gardens, however pretty and fashionable, were associated with loose living and subject to particular disapprobation. They were just as particularly enjoyed by the Prince and his racy friends such as Anthony St Leger, the Hon. Charles Wyndham, and Lord Cholmondeley, all early representatives of the bad company so abhorred by the King. The Dukes of Gloucester and Cumberland, the King's own brothers, both of whom led scandalous lives, made

Vauxhall Gardens (1779)—a water-colour by Rowlandson showing one of the London settings for outdoor entertainments at its most fashionable period. The Prince of Wales is accompanied by 'Perdita' Robinson, one of his first amours.

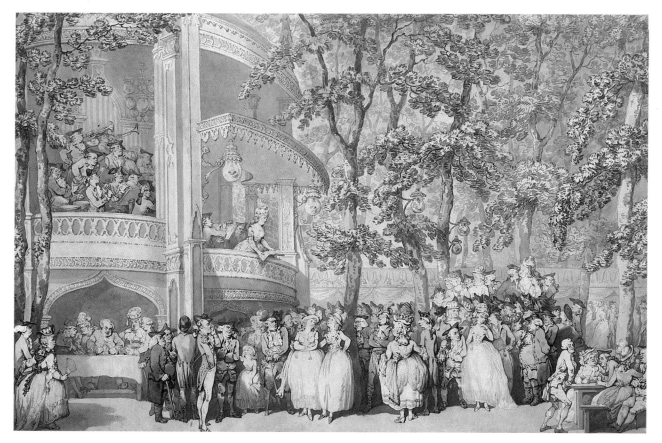

The Music Room, Carlton House, aquatinted *c.*1816 for Pyne's *Royal Residences.* Henry Holland's neo-classical design of 1783 was by no means obscured by later decorators. This can be clearly seen as a predecessor of the great Pavilion rooms.

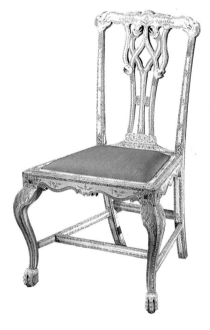

A chair of sandalwood mounted with ivory panels, from a suite made in Madras *c.*1770 and bought for Queen Charlotte by George III in 1781. In 1819 George IV bought the set from the late Queen's effects, for use (with red leather cushions) in the Corridor of the Royal Pavilion. (BP)

embarrassing marriages, and discovered Brighton long before the Prince of Wales, were regarded as specially dangerous influences.

Many of the Prince's associates were men of brilliant gifts: Sheridan, playwright and politician; Kemble the actor; George Hanger the mischievous aristocratic dandy; the artist Richard Cosway. Most dazzling of all was Charles James Fox, the greatest of Whig orators. His extraordinary charm and intellect enthralled the Prince; to the King his political views, no less than his vices, were anathema, and he could only with forbearance accept him as Foreign Secretary.

Primarily through Fox, the Prince associated himself with Whig circles. At their stronghold, Brooks' Club in St. James's, the intoxicants were not merely vinous. The heady mixture of libertarian politics, sophisticated aesthetic interests, and Francophile orientation was highly congenial to the Prince. He became their champion, and in turn received their support during his contest with the King in 1783 over an acceptable income for his first independent establishment. Fox had become so powerful in Parliament that the King had contemplated abdication. Now he was forced to compromise his position on his heir's income. The battle-lines for years of bitterness between father and son were now laid; meanwhile the Prince embarked upon his career of palace-building by calling in the Whigs' favourite architect, Henry Holland, to transform Carlton House in Pall Mall. In its magnificence and *Louis-Seize* stylishness, it was to make all existing Royal establishments staid and dowdy by comparison. As work began, the Prince took a holiday, a visit to his wicked uncle Cumberland at a place which had recently become much favoured by the kind of people to whom the Prince inclined — the little seaside town of Brighthelmstone, by then familiarly known as Brighton.

The Pleasure Town

Brighton in 1783 was already a fashionable seaside resort. Since 1750, when Dr Richard Russell of Lewes had publicized the health-giving properties of bathing in sea water (and drinking it too), the old fishing town had come to rival the spas of Bath and Tunbridge Wells as an attraction to those with leisure, money and a desire to meet others of the same kind in relatively unconstrained circumstances. There was from the beginning a remarkable lack of stuffiness about the place. And casting its spell over all the pleasure-seekers in their finery was the effervescent air and continuously changing magic of the Channel light. Even Dr Johnson had been tempted down to breathe the ozone, if not actually to bathe.

More recently, a younger and more naturally exuberant clientele filled the little houses which now began to multiply outside the ancient confines of the little town. Brighton had much in its favour. In addition to the refreshments of sea-dipping, there was a race-course and good hunting nearby. There were circulating libraries, balls and assemblies under the direction of a Master of Ceremonies at the new ballrooms in the Old Ship and the Castle Inn, baths, and a primitive theatre. But in comparison with more established resorts, the prevailing tone was of a picturesque informality. In particular, the constant toil of the fishermen and farmers lent an idyllic charm to the scene that was, in these closing years of the 'Age of Elegance', much relished by the *beau monde.* The phenomenon has its modern parallels: in the twentieth century the fishing villages of St Tropez and Acapulco were destined to exert a similar fascination. And no less than these were to do, Brighton began to attract an ample share of rakes, parvenus, and beguiling young women, including the euphemistically termed 'little French milliners' and the 'Cyprian corps'. 'Brighthelmstone', according to the *Morning Herald* of 9 August 1784, 'is the centre luminary of the system of pleasure . . . the women, the pretty women, all hasten to see the Paris of the day.'

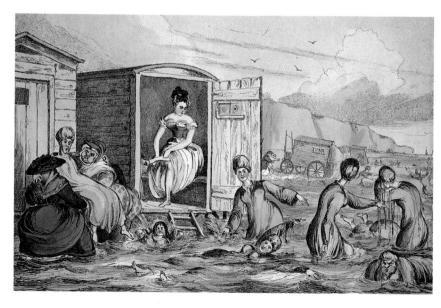

Early nineteenth-century bathing pleasures at Brighton.

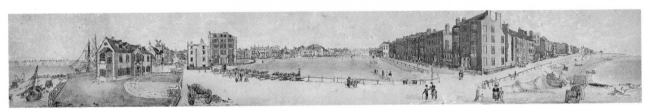

Brighton Racecourse, seen here in an aquatint after Rowlandson, was an important ingredient of the town's attraction for the fashionable world.

Panorama of Brighton *c.*1803. The intimate scale of Brighton's seafront was to give way to a grander appearance in the post-Napoleonic building boom.

The Duke of Cumberland, by now a familiar figure in Brighton, had for several years held out to his nephew the tempting prospect of its freedom and excitement. Soon after his twenty-first birthday the Prince succumbed. He stayed with the Duke in Grove House (a large brick house where the Music Room of the Pavilion now stands) for eleven days in September, and was fêted wherever he went. He attended a Grand Ball at the Castle Inn, promenaded upon the Steine, was saluted by guns and a firework display, and thoroughly gratified all expectations of his good looks and charm. When he returned to London, where Carlton House was now taking on the lineaments of stylish sophistication, the Prince renewed his acquaintanceship with a man whose notoriety far exceeded that of the Duke of Cumberland, through whom the introduction may well have been made, and who was himself wary of him. 'Be not too civil to Chartres,' he wrote to his nephew. The Duc de Chartres, heir to the Orléans line and cousin of Louis XVI, was the richest man in France — dissolute, untrustworthy, physically unappealing, and a great patron of the arts. He appeared now in England in the wake of the Peace Treaty of Versailles (1783) and was to return several times. In him, a passion for English things from clothes to gardening and racing burned hardly less intensely than the Prince's admiration of French civilization. The two men formed a friendship, with the much younger Prince falling greatly under Chartres' influence. Not the least significant of their common enthusiasms was the cultivation of a taste for excellence and distinctiveness in furniture and other works of decorative art.

In August 1784, the Prince of Wales entertained Chartres, amongst other members of the French nobility, in Brighton, where he had taken Grove House himself for the season. He was, at that time, in need of distraction: Maria Fitzherbert, a young and well-born Catholic widow whom he had met earlier that year, had escaped his importunate demands by taking herself off to France in July. In desperation, he used the pretext of economy to wheedle permission from his father to go abroad. It was unavailing. By November he was literally suicidal. He enlisted the aid of the Duc de Chartres to chase the object of his passion with pleading messages. By the end of 1785 he had accepted the only terms on which she would countenance sharing her life with him, and they were married by a pliant clergyman that December; but in secret and in direct contravention of the Royal Marriage Act which George III had designed to bring order to his family's marital affairs.

As for the Prince's financial affairs, they were deep in the quicksands of debt, brought on chiefly by the costs of Carlton House and by a general aversion to such uninspiring ideas as budgetary control. In aspiring to the life style of a Louis XV on an income designed for the heir of a constitutional monarch, he now owed more than a quarter of a million pounds, and throughout 1786 there was an unpleasant stalemate between him and his father, who would not contemplate relieving the Prince without a sufficient explanation of his expenditure. The Prince was not prepared to submit. As he said, 'the more I am endeavour'd to be crush'd, the higher my spirit rises.' Dramatically, in July he dismissed his household, suspended work on Carlton House, sold his stud of horses, and announced his intention of living like a private gentleman. A little time would surely secure a Parliamentary settlement of his debts and, perhaps, an improved position. In that same month he departed for a fourth season in Brighton.

It was time, in any case, to establish a base outside London, and so, needing a permanent stake in the little seaside town, he settled upon a house modest in status but rich in possibilities. Nothing could have been further from an oriental fantasia than the farmhouse, between the Castle Inn and Grove House, which was leased for him in October 1786, and nothing perhaps was further from his mind when he

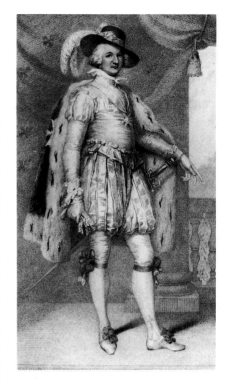

The Duc de Chartres in fancy dress. The Prince's French *ami damné* was an important influence on his tastes. Engraving after R. Cosway R.A.

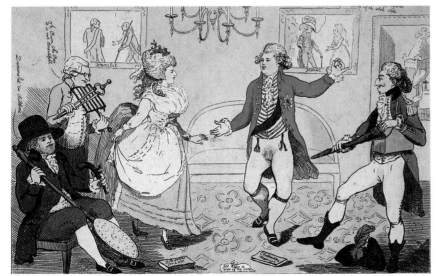

The April Fool or the Follies of a Night. The Prince's clandestine marriage to Mrs Fitzherbert was foolish and politically dangerous. The scene also alludes to the Prince's fondness for amateur dramatics and the theatre in general. Edmund Burke is the fiddler, and George Hanger joins the dance.

17

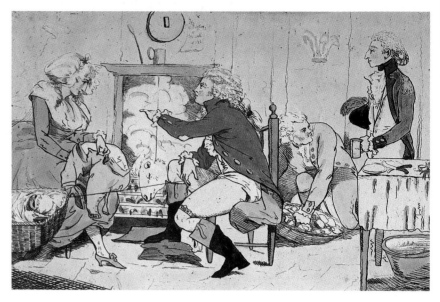

The Prince's brief display of economy did him some credit. He and Mrs Fitzherbert are shown living as simple cottagers in the Brighton farmhouse that was soon to be not quite so simple. Weltje, the Prince's factotum, is seen with baskets of oysters, at that time food for the common man.

established himself in what George Croly described as this 'singularly pretty picturesque fabric, where a few shrubs and roses shut out the road, and the eye looked unobstructed over the ocean.' It was known as Brighton House, a double-fronted, timber-framed structure, with angled bays, two up, two down. For the Prince, it must have held the thrill of fashionable romantic poverty.

Brighton House was the corner into which he had been driven by frowning father and 'ungenerous' Parliament, but it was his corner and he was careful, for the moment, not to get his knuckles rapped again. Apparent expense was judiciously minimized by the use of an intermediary. It was Louis Weltje, the Prince's Clerk of the Kitchen, who took a three-year lease on the property from its owner, Thomas Kemp. Weltje, a Brunswick pâtissier and cook of proverbial ugliness, who had set up a successful club in St. James's and subsequently entered the Prince's service at Carlton House, was useful to the Prince not only as a chef and a convenient landlord (taking up his option to purchase, he was to finance the building of the 'Marine Pavilion' and let it to his master on a twenty-one-year lease), but also as a scout for fine French furniture. For a brief period, the simplicity of the house won the Prince credit among the upright, for him a novel and possibly uncomfortable experience. In fact it soon became clear that simplicity, to the Prince, was better represented not by rustic modesty but by the scheme of enlargement undertaken for him in the summer of 1787 by Henry Holland, whose work at Carlton House had already exhibited from 1783 that august refinement and understanding of the latest French taste which was so agreeable to the Prince and the Whig grandees. Holland had inherited there a French Clerk of Works, the ex-cook Guillaume Gaubert, and in 1787 was adding to a cosmopolitan group of craftsmen a team of four French decorative painters, as well as capturing the services of the leading *marchand mercier* in France, Dominique Daguerre, as an agent for the commissioning of furniture. That May, Holland was summoned to Brighton from his activities at Althorp, Lord Spencer's seat.

The Marine Pavilion

At the end of three months, the 'respectable farmhouse' found itself but a single element in a villa of Palladian dignity, linked to a duplicate of itself by a striking domed rotunda, half encircled by Ionic columns, and surmounted by classical statues in Coade stone, a new and successful artificial material. This central feature, though strongly reminiscent of Paine's unexecuted design for Kedleston, published in 1783, had a French cachet, having recently appeared in Rousseau's Hotel de Salm, though with pilasters, not columns. A domed cylindrical centrepiece also marked Bagatelle, the exquisite pavilion in the Bois de Boulogne, built in 1777 by the Anglophile architect Belanger. Accounts of Bagatelle would undoubtedly have worked their allure upon the Prince of Wales. Holland himself had been directly exposed to new French influences during his visit to Paris in 1785.

The rotunda at Brighton House (by 1788 known as the 'Marine Pavilion') provided, with its apsidal ends, a high-ceilinged drawing-room of a noble and interesting shape, the one necessary grand room in the house. It was one of the two determining factors in the eastern elevation of the Pavilion. The other was the preservation of the shape, window bays, and homely low ceilings of the original structure—a decision prompted not so much by thoughts of economy, perhaps, as by senti-

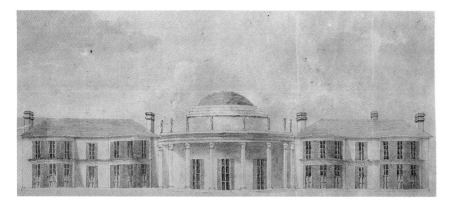

The East Front of the Pavilion, 1787. A watercolour from Holland's office.

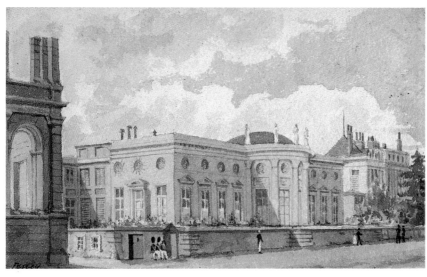

The Hotel de Salm, Paris, one of the most celebrated and influential houses of the neo-classical movement. Watercolour by Benjamin Ferrey for A.C. Pugin's *Environs de Paris*, 1828.

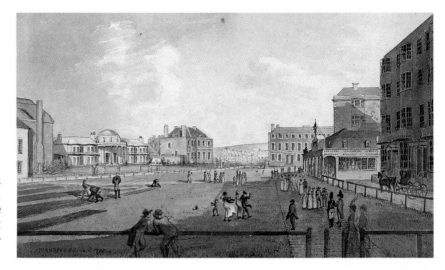

The Pavilion and the Steine, a watercolour by J. Spornberg, 1796. Marlborough House adjoins the Pavilion at the north. To the right is that essential of an eighteenth-century resort, a lending library.

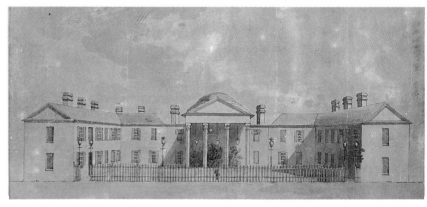

The West Front of the Pavilion, 1787. A watercolour from Holland's office. A sundial supported by a blackamoor figure stood in front of the portico.

ment, which was often seen to combine in the Prince's mind with the desire to cut a dash.

The angled bays of the farmhouse were rounded into bows, a feature that had already begun to appear on fashionable houses in Brighton, and was soon to characterize much of the town's architecture. These bows echoed the rotunda, so that the entire East Front was articulated by curved projections. In the Pavilion's final guise each was topped by an oriental dome. Otherwise both wings were plain, except for continuous ironwork balconies. Such suggestions of warmer climates were in the vanguard of fashion, and so was the conversion of all the ground floor windows into a type which opened, French style, on to the lawn. The possibility of immediate access to the garden was of course the very essence of a pavilion, and was later to contribute to the character of the Regency house. Repton, in his theoretical writings, compared the interior effect to that of a marquee.

The West Front took the form of an open court between two long projecting wings, both pedimented like the central Ionic portico. Simple enough, and containing only services, bedrooms, and passages. Nor was grandeur to be found in the Hampshire weather tiles with which the structure was surfaced. A speciality of Holland's, they resembled bricks of the colour and texture of creamy stone, so that the Pavilion must have sparkled among the brick and flint or coarse rendering of the neighbouring buildings. Similar local tiles were in current use in Sussex, giving the appearance of red brick to timber-framed houses.

The Pavilion was not yet a great house. There was a breakfast-room and ante-room below the Prince's apartment, and, on the other side of the Drawing Room or Saloon, an eating-room divided by a screen of scagliola columns, and a library. That was all, though throughout the interior a Gallic elegance seems to have prevailed in both furniture and decoration. The Library was 'fitted up in the French style, with a brilliant yellow paper; the Eating Room painted in yellow and maroon, with a sky blue ceiling', the corridors French blue, and the staircase walls green. Even at this date visual records of house interiors were still rare. Of the early Pavilion rooms only the Saloon was depicted for the *Excursion to Brighthelmstone in 1789,* a collaboration between Thomas Rowlandson and Henry Wigstead, who had a hand in the Pavilion decorations. Rowlandson's watercolour and engraving sketch out the Adamesque neo-classical scheme, in which the virtuoso decorative artist Biagio Rebecca painted the ceiling and wall panels in his 'best manner' of ornament. Even allowing for Rowlandsonian gusto, it can be seen that the figures within behave with gracious freedom of manner, that very combination of sophistication and intimacy which the structure itself embodies. The Pavilion encouraged a modish informality that bore something of the same relation to London court life as the activities within the delicious French aristocratic *pavillons,* which generated so many new types of furniture, did to the rigidities of Versailles. However, direct comparison is inappropriate, and from all accounts the early years of the Pavilion witnessed high spirits of a robustness that, despite the cult of liberty, was seldom found even among younger participants in the *vieille cour.*

But like the pleasure pavilions of the Île de France, the Pavilion was devoted to *la douceur de vivre,* where the complex web of re-

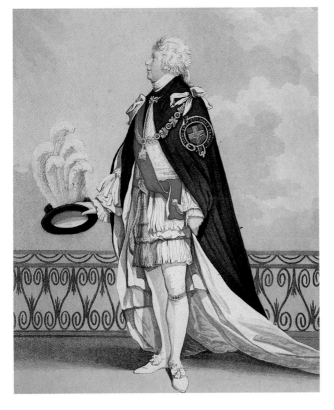

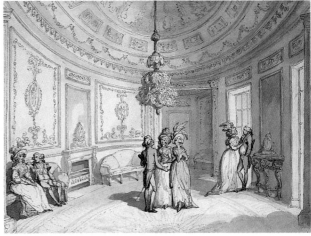

Rowlandson's watercolour of the Saloon in its first decorative scheme (1789).

The Prince of Wales in Garter Robes, 1799.

21

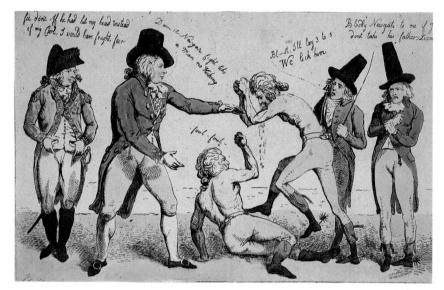

Among the Prince's favourite companions were the Barrymore brothers, sons of Lord Coleraine. Notorious hell-raisers, they are here depicted using foul means in a fight with the son of Brighton's theatre manager. The Prince of Wales is the referee.

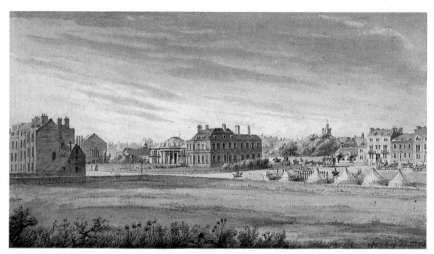

The Pavilion and the Steine, watercolour by J. Spornberg, 1796. French invasion threats at this time were the occasion of army exercises.

sponsibilities attached to an English country house simply did not exist. There was, instead, a freedom from obligations which charmed the Prince. In its way, the system of which he and Mrs Fitzherbert formed the centre was extremely satisfying. The more he enjoyed himself in Brighton the more prosperous the town became, and the more he was appreciated. He pleased everyone there by having fun. Brighton knew him as a generous patron, one who was glad to join in the cricket games, the ox-roasts, and the town sports on the level ground of the central valley.

The completion of the 'Marine Pavilion' in 1787 opened a new era in Brighton's social success. Visitors came in double the numbers to see and be seen, to be dipped in the sea, to attend the assemblies and balls at the Old Ship and the Castle Inn. There was a rage for dramatic performances, in which even members of the Prince's circle, such as the roistering Lord Barrymore, took part. Two miles away the well-appointed race-course drew teeming crowds up the slope of the Downs, especially on the Prince's birthday. In the wake of visits by the Duc de Chartres (by now Duc d'Orléans), Brighton became popular with the French aristocracy, but, by a mordant irony, never so popular as between 1791 and 1793 when the accelerating terrors of the Revolution

threw hundreds of bedraggled refugees onto the pebbled shores of what was becoming the most fashionable place in Europe. Among them was the Marquise d'Osmonde, Mrs Fitzherbert's own cousin, who like many of the dispossessed was graciously received in the Prince's house.

The reports from France sent a shiver through the ranks of English society. For the next thirty years it represented both a terrible warning and, in some quarters, a signal for defiant extravagance. In the Prince of Wales' mind there was a variety of reflections to make. His friend the Duc d'Orléans (by this time plain Philippe Egalité) turned regicide, shocking him deeply. His Whig friends were ambivalent in the face of French events — was revolution where the call of liberty led? If anything, the experience of France sharpened his desire for the endangered splendour of monarchy and all the pomp and circumstance in which he shone. If princely glory was dead in its native land, it could be reborn in England, with the added benefits of modern comforts and ingenuity. For an admirer of the arts of France to be separated, after ten years of peace, from the source of so much delight and the finest furniture, was penitential, but the declaration of war in February 1793 brought the excitement of arms and their accompaniments — uniforms, ceremonial, splendid paraphernalia, and dreams of glory. The Prince revelled in the theatricality of it all, even though he was denied, to his lasting chagrin, a genuine military command. As Colonel-in-Chief of the 10th Light Dragoons, he took his place in the famous Brighton defence camps on the Downs. In view of the Pavilion's later transformation, accounts of his ephemeral accommodation have a premonitory ring. 'The Prince's tent was handsomely furnished', though the bed, considered too sumptuous, was later replaced by a common tent-bed. There was 'a dining room in the centre, with the Bed Chamber and

Holland's plan of the ground floor of the Pavilion, 1787.

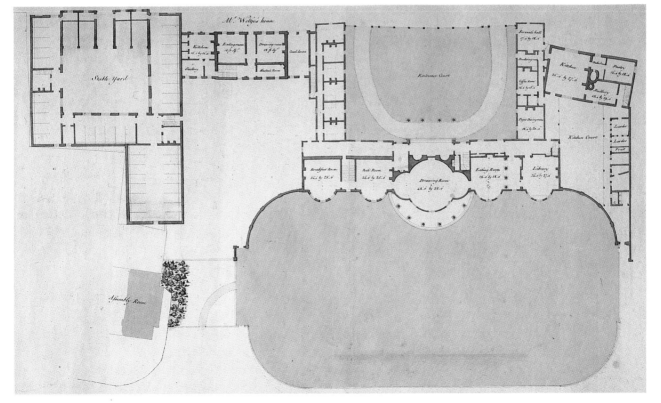

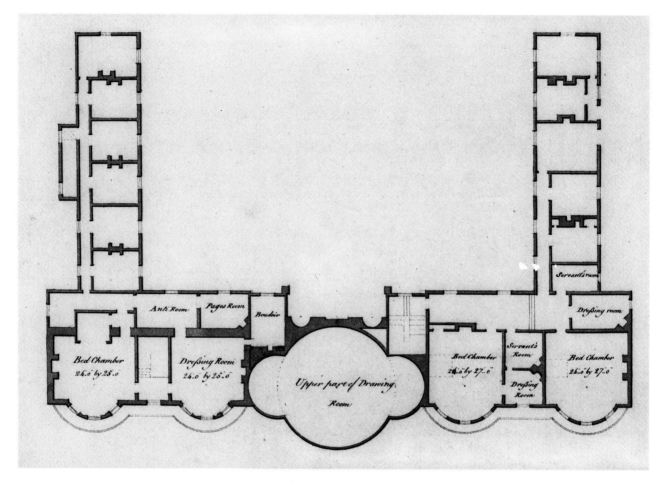

The upper or chamber floor, 1787.

Drawing Room on each side forming the wings. All was hung with different patterns of chintz. The Drawing Room was particularly beautiful in a highly-glazed chintz and two sophas covered with the same.' Even officers' tents had glass doors, paved entrances, and neat parterres of flowers. The observer was the intelligent young daughter of Lord Sheffield, face to face in 1794 with the glamour that Lydia in *Pride and Prejudice* could only envisage: 'A visit to Brighton comprised every possibility of earthly happiness. She saw with the creative eye of fancy, the streets of that gay bathing place covered with officers. She saw all the glories of the camp—its tents stretched forth in beauteous uniformity of line and dazzling with scarlet.'

The Prince's affairs now descended to another low point. In debt to the tune of a staggering £640,000 and estranged from the sound counsels of Mrs Fitzherbert by the enticements of Lady Jersey, he accepted in 1795 the seductive financial solution of an approved marriage. His bride and cousin, Caroline of Brunswick, was as coarse as he was polished. It was a disastrous match from the beginning, and though some special alterations at the Pavilion obliged the Royal couple to find other quarters on their visit, their brief cohabitation had little effect upon the building. Plans by Holland for curved additional wings were never executed.

For the first time even Brighton turned against the Prince. It was clear that Lady Jersey, now pursuing her mischief as the Princess's lady-in-waiting, held sway over him. As the perceived villain of the

piece in the miserable spectacle of his marriage, she was hissed in public. The Prince threatened to leave Brighton and convert the Pavilion into a barracks (he repaired to Bognor for the summer of 1796), and for the next four years the town saw little of him. La Jersey's fascination for the Prince of Wales quickly expired. In his wretchedness he sought to recapture the happiness of his early years at Brighton and threw himself on Mrs Fitzherbert's mercy. Once again the exercise of her virtuous conscience made her hard to win and therefore doubly desirable. Only after Papal confirmation of the canonical validity of their marriage did she consent to renew their relations, in 1800. The high regard in which she was always held in Brighton ensured that this arrangement was acceptable to the public. For her and the Prince, although decorum, as always, forbade that they should share a roof, the next few years were among the happiest in their extraordinary life together.

Mrs Fitzherbert was an entirely good influence upon him. In dealing with him she was firm but tactful, understanding of his weaknesses, and impressively conscious of her dignity. He still got drunk, and the fantastic nature of his stories often stunned company into embarrassed silence, but he kept better company than before, was good-humoured and kind. Life at the Pavilion became a pattern of polite entertainments and musical activities, in which the Prince's interest had vigorously blossomed.

To celebrate this new era, and in order to meet the wider social demands of what had become a little seaside court, Henry Holland was recalled to design substantial extensions and alterations to the Pavilion. In July 1801 he produced a scheme. One of the sketches was startling. In every respect it was identical to what was executed, but for the Chinese fancy-dress in which all the exterior forms were clothed. It was the first hint of the singular taste which was beginning to emerge in advanced circles. Brighton soon saw it erupt everywhere — in the dress of both sexes, the ebullient variety of vehicles and equipages, in the adoption of clamorous schemes of colour. In the event the Prince kept a reticent public face upon the Pavilion. Unprivileged observers would not have guessed that over the next years the building was a gigantic chrysalis, in which the spirit of the orient was filling out its fabulous wings. Between 1802 and 1804 the Chinese taste took over the interior with an almost obsessive strength of purpose.

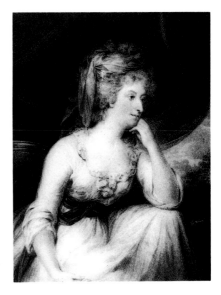

Mrs Fitzherbert in an engraving after John Russell, RA.

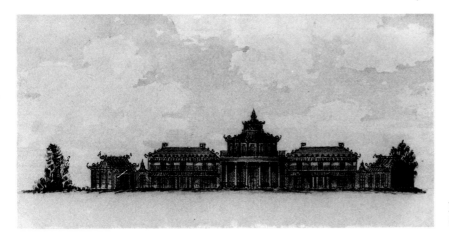

Holland's unexecuted design for a Chinese exterior, dated July 1801.

The Celestial Dream

The special fascination which China holds for Europe has a very long history. It returned again and again to fertilize the decorative arts of the West in all their forms. Ceramics, furniture, tapestry, printed textiles, metalwork, wallpaper — all have borrowed from the mysterious East. The first great impact was made in the seventeenth century by the import of much-prized lacquer panels and porcelain: products, it seemed, of a civilization of superior and baffling skills, and, it was thought, of a political and social sophistication greatly in advance of Europe. To the thinkers of the Enlightenment in the incompleteness of their knowledge, to Voltaire himself, China represented a land of admirable stability governed by philosophers.

Voltaire was witness to the second and greatest wave of interest, coinciding with and stimulating the development of the rococo, in which the delicacy and elegant prettiness of Chinese artefacts gave inspiration to the flights of wayward graceful fantasy in drawing-room and boudoir. Imported vases, papers, painted and embroidered silks, found an easy place in rococo interiors. But it was through the impor-

Chinese painting of a court scene at the Imperial Palace, Peking (Ch'ien Lung, c.1800). Brought back by an agent of the East India Company it is a firsthand record of oriental magnificence, of the kind which inspired the early Chinese decorations in the Pavilion.

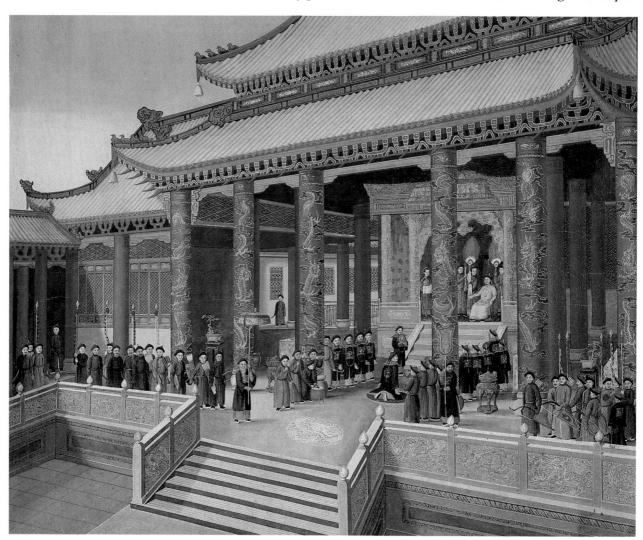

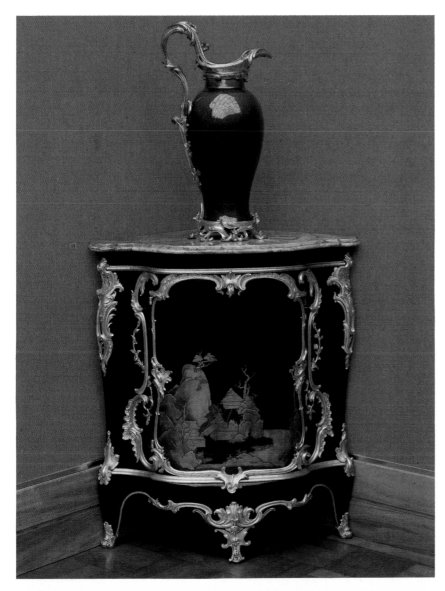

Japanese lacquered panels were elements of some of the most splendidly expensive furniture throughout the eighteenth century. This *Louis Quinze encoignure* by Bernard II van Risamburgh eventually found its way into the Prince's Apartment on the upper floor of the Pavilion. (BP)

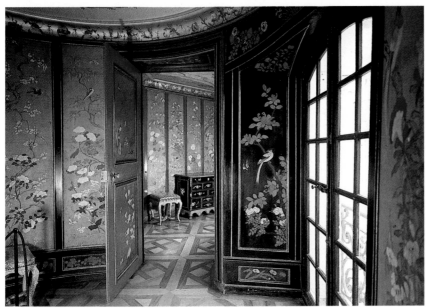

An early eighteenth-century chinoiserie interior—the Pagodenburg pavilion built by the Elector of Bavaria, Max Emanuel, in 1715.

27

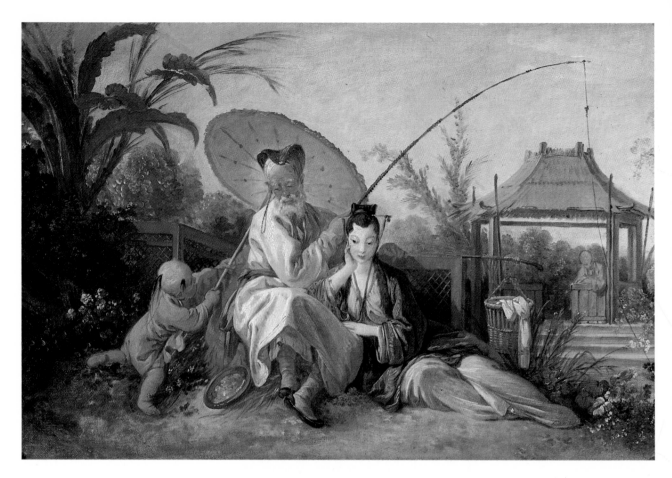

Rococo pictorial chinoiserie at its most refined. A *scène galante* by François Boucher, painted for reproduction in a series of Beauvais tapestries.

tant branch of decorative art that they inspired, chinoiserie, that 'the Exotic', with which the eighteenth century played a coquettish game, was most happily assimilated.

Chinoiserie had become chic, a persistent vogue in the French court and its imitators. Louis XIV's brother, 'Monsieur', had had a Chinese closet filled with porcelain at St Cloud in 1690. The King himself built the *Trianon de Porcelaine* with ceramic exterior walls, the inspiration in turn for Max Emanuel of Bavaria's Pagodenburg (1719) in whose lacquer rooms *trompe l'œil* decoration and cane furniture went one stage further. By the 1780s princes and kings all over Europe had tried their hand with *le goût chinois* in one or other of its forms — at Pillnitz in Saxony, in the famous Chinese tea-house at Potsdam, at Tsarskoe Selo near St Petersburg, and with special enthusiasm in Sweden at Drottningholm, among many other examples. Early in the century Watteau himself was called upon to conjure up a fictitious China at the Château de la Muette. Indeed many distinguished painters, from G.-D. Tiepolo to Boucher, were to provide chinoiseries for their patrons.

In England, which was generally resistant to the feminine frivolities of the rococo, the Chinese taste was of even greater relative prominence. Hard on the heels of the 'Gothick' fashion, which similarly represented a kind of relaxation from prescribed taste, it took English society by storm in the 1740s. By 1753 it could be said that 'according to the present prevailing whim everything is Chinese, or in the Chinese taste . . . chairs, tables, chimneypieces, and without doors so universally has it spread, that every gate to a cow yard is in T's and Z's, and every hovel

for cows has bells hanging at the corners.' Mrs Montagu had complained in 1749 that 'we must all seek the barbarous gaudy *gout* of the Chinese, and fat headed Pagods and shaking mandarins bear the prize from the great works of antiquity', but soon her house in Portman Square had one of the most famous of all Chinese rooms.

All the most fashionable great houses were equipped with a room in the Chinese taste, almost invariably a bedroom or a drawing-room, for which Chinese paintings or wallpaper were in enormous demand. As an architectural inspiration Chinese influence was considered suitable exclusively as part of the landscape garden repertoire of pavilions and kiosks, where such structures enjoyed enormous favour. Wherever these distinctively English gardens were copied throughout Europe (there named *jardins Anglo-Chinois*), the Chinese garden pavilion appeared too, often in finer and more elaborate guise than in England. When the Duc de Chartres, before he befriended the Prince of Wales, set up one of the finest of these gardens in the Parc Monceau in 1776, the fashion was still fresh, though long past its peak in England. Henry Holland's Chinese dairy at Woburn (1787) marked a quiet re-importation from the continent of the Chinese taste.

However, the rich eighteenth-century background of chinoiserie is no explanation of why the Prince of Wales 'went Chinese' in the Pavilion in 1802, let alone in 1815. The Chinese taste was no longer fashionable in domestic interiors when it seized the Prince. The Egyptian or the Greek, yes, picturesque Gothic, certainly, but not a taste which was now associated with places of public amusement such as Vauxhall and Ranelagh Gardens, though these still attracted sections of fashionable society. A revival did take place, and it was the Prince who led it. One powerful motive is suggested by his personal circumstances at the turn of the century. During the last dozen years he had lived in expectation of his father's total incapacity and the role of

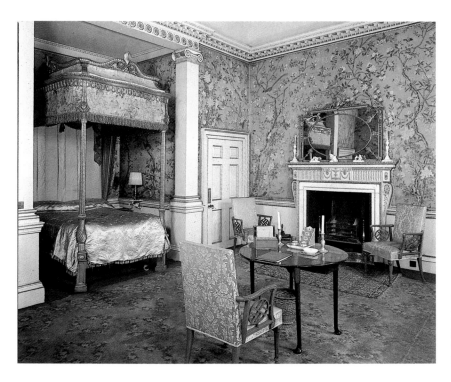

The State Dressing Room at Nostell Priory, Yorkshire. Robert Adam provided the Chinese wallpaper, Chippendale the 'Chinese' pattern chairs (1771).

29

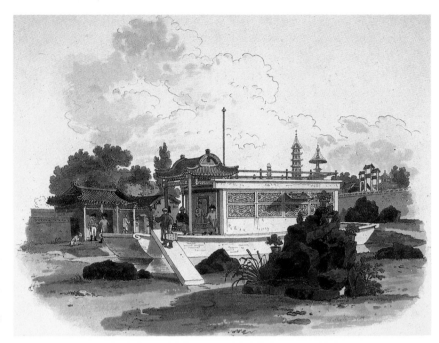

A plate from William Alexander's *Costume of China* (1805). The stone building in the form of a boat, which was in the grounds of the mansion allotted to Lord Macartney's Embassy, appears in one of the Music Room murals (see page 106).

Regent falling to him; it had not come to pass. He had expected the opportunity of military command; it had been denied him. He had experienced a disastrous marriage, he was entering middle-age frustrated in all his ambitions, and so to a man who was at once sentimental, nostalgic and a lover of novelty, the associations of the Chinese taste with the forbidden masquerades and the festive amusements of his youth would have spiced it with delightful recollections. Chinese things offered comfort as well as excitement. His earliest years had been spent in sight of Chambers' great Pagoda at Kew and among his mother's favourite Chinese mandarin figures, fine porcelains, and silks. Moreover, knowledge of China had been given greater currency since Lord Macartney's Embassy to the Emperor Ch'ien Lung in 1794, not least through the evocative pictorial records brought back by William Alexander. What the Prince heard concerning the proud dignity of the Chinese court must have greatly impressed him and encouraged his own conception of the role of monarchy. The Emperor had received Macartney as the representative of a tributary nation, but it was of greater significance for the Prince of Wales that his magnificence had been displayed in a domed tent in the Imperial summer garden. Such motives and inspirations now reinforced the existing interests which had, in 1790, produced the Chinese Drawing Room at Carlton House — one of the most celebrated apartments in that august and vanished palace, recorded by Sheraton in the *Cabinet-Maker and Upholsterer's Drawing-Book*. A low rectangular room on the basement storey, it was fitted up in a completely unified style, the Chinese taste as seen through the fastidiously elegant prism of *Louis Seize* decorative practice. Apart from the architectural details, the furnishing and decoration of what Holland refers to as the *Sallon Chinois* are now known to have been the products of French craftsmen, notably the two superb open cabinets, probably by the great ébéniste Weisweiler, which, with duplicates, were brought to the Pavilion in 1819 and provided a key to many features of its decoration.

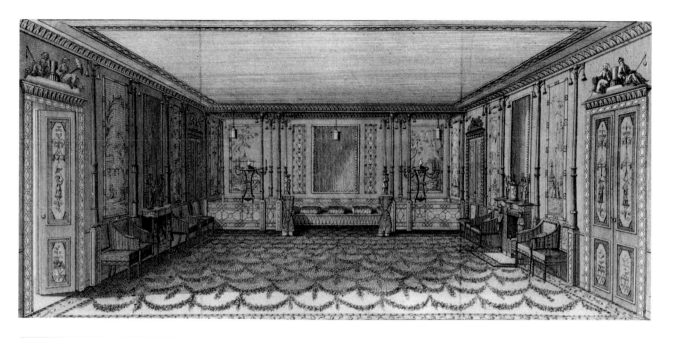

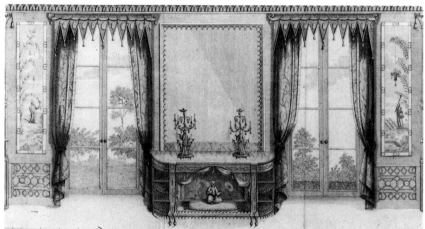

The Chinese Drawing Room, Carlton House, from Sheraton's *Cabinet-Maker and Upholsterer's Drawing-Book* (1792). The furniture became the basis for the final, 1821, scheme for the North Drawing Room of the Royal Pavilion.

The south wall of the Chinese Drawing Room, Carlton House.

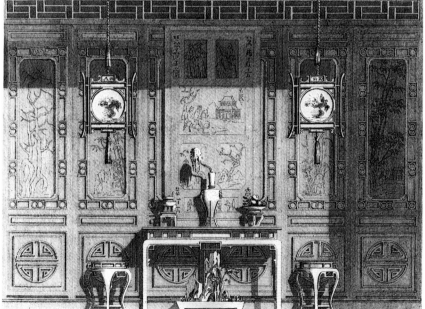

A Cantonese room, from Sir William Chambers' influential *Designs of Chinese Buildings* (1759).

31

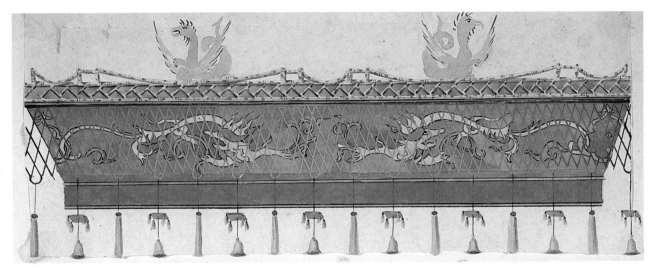

A design for the cornice of the Saloon in the scheme executed in 1802 by the firm of Crace.

The Carlton House Chinese room, with its tall panels of Chinese scenes alternating with mirrors or doors, assimilated to current French taste ideas from Sir William Chambers' mid-century *Designs of Chinese Buildings,* notably the Cantonese room. As a work of art, it is most thoroughly worked out and ranks as one of the most successful chinoiserie interiors ever created. It is impossible to imagine anything more capable of sustaining an interest in *le goût chinois* than this room, although when the early Chinese interiors of the Pavilion were begun twelve years later, French characteristics were conspicuously more scarce. The Prince's enthusiasm for French furniture had been suspended since 1793, when the Duc d'Orléans, whose influence on Carlton House had been so strong, had stained his hands with royal blood. Indeed, in explaining the fulsome exoticism of the Pavilion's decorations to Lady Bessborough in 1805, the Prince said 'he had it so because he was afraid of his furniture being accused of Jacobinism.'

E. W. Brayley, in the first complete account of the Pavilion and its history (1838), explains the introduction of the Chinese taste by the gift of some wallpaper in 1802. If so, the paper could not have been installed before the autumn of that year, for a report in the *Morning Advertiser* which described the substantial improvements made by August made no mention of Chinese decorations. If the gift preceded Holland's sketch for a Chinese exterior in July 1801, its influence upon the interiors was delayed. The Prince may indeed have been given such a present perhaps even by Lord Macartney, who presented a roll of Chinese paper in 1797 to Coutts Bank—a firm, incidentally, through which many of the Prince's disbursements were made.

Whatever the reasons, the progressive oriental fantasia within the rooms was no ephemeral caprice. Fun it was, but fun taken seriously and executed with conviction. There was an edge to Chinese art that had been blunted in previous generations who in their selectiveness had suppressed the intensity of colour and those disturbing representations of Chinese mythology, the vigorous dragons, serpents, and monsters that European civilization had confined since the Middle Ages to history painting, but which retained who knows what power to thrill the nerves. Such things no longer terrified the Western mind as accompaniments of evil; they partook of the awe-inspiring 'Sublime',

which in the 1750s Burke had distinguished from 'Beauty', and which his contemporary Piranesi, in his engravings of architecture and exotica, did so much to reintroduce into the visual imagination of the West. There may have been personal motives in placing these evocative monsters on ordered parade, but nothing could have been more timely in the heyday of the Gothic novel, of Beckford's *Vathek*, and of the mounting Romantic interest in exotic sensation, than the world created inside the Pavilion, in which the thrill of the unknown combined with the refined aestheticism of that other type of the age, the dandy.

The first quarter of the nineteenth century in England pulsed energy in almost every human activity — in science, industry, literature and in all the visual arts. Contradictory impulses and variety abounded as if all restraints had been loosened. We see in the transformation of the Royal Pavilion that in architecture the Vitruvian consensus had weakened its grip and that the sense of classical authority in the decoration of a great house, present even in the wallfuls of illusion derived by a Verrio or Laguerre from Renaissance painting, was being undermined. The decorative arts of the later eighteenth century had sought fresh inspiration in the fruits of antiquarian research. Designers borrowed from a seeming infinity of sources, Etruscan here, Gothic or Chinese there, with promiscuous adaptations of motifs from one medium to another be they ceramics, textiles, metalwork or stage effects. There had long been a place for grotesque fantasy, in the sense of Raphael's Roman-inspired decorations of the Vatican loggias. However, as the old conventions were breaking down, that place was much extended until the yearning for fantasy, inspired by any remote era or place, itself became a convention. In an age that was busy defining aspects of mental activity, visual fantasy could be compared with the Fancy which Coleridge distinguishes from Imagination as an ingredient of poetry, or with Sensibility as distinct from Sense.

So in a period when it was no longer the *rules* of taste, but something with even more mystique — *taste* itself — that marked a connoisseur, the Prince was staking his claims in a way that was bold but well understood where it mattered. Other connoisseurs might seek inspiration in Classical Greece, but he pronounced it 'an absurd and perverted taste' that introduced the simplicity of the great temples into every structure, without regard to its purpose; moreover it was too stern, too Jacobin, unassociated with panache and *galanterie*.

Some kind of associative element is a highly important, though often unconscious, ingredient in all architectural styles. It was a principal tenet of the picturesque movement. In whatever manifestation, exterior or interior, its devotees set out deliberately to conjure up not abstract beauty but remote associations. In the Pavilion's case these drew upon travellers' tales from Marco Polo to Macartney's Embassy and upon several generations of aristocratic fascination with sumptuous Chinese craftsmanship. In the Prince's day still, but not for much longer, the connotations of China were those of luxury, gaiety, and the trappings of rank. Together with his recollections of youthful pleasures, these perceptions combined to make the Prince's Chinese adventure much more than the *coup* of a 'man of taste'. And, we may note, it was initiated during his second honeymoon with Mrs Fitzherbert.

The First Chinese Interior

The improvements that Holland designed and which were executed under the supervision of his assistant P.F. Robinson turned the intimate early Pavilion into a large, long Regency house, made unusual by the placing of two spacious new rooms projecting from the ends of the building at an angle of sixty degrees. Because the available space between Marlborough House and the northern wing was confined, this was a necessary device at one end, duplicated, for symmetry, at the other. Only a few years earlier, before the dissemination of picturesque ideas of planning, the idea might never have seemed permissible. The staircases were removed from the main body of the building, reappearing rather awkwardly in 'bubble' projections on either side of the enlarged hall and portico. More immediate access to Holland's old northern wing, where the Eating Room and Library were thrown into one room, was thus created. The original 'farmhouse' wing retained its Ante-Room, and in place of the staircase and Breakfast Room appeared the Small Drawing Room. In keeping with these improvements of planning, the exterior took on an altered aspect. The tiled surface was stuccoed and lined in imitation of Bath stone and given extra verisimilitude by frescoing (in reality the application of a variegated wash) by the scene painter Louis Barzago. The statuary was removed from the dome, but the enlivenment it gave was amply compensated for by the addition of curved-up metal canopies, painted green, over the windows, a feature which was to become a commonplace on Brighton houses.

The firm of John Crace, in which his twenty-four year old son Frederick was already assuming an important role, appears to have begun decorative work in the first half of 1802 when building was finished. The decision to adopt the Chinese taste, probably taken about midsummer, led to the early obliteration of this work, at least in the new, angled Conservatory. But it was in the old northern wing, now one long room, that according to Brayley the transformation began, apparently with the application of the Chinese wallpaper. He calls it the Chinese Gallery, but it can also be identified in the Crace accounts after 1802 as the Billiard Room and in 1815 as the Old Gallery or Breakfast Room, before it emerges as the Yellow Drawing Room and eventually the North Drawing Room.

There is no adequate account of its decoration, but the Chinese wallpaper was probably of scenes busy with figures, bordered with panels of Chinese fret. For the next two years Crace and his men were engaged in intense activity, developing a rich and unique vocabulary of design in the Chinese taste, partially recorded in the many trial patterns and sketches which still exist. There was a marked concentration on Chinese fret patterns, colourfully picked out and shadowed, Chinese columns, imitation trellis work, marbling, simulated bamboo fillets, and graining in a dazzling variety of woods — 'the pink teawood', satinwood, rosewood, tulipwood. Many of the ceilings were given clouded skies. A predominantly scarlet Ante-Room was applied with Chinese paintings, exhibiting 'the manners of the people', the surrounds

Sketch plan of the ground floor, 1801, incorporating the changes made by Henry Holland and his assistant P.F. Robinson.

Sketch plan of the first floor, 1801.

The Royal Pavilion in 1806. The new domed stables and the 1801 additions may be seen in the background. Fashionable promenades upon the Steine were a continuing feature throughout the Prince's lifetime.

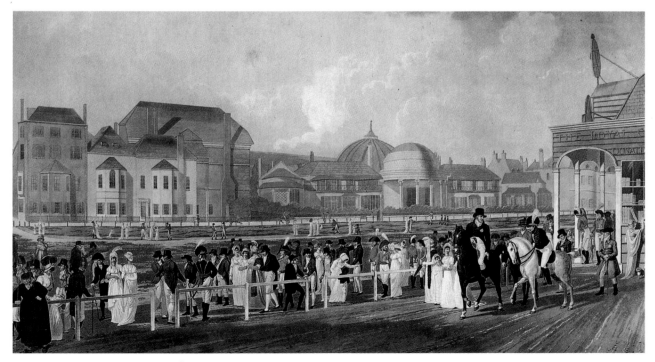

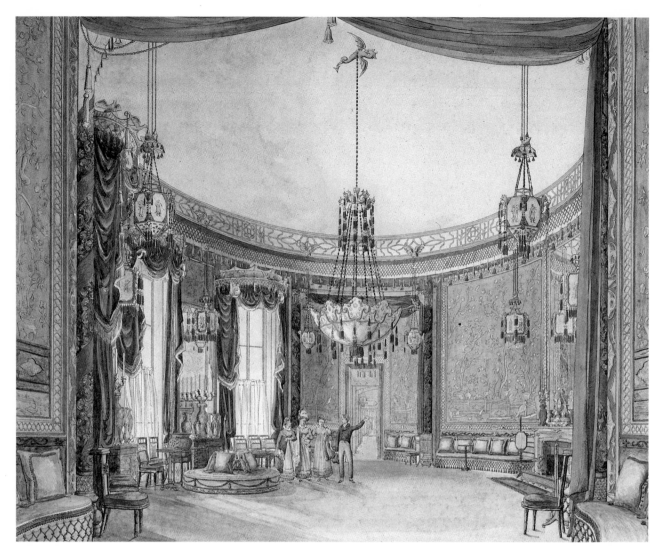

The second phase of the Saloon interior, from Nash's *Views*. The scheme was initiated in 1802 (see page 32).

painted with Chinese implements of war. Similar paintings with more peaceful embellishments were placed on the fretted yellow ground of the Small Drawing Room.

The new, angled extensions were round-ended. Deep, canopied windows filled the walls facing the Steine, merging house and garden in a way sanctioned by picturesque principles. The south extension was Conservatory-*cum*-Music Room, with a roof simulating boards of 'teawood' and rosewood seemingly supported on twenty red columns in the coils of twisting dragons, and large expanses of Chinese wallpaper. Poorly resistant to the elements, the room is said to have been seldom used, but the passage which joined it to the drawing-room struck every visitor with delight and astonishment. Twelve feet long, it suggested a huge Chinese lantern, and its side walls were frameworks for exquisitely painted glass, illuminated from without. The northern angled room was the Dining Room. Under the ceiling of clouds in a sky was probably a relatively simple scheme, which Creevey described as comfortless. But almost everywhere, in Lady Ilchester's words, 'the Chinese scene was gay beyond description.' Even the narrow corridors, with columns and ornaments and sky blue ceilings, imitated Chinese covered ways.

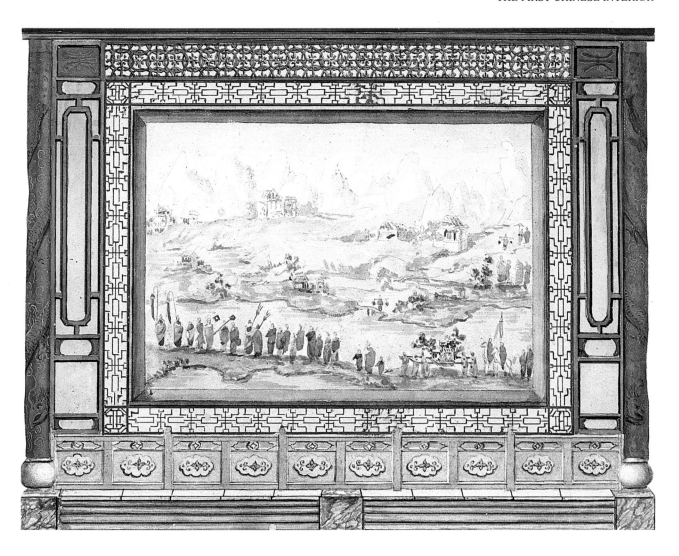

Of all these interiors, their intricate schemes glowing with intense and varnished colour like richly-enamelled vessels and hung everywhere with Chinese lanterns, it was the hitherto neo-classical Saloon upon which greatest attention was lavished. The chief features of what was established there by 1803 outlasted all the other 'Chinese' confections of the middle phase. Only in 1823, when the very final transformation scene was acted out, did it join the ranks of great lost rooms.

Three tall French windows looked out from the saloon upon the lawns and gardens and the fashionable Brighton promenaders. Everything else conspired to suggest an enchanting Chinese garden structure, like an arbour completely open to the sky, which filled the enormous domed ceiling. From it, and from the concealed half-domes of the recesses, hung large and brilliant Chinese lanterns. In front of a frieze and cornice elaborated in scarlet, blue, and yellow hung a yellow silk net (simulated in wood), weighted with bells and hangers. Above the frieze, projecting bamboo rods appeared to support a trellis encircling the ceiling, clearly a gigantic enlargement of the split-cane panels that adorned the imported bamboo furniture with which the Pavilion was by now well provided. Richly-painted dragon

A design by Crace, corresponding to a description of the Conservatory/Music Room in the angled south wing of the Pavilion which existed between 1801 and 1817.

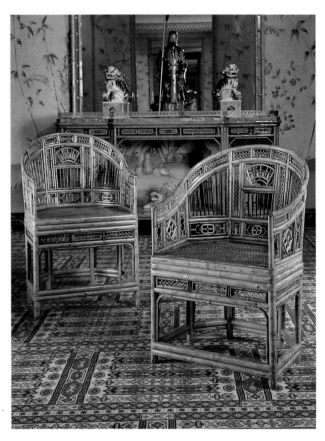

left
Bamboo chairs from the second phase. Of no special value in China, such furniture when imported into Europe was considered exotic and pretty. Within a house, it carried a suggestion of the informal pleasures of a garden pavilion.

right
Probably one of the thirty-six dining-room chairs made for the Pavilion by Elward Marsh and Tatham in 1802 — many designs, in simulated bamboo, were devised over the following twenty years. The quasi-oriental effect, far more robust than Chippendale 'Chinese', had already been attempted in both England and (by Georges Jacob) in France.

columns and patterned pilasters framed the recesses, and thoroughly Chinese-looking canopies were fixed above the windows. Nearer to the eye on the curved surfaces of the wall large bordered panels of Chinese blue-ground wallpaper filled with flowering trees in white and silver and birds in rich colours conjured up the Chinese garden of the imagination. This saloon was a vision of delight that the Prince preserved through nearly twenty turbulent years.

Throughout the Pavilion of this period the furnishings were fully in the spirit of the decorations. Repeated trips were made to London by the Crace firm to collect from the wharves of the East India Company every conceivable type of article of Chinese workmanship — lacquered cabinets and wallpaper, porcelain and mandarin figures, costumes, models of junks, curiosities such as birds nests and Chinese tobacco — selections of which were to be found in the cargoes brought back by Dr Garrett and other entrepreneurs. The equally exotic bamboo chairs and sofas of traditional Chinese type were similarly imported. All this lent considerable authenticity to the Pavilion scene, but there was no pedantry, for the London firm of Elward, Marsh and Tatham was called upon to supply furniture of simulated bamboo, more realistic in appearance than the 'Chinese' chairs of the earlier Chippendale period, but unmistakably English in outline. Thirty-six such chairs were supplied for the Dining Room in 1802. At least two of the side-tables which ended up in the corridor and perhaps other related furniture were also of this date.

The Search for an Eastern Face

In 1803 Holland finally withdrew from the Prince of Wales's patronage (never an unmixed blessing). The business of embodying the increasingly exotic imaginings of the Prince had passed in December 1802 to William Porden, a pupil of James Wyatt. His inventive gifts and exercises in the Gothic manner of his mentor won him at about the same time the commission to build, at Eaton Hall, a Gothic house that can be compared in fantasy and technological innovation with the Pavilion itself.

One of the schemes he designed for his new patron was a proposal for the further enlargement of the Pavilion in the Chinese style. Eastern and western elevations show how, had it been executed, Holland's building would have been preserved under an application of tall red Chinese columns, a profusion of lattice work, and an animated roofscape with upswept curves clad in Chinese tubular tiling and mounted with dragons and dolphins. Behind it, echoing the existing forms, would have been a range of much larger structures. The drawings show careful study of the pictorial records brought back by William Alexander from Lord Macartney's embassy. Yet for all its clever assimilation of Chinese conventions, the design seems not to have allayed the old misgivings concerning Chinese architecture. It was a final attempt to establish the Chinese taste in English domestic exteriors.

The western elevation was exhibited at the Royal Academy in 1806. It is quite possible, however, that these designs were by then three or four years old. A further drawing shows a long tripartite structure topped by an immense octagon 'pagoda', the centre part clearly devoted to a luxuriant conservatory. It is apparently a projection for a different building, very likely on the western grounds, most of which land, including a miniature Vauxhall pleasure gardens called the Promenade Grove, the Prince had acquired by 1803. It is hard to believe that these designs were conceived later than the building which began to arise along one side of the new land that year—the magnificent stable complex in which Porden introduced the romantic and unfamiliar outlines of Muslim India. The die was cast that was to stamp its impression on the future appearance of the Pavilion itself, although the choice of a suitable style was even then undecided.

The old stables adjoined the Pavilion to the south of the west front, and were modest enough. When the new accommodation was completed, it was acknowledged as one of the wonders of Europe, a very palace for horses. A two-storey circular structure, enclosed within an angled bay, and flanked by a long and lofty riding school to the west and a similar wing to the east intended for a tennis court, it was surmounted by a massive lantern-topped dome, of a shape suggesting the visible part of a perfect sphere. The dome was consciously modelled on the Halle au Blé in Paris, which on its erection in 1782 had been compared with the engineering achievements of ancient Rome.

The boldness of Porden's dome lay in its construction as a framework for glass, arranged in sixteen huge divisions tapering to the crown. Around this well-lit space opened forty-four stalls, with a grooms'

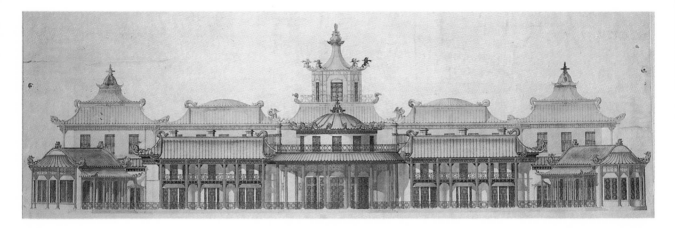

Porden's unexecuted design for the East Front of the Pavilion. The form of Holland's building can clearly be seen beneath the Chinese architectural dressing.

Porden's unexecuted design for an additional building with a conservatory.

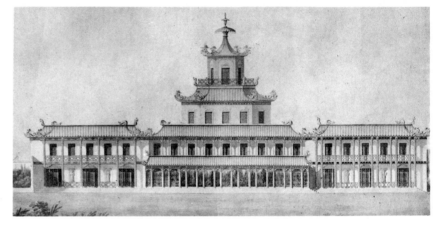

gallery above. Externally, the entire brick-faced complex was made remarkable by tall pinnacles, crenellations, and richly-scalloped heads to windows and to stucco architraves. All of these features could be seen by a select body of *cognoscenti* to derive from the Indian aquatints and paintings of William and Thomas Daniell, whose volumes of *Oriental Scenery* had begun to appear in 1795. The great Jami Masjid at Delhi was the source of many of the elements. Porden may have first known the Daniells as a consequence of his earlier association with Samuel Pepys Cockerell, who was architect, for his wealthy nabob brother, of the only great English house apart from the Royal Pavilion to be executed in an Indian style—Sezincote in Gloucestershire.

Sir Charles Cockerell's house and garden were the products of a scholarly and rapturous interest in the civilization of the great subcontinent which British arms and commerce were bringing to a state of subjugation. Unlike the Chinese taste, with its familiar associations of gaiety, wealth, and rank, the interest in India was the preserve of a serious-minded intellectual circle, alive to its thoroughly romantic potentialities. Of all the confederated styles of the picturesque movement, the Indian was always one of the most *recherché*. The Egyptian, boosted by the researches of Napoleon's archaeologists and popularized in furniture by such taste-makers as Thomas Hope, achieved a greater currency; it was considered to be a primitivist counterpart of the Greek, just as the Indian style, with some justice, was seen to have affinities with that other main contender for favour, the Gothic.

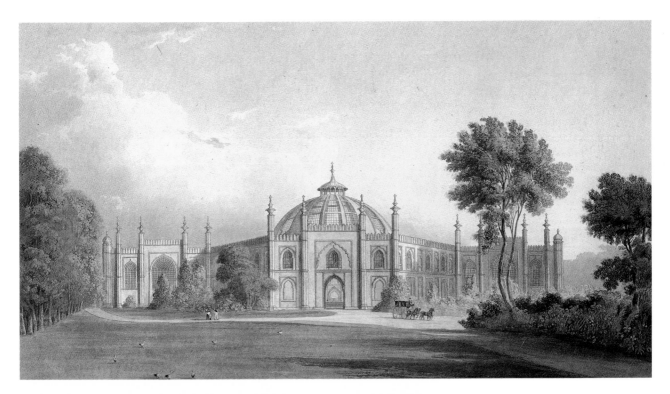

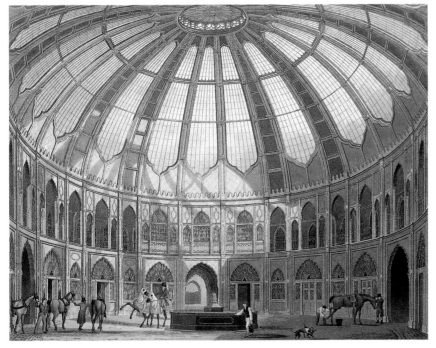

The stable buildings (built by Porden 1803-1808), from Nash's *Views:* '. . . like one of those Indian mausoleums in Daniell's Views. They are really very pretty.' (Samuel Rogers, 1808.)

The interior of the stables, from Nash's *Views*. The building is now a concert hall.

At Sezincote the Cockerells drew together the combined expertise of Thomas Daniell and the leading landscape improver Humphrey Repton to create an ensemble that by comparison with Nash's Pavilion is a conscientious tribute to Mughal architecture. The stone-built house is basically square in plan. From its centre rises a prominent Indian dome, while from behind it two low conservatory wings curve outwards to small hexagonal pavilions. On the main block a complex variety of window mouldings—hooded, scalloped, and recessed—the lantern-like *chattris,* the crenellations, and long verandah exhibit a

41

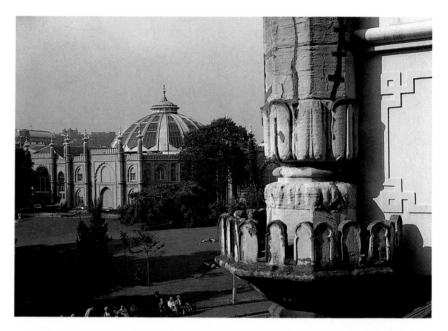

The stable group seen from the roof of the Royal Pavilion, where stonework awaiting restoration bears the marks of long exposure to sea winds.

The Jami' Masjid, from T. and W. Daniell's *Oriental Scenery* (1795-1808)

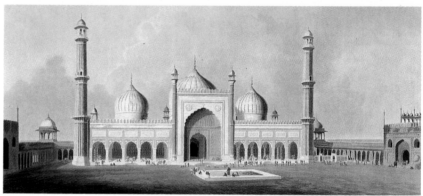

Sezincote, Gloucestershire—the other major building in England to be built in the Mughal style. Designed by S.P. Cockerell (of whom Porden had been a pupil) with detailed attention to Indian sources.

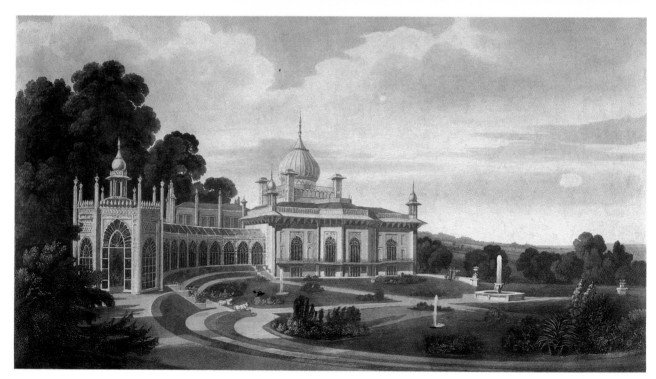

literal attention to their sources. Another feature, the projecting cornice or *chujjah*, reinforces with its deep shadow an impression of horizontality and weight that is quite absent in Nash's Pavilion.

A similar care was lavished upon the gardens, where an Indian temple, bridge, and ornamental pools were among the picturesque ingredients. The whole extraordinary enterprise is said to have been visited by the Prince while staying at Ragley, the seat of his friend Lord Hertford, whose wife was later to supplant Mrs Fitzherbert in the Prince's unstable affections. Whatever the case, Repton was summoned to Brighton in 1805, before the building of Sezincote was under way, in order to design a transformation of the Royal Pavilion in a similar idiom. The Prince was becoming gripped by a fascination with India. Exhibition of the Daniells' paintings at the Royal Academy and the publishing success of their aquatints formed only the crest of a wave of attention. William Hodges, Captain Cook's artist, had already published *Select Views in India* in 1785, whilst the discovery of Sanskrit literature and philosophy encouraged by Warren Hastings astonished readers in England and Europe. The epic *Bhagavad Gita,* the *Upanishads,* and the verse drama *Sakuntala* were translated by English orientalists, and seemed to promise a rich culture alternative to and possibly comparable with that of Greece. The significance of such revelations in the genesis of the high Romantic movement can hardly be overestimated. Through Goethe and Schlegel, Byron and Moore, and Coleridge the influence of Indian perceptions of the world was to enter the mainstream of European literature. One may surmise that accounts of the glittering pageantry of the Mughal Empire played an important part in the Prince's perceptions of India. Some of the propagandists emphasized the noble and sublime qualities to be found in Indian architecture, a message which would not have been lost upon the Prince, any more than the fact that the British monarch was now the virtual sovereign of large parts of the rich and mysterious land.

Humphry Repton placed at the Prince's disposal a comprehensive service of picturesque architecture and landscape gardening. His advice was a radical rethinking of the grounds and the enlargement of the Pavilion as an Indian Palace. The Prince was receptive. Repton wrote later of 'the elegance and facility of the Prince's own invention, joined to a rapidity of conception and correctness of taste which [he] had never before witnessed.' Indeed, his patron had got there before him with Porden's Mughal stables. 'I found in the gardens,' said Repton 'a stupendous and magnificent building which by its lightness, elegance, and boldness of construction and the symmetry of its proportion does credit to the artist and his Royal employer.' What Repton had to do was to solve the problem it had created. The low, discreet Pavilion was decidedly dwarfed by its palatial outbuilding. It was also a source of some irritation to the Prince that his horses were better housed than he was. Something had to be done, but the stylistic options were already reduced, for, as Repton agreed, 'neither the Grecian nor the Gothic style could be made to assimilate' with the new stables.

The plans were ready in February 1806 before Sezincote was finished, and were published in 1808 in a superlative edition of fine aquatints

An 'Indian' window on the stable façade.

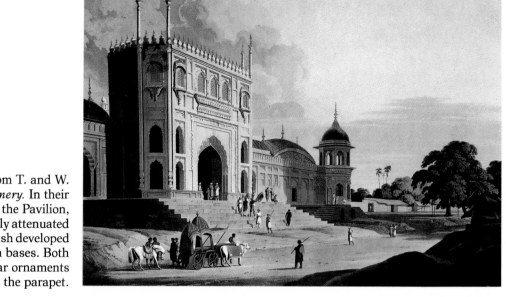

'Pillibead Mosque', from T. and W. Daniell's *Oriental Scenery*. In their respective designs for the Pavilion, Repton favoured similarly attenuated column shafts, while Nash developed the idea of leafy column bases. Both adopted the globular ornaments which appear upon the parapet.

with 'before and after' flaps. The Chinese rooms were to be kept, but ranged behind them would be, from the north, a vast entrance front and hall linked by an inner court to a massive turban-domed music-room. Overlooking the western gardens would be a second additional range with the three enormous dining-room windows in its centre. Virtually all the details derive from the Daniells' engravings, but impressive though the design is, there is something almost oppressively insistent in its effect. The one interior, the dining-room, is an ominous borrowing from a Hindu temple interior.

Repton was at his most ingenious in his plans for the gardens, having poured scorn on the existing attempts, recently executed by Lapidge, to make the five or six available acres into a landscaped park. The grounds, he wrote, should not reflect the pictures of Claude or Poussin, but 'the blended graces of Watteau, with the rich embellishments, variety and intricacy of a true garden' (an early indication perhaps of the rococo revival begun in the 1820s). It would be a perpetual garden surrounded by a continuous peripheral conservatory linking the house with the stables, the hothouses, and the pretty garden buildings such as the aviary and pheasantry, both witty adaptations from Indian temples.

The whole scheme for the Pavilion and its grounds was certainly formal by picturesque standards, but there was enchantment in it, and, in its interpenetration of architecture and nature, a unique realization of an ideal. Nevertheless, despite the Prince's fulsome response (he described it as perfect, and declared that he would put it into immediate execution), Repton was subjected to the cruel disappointment of seeing his plans gather dust upon the shelf. When the Prince's interest revived after a period of expensive new work at Carlton House and a chaotic episode in his emotional affairs, it was to Wyatt, and then Nash, that he turned his attention.

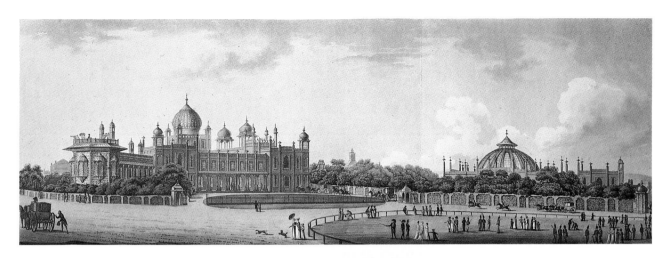

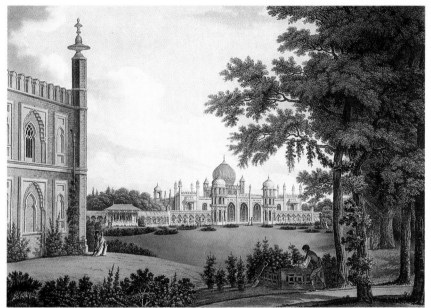

Northern view of the Pavilion as projected by Repton in 1805, from *Designs for the Pavilion, Brighton* (1808), in which Repton's technique of 'before and after' views is shown in a luxuriously printed form.

The western view from Repton's *Designs.* The glazed corridor which leads to the stables around both sides of the western grounds can be seen where it touches the Pavilion.

The western grounds, with their fanciful ornamental structures, as proposed in Repton's *Designs.*

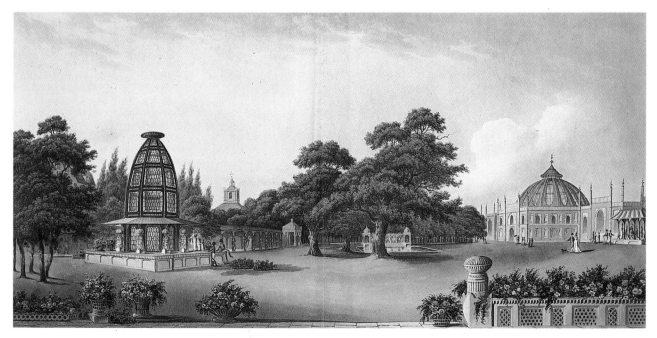

The Leader of the Parade

George III's appalling afflictions entered an acute phase in the last weeks of 1810 and his son was elevated to the long-awaited title of Prince Regent in February 1811. For the first months, the Prince's powers were limited, but from 1812 he was sovereign in all but name. He was fifty, and his personal life was as wretchedly unstable as it had ever been. Mrs Fitzherbert had long been abandoned. His recent efforts to collect evidence of his legal wife's immorality had steeped him in public odium; with Princess Charlotte, his adolescent daughter, he had only infrequent contact. For the country, at war with Napoleon's Empire without a break since 1804, it was a dangerous and critical time; the Peninsular War dragged on, while the Emperor's Continental System, designed to break British resolve, threatened to accomplish its purpose.

With the reins of power in his hands, constitutionally bound though they were, the Regent altered his political stance. In continuing the Tory ministry of his father, he made bitter enemies among the Whigs, who considered themselves cheated of their prize by a treacherous patron. But the Prince knew it was Tory determination in war that would glorify him with victory, and Tory faith in monarchy that would sustain him.

The Prince seems genuinely to have believed that his person and circumstances should be the embodiment of national glory and status. That his own character thirsted for splendour was, to him, beside the point. To others, his distinctly Bourbon conception of his role was clearly more appropriate to an absolutist state than to the oligarchical government and society of Great Britain, yet the idea of monarch as servant of the people was quite alien to him. He was continuously captivated by examples of royal magnificence. All of them, being outside his direct experience, glowed with exotic charm — Peking and Agra distinguished from Versailles only in that they were more dream-like and remote.

Nevertheless, while he was in no sense a populist, he perhaps understood, as his detractors did not, that his own love of pageantry and splendour was shared by the public, and was in tune with a basic human need for spectacle. His tactful royal successors have hugely benefited from the lead he set. His coronation in 1821, by far the most lavish this country had ever seen, brought him more popularity than any other of his actions.

Unquestionably the Prince was a true fantasist. In him one kind of fantasy justified another. He imagined that Britain's triumphs in the wars were the outcome of his personal efforts. When in 1815 he understood (mistakenly) that there was a surplus of £8,000,000 in the national coffers, he thought it only right that most of it should come to him in recognition of his great services to the country, among them, no doubt, his 'personal' appearance at the battle of Waterloo, a fiction with which he embarrassed even his most devoted hearers. How galling it must have been to him when Parliament voted £640,000 to build Wellington a palace, when every penny he himself received was

Though he was frequently savaged in popular prints, the Regent's conception of monarchical pride could also strike a responsive chord (1806).

grudged. He continued to spend his way to glory, ignoring criticism by insisting upon 'the dignity and splendour of the crown'. On becoming Regent, he spent the equivalent of a week's wages for 30,000 artisans on a splendid fête at Carlton House ('Sadler's Wells business' said one politician). In 1814 even more lavish celebrations, designed to impress the victorious allied sovereigns, took place there, followed by triumphant festivities, adorned with extravagant ornamental structures, for public enjoyment in St. James's and Green Park. The showman in him gathered strength. Indeed, in one of the great eras of stagecraft he exploited the theatrical vein of monarchy to an unprecedented degree.

For the long-running dramatic spectacular of his reign, stylish costumes, gilded ceremonial, and stirring music, the glittering assemblies of the fashionable, and even the dangerous groundswell of the impressionable mob, were the ingredients of success. So were the settings, and it was the Prince who provided them in a land so deprived of fine palaces that foreigners, accustomed to buildings of dazzling wonder in the tiniest German duchy, were known to scoff. St. James's was a creaking, if picturesque, jumble, Windsor a mostly medieval pile. Buckingham (the Queen's) House, before George IV, was like all the rest, quite unfitted for state occasions or in any way to reflect the tumultuous rise of Britain's power. Apart from Wyatt's aborted new palace at Kew, the last attempt at adequate Royal grandeur had been Inigo Jones' Whitehall Palace, uncompleted and later reduced by calamities. For long years the sovereign lords of Britain had by stages lost their appetite for architectural prestige, and thereby a powerful constituent of regal mystique.

Building to impress was one of George IV's special talents; his intuitive grasp of its importance to monarchy has since been justified. It was also an addiction. He built in high spirits and when he was debilitated, when he was in debt and when, more rarely, he was in funds. In his youth he created in Carlton House a palace of European luxury and style, and in later days encouraged Nash to cut through the warren of London streets a noble thoroughfare, of proportions never before seen in England, to make an architectural parade from Carlton House to Regent's Park. His declining years brought comfort

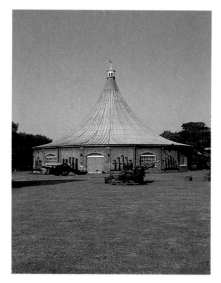

A twelve-sided ballroom, designed by Nash and Sir William Congreve for the Carlton House Victory Fête of 1814, was later transferred to Woolwich Arsenal. There is a clear similarity to the tent roofs on the Royal Pavilion.

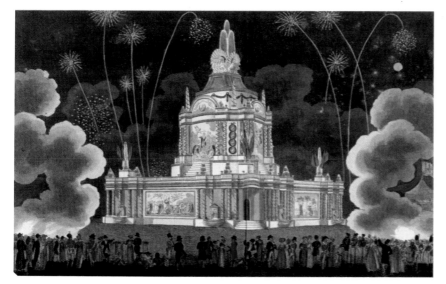

Napoleon's defeat was a perfect excuse for the sort of spectacle that Prince and populace adored and solemn persons despised. In August 1814 a mock castle in Green Park, London, disappeared in a cloud of smoke, revealing an illuminated Temple of Concord from which fireworks were lit. A Chinese bridge adorned St. James's Park.

47

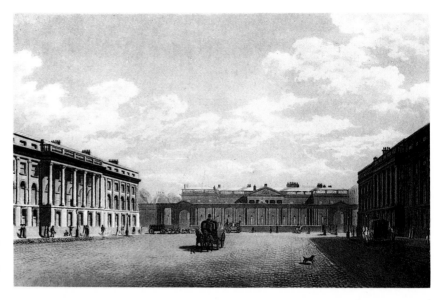

Waterloo Place facing Carlton House. Nash's triumphal route from Carlton House to Regent's Park introduced an unfamiliar note of grandeur in the appearance of London.

and Gothic romance to Windsor Castle, and the grandiloquence of Buckingham Palace.

Nothing, however, engrossed him so much and for so long as the Pavilion at Brighton, for which no reasons of state could be adduced. While he lived, the Pavilion was never the property of the Crown, but the personal indulgence, strange and disturbing to the English, of an *ancien régime* prince.

His enterprise at Brighton naturally enough gave him in public opinion the character of an oriental potentate. The eventual Indian character of the exterior was not to emerge until 1817, but the luxurious interior work in the Chinese taste reinforced this notion. In June 1816 a Whig Member of Parliament hoped that the House would 'hear no more of that squandrous and lavish profusion, which in a certain quarter resembles more the pomp and magnificence of a Persian satrap seated in all the splendour of oriental state than the sober dignity of a British Prince, seated in the bosom of his subjects.' There was a great deal of truth in all this, but nothing that would unnerve a Prince for whom the Eastern Empires were synonymous with the voluptuous luxury and enchantment to which he aspired. In time, the gathering of accurate knowledge would disappoint the drawing-room romantics of the West, but perhaps because of a sense that this process was already in train, the long literature of European travellers' tales represented a peculiarly intoxicating draught for the imaginative thirsts of the Prince Regent's time.

Strangely the Prince was almost alone in expressing in architectural form the essence that, in this period of the 'renascence of Wonder', had not only excited such poets as Southey and Byron, but had been for years the resource of masquerades and the theatre, (where popular success was almost assured for productions such as *Rama Droogh* and *The Rose of Gurgistan*). However, to the Prince Regent, Eastern magnificence is likely to have stood for the assertion of monarchical privileges, above the flux of argument, in a time of revolution political, intellectual, and economic. Provocative perhaps, but also a talisman of protective power.

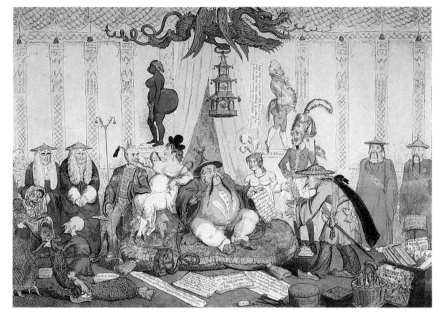

The Court at Brighton à la Chinese!!! by Cruikshank (1816). The Oriental potentate is the Prince Regent, ordering his ambassador, Lord Amherst, to 'get fresh patterns of Chinese deformities to finish the decorations of ye Pavilion.' Lady Hertford, his current favourite, lies on one side, his daughter Princess Charlotte and her future husband, Prince Leopold, stand on the other.

Oriental splendour possessed the 'singularity' that fashion encouraged and his nature increasingly required—a singularity more pronounced even than James Wyatt's gargantuan exercise in the Gothic-sublime at Fonthill Abbey, or Porden's very different Gothic fantasy for Lord Grosvenor at Eaton Hall. This shared with Thomas Hope's Indian, Egyptian, and scholarly classical rooms at Duchess Street the schemes of deep and rich colour which were widely adopted during the Regency and which looked so good in the light of the new Argand burners or yet newer gas jets. These demonstrations of the individuality of a man of taste were joined by many other claimants of attention—the pseudo-Norman extravaganza at Penrhyn for the slate-enriched Richard Pennant, the Louis XIV revival interiors at Belvoir for the Duke of Rutland, friend of the Prince Regent, as well as the multifarious castle-Gothic and 'Tudor' houses, whose styles, associated with ancient families, and increasingly authentic in detail, were to become such important vehicles of Victorian social distinction and taste for privacy.

In one sense Regency England resembled a transformation scene, where the lingering ideal of a classical golden age merged and faded into the nineteenth-century belief in perfectibility. In another, the pace of change had the explosive acceleration of one of Congreve's rockets. But the immensely varied background of inventiveness and extravagance against which the Royal Pavilion took shape was illuminated everywhere by romantic excitement. It should therefore be no surprise that such pyrotechnic activity, in which the Prince fully participated, should also beget a nostalgia for the past and for fantasy, just as when the Middle Ages drew to a close there was an upsurge in the outward forms of chivalry and a spate of fantastic castle-building.

The Prince Regent's virtuoso displays call to mind in their inspiration the fanciful châteaux, such as the famous Mehun, depicted in the *Tres Riches Heures* of the fifteenth-century Duc de Berry, or Henry VIII's staging of the Field of the Cloth of Gold. Indeed Henry VIII was the one English royal builder with whom George IV can be

The Camelopard. A giraffe presented to George IV by the Pasha of Egypt in 1827 seemed an apt symbol of the King's interest in exotic novelty. This caricature also depicts Lady Conyngham, the last of his female companions and much resented by the public for her alleged avarice.

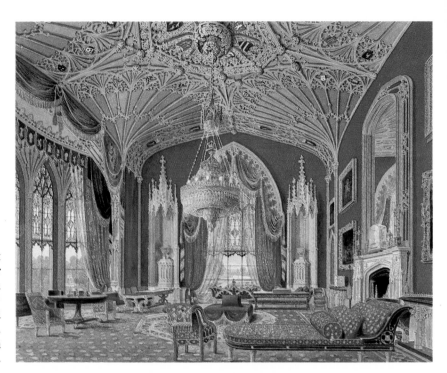

The Drawing Room, Eaton Hall, built by Porden (1802-26) and later demolished, was in many ways a Gothic counterpart of the Pavilion — in its fantasy, lavish brilliance and its use of new building techniques. The sofa in the foreground is now in Brighton Museum.

Nonsuch Palace, Surrey — a byword for fantasy in sixteenth-century England.

compared. Of his many palaces, the now-vanished Nonsuch (aptly named), with its skyline of turrets and pinnacles and its fabulous exterior adornments, might be seen as the Pavilion's true, Tudor, analogue.

The Architect and his Method

In 1812, when James Wyatt, the Crown's Surveyor-General, was commissioned to enlarge the Pavilion, his estimate of the cost was a substantial £100,000 for who knows what Gothic or classical extravaganza. Whatever grand visions the Prince and Wyatt may have shared, and nothing remains to indicate their character, they were to come to nothing when Wyatt fatally succumbed to the hazards of carriage transport in December 1813. John Nash must have been called in almost immediately to take over the reins of the Prince's architectural imagination, for the Royal accounts show that he completed a modest amount of the work begun by Wyatt.

A combination of circumstances, partly of his own ambitious making, had given Nash an advantageous position at exactly the right time. It seems almost inevitable that he and his royal patron, both of them architectural visionaries, should have come together. From somewhat mysterious, even shady, beginnings in London and Wales, Nash had emerged in the early years of the century, already in his fifties, as the leading architect of picturesque country houses. While he was making his name he was in partnership with Humphry Repton, a fact not without irony in view of the subsequent history of the Pavilion. Schooled by Sir Robert Taylor in the Palladian inheritance, he could turn his hand to almost any style—advanced Franco-classical (Caledon, Southgate Grove), picturesque Italian (Cronkhill with its round Tuscan towers), Tudor ogival domes (Aqualate), Elizabethan (Ingestre), and Jacobean (Hale). He was perhaps chiefly known for his numerous essays in castellar Gothic, such as Luscombe Castle and Knepp Castle, in particular for the adaptable way in which he realized the principles of theorists of the picturesque such as Sir Uvedale Price and Richard Payne Knight, with whom at one time he had close dealings. Always eager to make use of the latest developments in building technology, he made sure, even in the late 1790s that he had a reputation (only partly merited) in the use of cast iron construction, which he had used in the gallery at Corsham and for an iron bridge in Staffordshire. Government patronage came to him in 1806 when he was appointed architect to the Office of Woods and Forests: it was in this capacity that in 1812 he drew up the scheme for Regent's Park that

John Nash, by Sir Thomas Lawrence (1825). The portrait belonged to Nash himself.

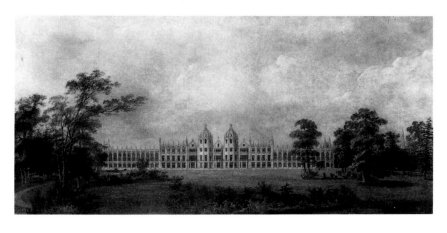

Nash proposed alternative designs for the remodelling of the Carlton House garden front in about 1816. This Tudor Gothic version is somewhat reminiscent of the Pavilion in general effect. The other design was classical, but neither was executed.

51

so captured the Prince's imagination. By 1813 he was playing a courtier's role at Carlton House, acting as a useful intermediary in the Prince's political affairs. This suggests not only a measure of tact in someone who had been described as impudent, but the opportunism and self-confidence that were among his chief characteristics. He was ready to put his extrovert, buccaneer style, and his willingness to take risks, at the disposal of the Prince. It did him no harm whatsoever in that quarter. In 1813 we find Nash rebuilding the Royal Lodge in Windsor Park as a large thatched *cottage orné,* and preparing estimates for the remodelling of four rooms in Carlton House, two of them Roman and two Gothic.

In Brighton Nash completed what must have been a considerable amount of work in 1814. We can only guess its nature, but it was probably confined to Marlborough House. In June 1814 the visit of the Allied Sovereigns included appearances at the Pavilion by the Tsar of Russia and the King of Prussia, and in August Queen Charlotte came to stay there with her son for the first time. Nash now took the opportunity to make his only recorded visit to Paris.

An important meeting took place on 24 January 1815 between Nash and the Prince, at Brighton. It was perhaps then that the great project first began to take shape, yet it is very unclear when a conception in any way resembling the final Indian exterior developed. No exterior feature in any of Nash's additions of 1815 seems even to have whispered of the Eastern world. The first presentiments were the great tent-like 'pagoda' roofs of the two impressive rooms which replaced the angled

The plan of the ground floor, from Nash's *Views.*

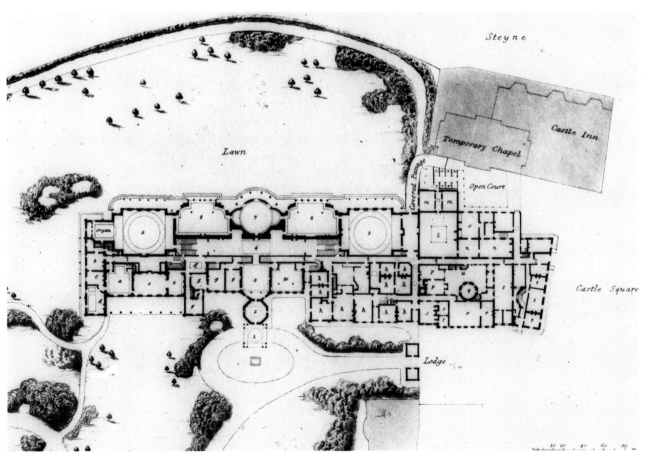

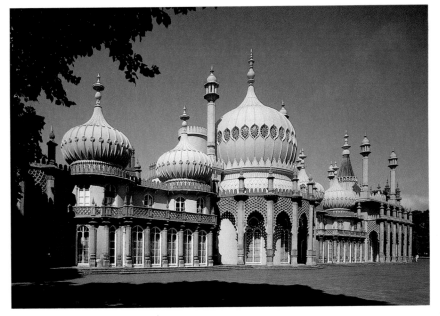

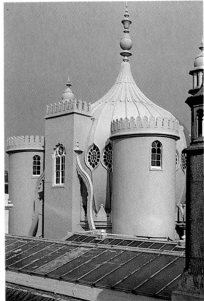

wings in 1817, although a highly perceptive individual may have speculated upon the appearance in the previous year of £61-worth of windows to correspond with those of the 'riding house'.

Despite Nash's assertion that the choice of an oriental character had been a continuous factor, it seems unlikely that this crystallized in any way before well into 1816. Not until 14 November 1815 was Nash lent from the Library at Carlton House four volumes of Daniell's *Oriental Scenery,* for the purpose of 'making drawings for the Pavilion'. These illustrations may have been an inspiration, but only in a rather general way. Nash may have owed just as much to Repton's designs, which were based on the same sources.

For the basic structure and the interior planning, Nash drew not upon exotic sources at all, but upon two currents of ideas which were much more in the architectural mainstream of the time—the neo-classical and the picturesque. At first glance, nothing seems to have less in common with the neo-classical mode, whose romantic streak is often forgotten, than the pragmatic, associational movement known as the picturesque. Common to them both, however, was a liberating opportunity to design in terms of mass and volume and function, instead of subjugating interior arrangements to the demands of the façade.

The picturesque, almost by definition concerned with scenic, often illusionistic effect above all things, was the perfect medium for Nash's qualities—his flair for drama, his impatience with conventions, his desire to please, his opportunism. In spite of his observation in the projected preface to the published *Views* that those who are 'led to add to old houses . . . purpose to do but little but they are led on from one desirable object to the other till not unfrequently it would have been cheaper and generally wiser to have rebuilt the whole', it is hard to believe that Nash did not relish the problems provided by the existing structure. The procedure also suited the Prince. A significant thread in the story of his building activities is his fondness for early associations, the impulse to conserve as well as to renew.

left
The East Front—all the ground-floor windows open onto the lawn.

right
The meeting of Indian and Gothic—the dome over the Saloon with its curious flying buttresses supporting the chimney stack. One of the circular turrets is a staircase.

When the Octagon, or Outer, Hall was added, Nash adapted the structure of the Entrance Hall. Two columns permit ample lighting while supporting the wall of the upper storeys.

Nash began his operations, and was to continue them, in an entirely clear-headed manner. He could see that the first requirement was for a communicating apartment which was spacious, socially useful, and interesting in itself, in place of the narrow corridors opening off the entrance hall. This, the present Corridor, forms a unifying spine to the lower floor, permitting easy and visually delightful access to both drawing-rooms, linking the two great rooms that Nash was soon to add at each end, and rising by means of terminal double-staircases to the chamber floor. It also allowed a more satisfactory management of the sequence, in which, if we compare it to a menu, we are now given an appropriate *hors d'œuvre* before the main course.

Spinal galleries had been a speciality of Nash ever since his remodelling of Corsham House near Bath in 1798. In them he had made early constructional use of cast iron: in the Pavilion Corridor cast-iron frames make possible the three large skylights as well as the airy bamboo fantasy of the staircases. These, with their playful bamboo balusters, were cast in London by William Slarke, one of Nash's future lessees in Regent Street, and hoisted into position by September 1815. Each led up to skylit ante-rooms, off which opened the existing eastern bedrooms (the Prince's apartment on the south, those of the Dukes of York and Clarence on the north) and the new bedrooms to the west.

The new entrance hall made necessary by the building of the Corridor was a taller affair than the present hall—twenty-four feet high, with a gallery above the entrance to the Corridor. It was painted by the firm of Crace in panels of imitation green and pink marble, supposedly Chinese in feeling, and was entered under a portico, described at the time as of the Doric order: another version, it seems, of what was there before. Nash was not yet ready in 1815 to hoist the Indian banner.

The west façade at this stage still rose without interruption in two storeys; the ground-floor rooms, squashed by a servant's passage between them and the Corridor, were subsequently extended forward,

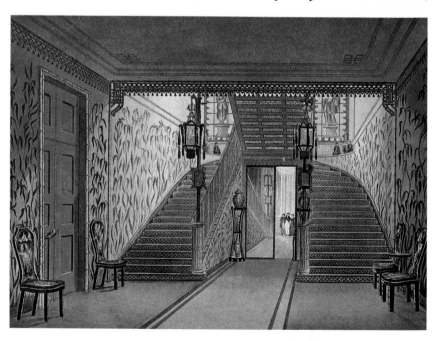

The Northern end of the Corridor as decorated in 1815, from Nash's *Views*.

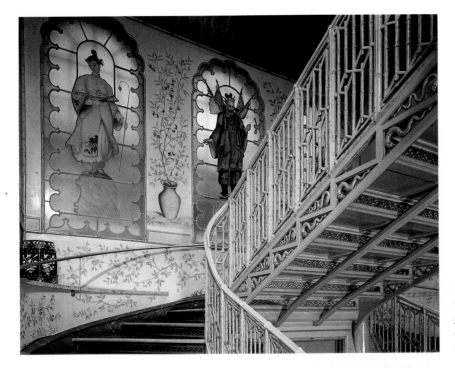

Cast-iron 'bamboo' lends to the Corridor staircases the charm of a garden pavilion. The stairs are made even more light and open by the use of iron for their structure.

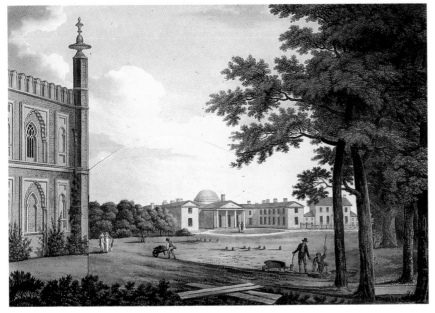

The West or Entrance Front of the Pavilion as it appeared in 1805, from Repton's *Designs*. It was probably little changed until Nash began work in 1814.

while within them were placed columnar iron supports for the upper walls. One of these rooms achieved a distinctive charm as the Red Drawing Room.

Marlborough House, adjoining the Pavilion on the north, had been linked with it since its purchase in 1812. Extensively adapted, it now provided much-needed rooms of sufficient splendour for the entertainment of the most illustrious visitors. A sumptuous dinner was given here for the Grand Duke Michael of Russia as late as September 1818, well after the new Music Room, which involved the partial demolition of Marlborough House, was structurally complete.

But long before the new Banqueting Room was serviceable, perhaps towards the end of 1818, the splendid new kitchens were ready and

The Great Kitchen fireplace; power
for the spits is from a revolving vane
in the chimney.

waiting (Madame de Boigne mentions their apparatus in 1817): they
were the product of Nash's second full year's work in 1816, in which
he utilized the site of the old stables. Clustering around the Great
Kitchen, with its superb equipment, lighting, and ventilation, were
subsidiary rooms for culinary preparations and storage, and an
impressive water tower embellished by a clock visible from Castle
Square.

The two large new rooms now put into effect as grander replacements
for the two angled rooms built in 1802 were Nash's most prominent
contributions to the interior of the building. Circumstances no longer
impeded an arrangement in line with both the enfilade and the new
Corridor; the Banqueting Room, and at the other extremity the Music
Room, opened into each. Apart from significant differences in the
apparent support of their domes, both were fundamentally identical
in design—forty feet square, with lateral extensions, and twenty feet
high from floor to cornice. They represent Nash's first exercise in the
kind of palatial interior he was to devise for Buckingham Palace in the
1820s. Technically, the design is inventive and artful. The effects are
those of daring ingenuity of vaulting and a marked simplicity. In the
Banqueting Room a ceiling of dome and cove seems to rest upon four
flattened arches of little depth containing the clerestory windows and
descending to meet at narrow points. The walls below give no hint of
great solidity. That two sides of the room extend outwards under

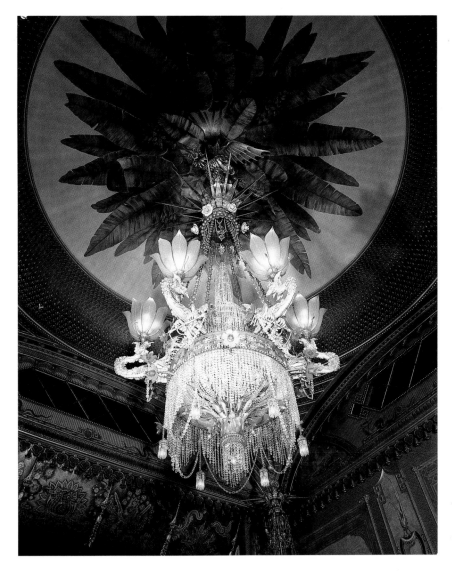

The dramatic ceiling of the Banqueting Room with the great chandelier, or lustre, first lit by gas in December 1821.

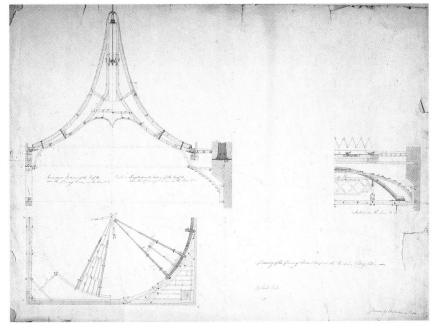

A measured drawing of 1827 by William Nixon, the Clerk of Works, showing the structure of the Banqueting Room roof.

57

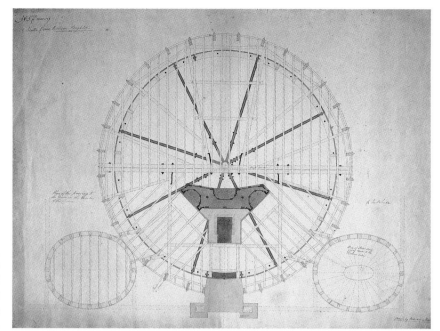

A plan of the structure of the Saloon dome at a level which shows the cast-iron support for the fireplaces of a large, oval billiard-room and two others. Before completion, they were remodelled as bedrooms.

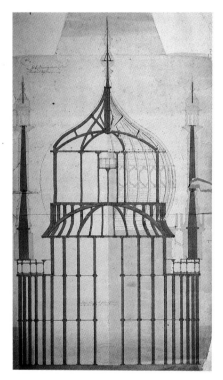

The superimposed cast-iron framework supporting the Saloon dome (W.Nixon, 1827). In 1818 Nash referred to 'the very difficult and unusual work we are performing this year.'

convex canopies which ostensibly hang from the cornice furthers the illusion of a light construction. In fact the flattened arches conceal strong segmental arches of iron-sleeved brick for which the angles of the room form substantial supports. These concealed arches carry the thrust of the conical superstructure, a soaring timber framework, from which the dome is suspended, standing upon a flat ring of cast iron. The Banqueting and Music Rooms were built in 1817.

Even more enterprising was a quite extraordinary engineering spectacle enacted before passers-by in the summer of 1818 — the erection of the Pavilion's centrepiece, the great dome over the Saloon. The Prince made a special journey from London to witness the event. There was no question of simply building upwards, as Holland's structure was not built with strength to spare. A radical solution was required, but not, as it happened, an entire rebuilding. Astonishingly, the original fabric and current decoration of the Saloon survived the transformation virtually intact.

It is possible that the Regent was especially attached to this room (just as later he was to ask that Buckingham Palace not be built on any other site but that of the original house, since 'early associations endear me to the spot'), or it may be that the excitement of the challenge was an inspiration in itself. Whatever the explanation, Nash succeeded in building a huge iron cage, around and outside the walls, on which to support the iron framework of the dome. This was daring indeed, in the very forefront of the technology of the time, and, we may suppose, achieved as much by judgement as by science. Nash had perhaps been much impressed by Bélanger's pioneering use of cast-iron ribs for the re-roofing of the fire-damaged Halle au Blé in Paris in 1809. In Nash's dome, the resultant structure was sufficiently strong and stable to permit three rooms, including an oval billiard room, all with fireplaces, attainable by a turret staircase. On each side, a tall Bath stone minaret with an iron core was positioned upon an iron cradle.

During 1819 the eastern lawns continued to serve as a noisy building

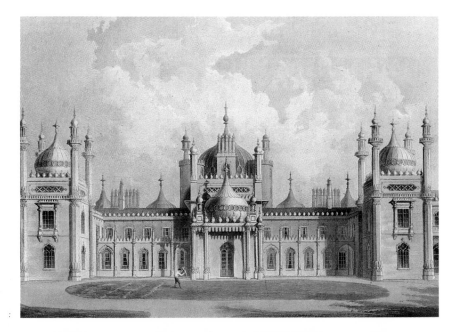

The picturesque massing of the entrance section of the West Front, from Nash's *Views.* The stucco was scored and tinted to resemble Bath stone blocks.

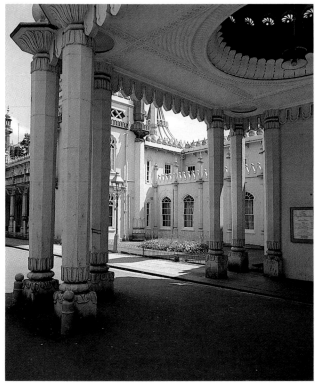

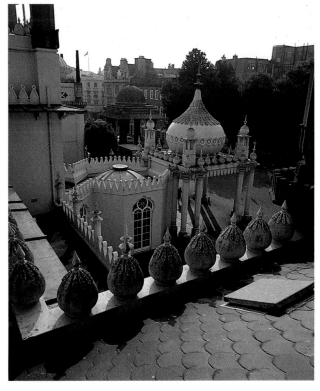

site. In that year the bulk of the Bath stone tracery, columns, and ornaments, was fashioned and installed, and further minarets and smaller domes completed. While this work continued, the West Front received attention. Holland's old wings still remained, flanking a court now partly filled by Nash's extensions of 1815. What took place here was not a direct application of oriental dress in the manner of the east façade. There is evidence of second thoughts, and of the weakness produced by developing one range of building (the eastern) in isolation. However, the functional problems that faced Nash were solved by some of his most inspired strokes, and although some of the beauties of

right
The entrance, from the roof of the original north wing. The slates are shaped in a fish-scale pattern.

left
Inside the porte-cochère, looking towards the rooms originally occupied by the King's private secretary, and the bedrooms above.

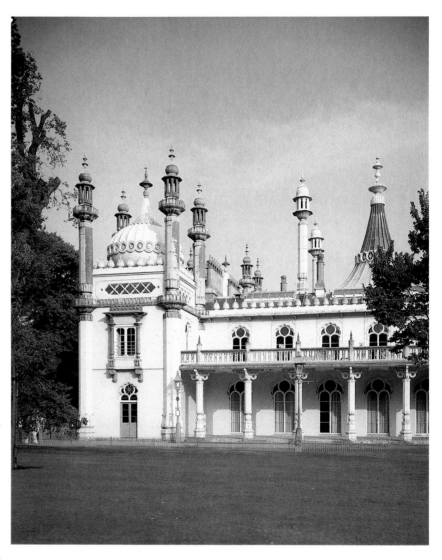

The northern end of the West Front, in which the King's Apartment opens into a loggia. With the demolition of the old kitchen on this site, and of Marlborough House behind, Nash's design was unimpeded by existing buildings.

this section are adventitious, this after all was one of the bonuses of picturesque architecture.

The west bedrooms remained undisturbed, but the rooms below were extended forward. The hall ceiling was lowered and two bedroom storeys built above it; in front, in place of the imposing portico, were added two small structures of disingenuous charm—a porte-cochère fringed with a stucco valance and surmounted by a dome, and a tiny octagonal vestibule with a tent ceiling—both wittily reminiscent of the pretty garden pavilions to which the rest of the building could now only glancingly refer.

The complex centrepiece, a pile of masses of varying size decked with a variety of oriental ornament and rising to the turreted Saloon dome behind, is typical of the way Nash in his Gothic houses had added to old buildings and capitalized upon the picturesqueness of the ensuing medley.

The final demolition of Marlborough House provided a clean sheet in 1819 for an extension to the north and its return to the East Front. Behind those two new façades and their projecting stone verandahs were built bedrooms above and a new apartment for the Prince below. It was approached from the end of the Corridor, through an ample

vestibule or ante-room, toplit and set with applied Chinese pictures on its yellow walls. From the vestibule also led a circular stair to the upper floor corridors, the entire communication lined with a Chinese paper painted with figures, some of which still remains in place.

A corresponding range of building at the south-west was never executed, so with this north-west extension Nash's work at Brighton was virtually complete by the end of 1820, apart from the stone-faced window bays for the altered drawing-rooms on the east. Within a short time his relations with his patron, now King George IV, were temporarily soured by the failure of the mastic composition roofs, the beginning of a tale of water penetration that has kept the guardians of the building on their toes ever since. The problem lay in the properties of a new material which had been used extensively in the surfacing of the domes, walls, roofs, and ornaments. Dihl mastic, as it was known, was one of the patent stuccos that had been developed to answer the need for stone-like rendering, which was so widely used from the time of Adam until it began to be deprecated as deceitful by Victorian opinion. This particular variant contained linseed oil, which must have given it much of the liveliness of Bath stone, but probably, in drying, left the substance permeable. The tent roofs were re-covered in copper as early as 1827, but not until considerable damage had been done to the interior decorations. Before this, the entire exterior surface, where it was not embellished with real Bath stone columns and ornaments, resembled that material in texture and colour.

On flat areas, the stucco was scored in block shapes individually streaked with colour, a laborious procedure used also in the Regent's Park Terraces and elsewhere. When newly executed, it must have been among the most striking examples of the imitative arts, but the difficulties of cleaning and renewal led to its early abandonment, and with it a most important element in the Pavilion's appearance.

The extraordinary pains that were taken to produce the effects of solid masonry blocks extended even to the real stone minarets, in which hollowed out rings were lowered over the bolted cast-iron cores. It was a most unusual method of construction, perfectly solid until the cores began to rust and expand, and yet another illustration of Nash's infatuation with iron as the great construction material of the age. There was also extensive use of sheet iron as a mastic-covered skin for the domes and tent-roofs; it may have been favoured for its properties of stability as well as the fire resistance for which it had been promoted in the spate of theatre building which began in the 1790s.

Nash was sensitive to suggestions that he had resorted, in the building of the Pavilion, to experimental techniques — 'inconsiderate conduct' as the King's private secretary Sir W. Knighton wrote. Yet Nash was undoubtedly operating, in many cases, on the borders of existing technology. In the reconstruction of the Saloon alone, he may lay claim to one of the earliest instances in domestic building of a cast-iron frame construction.

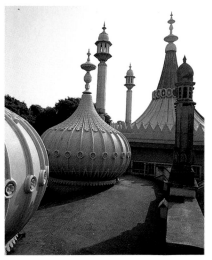

above
The 'tent' roofs of the Banqueting and Music Rooms were covered in copper in 1827, after their covering of patent mastic stucco had proved a miserable failure.

below
Twin minor domes over each drawing-room wing have no function except for their role in the visual harmony of Nash's design.

The Nash Transformation

Nash's brilliant achievement on the East Front was to accept the existing structure and find ingenious and exciting means not only of transforming the façade into a picturesque oriental fantasy, but also of lending it a greater sense of unity than before, both reinforced and made more subtle by his incorporation of high new rooms at either end. If we glance again at Holland's façade, the early Pavilion with its three units seems by comparison unintegrated. A heightened impression of this feeling may be had from the fascinating view in May 1818 of the same Front with Nash's new rooms added, but as yet without the traceried colonnades, an image reminiscent of a row of Regency villas, each one built in a different style.

To make a convincing whole from such ingredients was a challenge perfectly suited to an architect with Nash's instinct for dramatic effect. It is true that in the Regent's Park terraces this sometimes led to a kind of scenographic illusion, but whatever Nash did elsewhere, the East Front of the Royal Pavilion exhibits a true grasp of three-dimensional form, in which a sophisticated harmony of cubes, spheres, cones, and cylinders is worked out. In great baroque churches, such as Les Invalides and St Paul's, complex combinations of these elements tend to produce a sensation of great controlled power. In the Pavilion Nash responds to the more modern fascination with purer geometrical shapes that had already appeared in the work of Piranesi and Ledoux.

The grandest gestures are on the roof—the huge inflated dome at the centre, the sagging circular tent-roofs at each end with soaring minarets around them, and the smaller domes between and beyond. It is a skyline composed entirely of sweeps and curves and points, the three highest finials marking the apexes of intersecting triangles, one of the chief effects used to give to the long, relatively low building a repeated upward movement. The tent-roofs (suggestive of Chinese structures, but also of Western military tents) may sag like cloth, but their outline is an accelerating curve; the Mughal domes, made less solid by vertical ribbing, seem to be restrained from rising like so many early air balloons.

The body of the building was made to co-operate in this upward

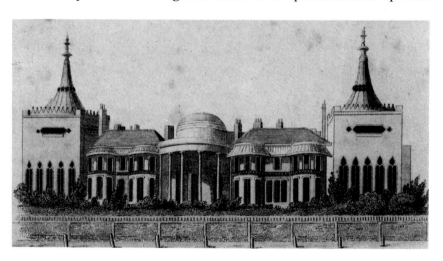

An intermediate stage (May 1818) of the East Front.

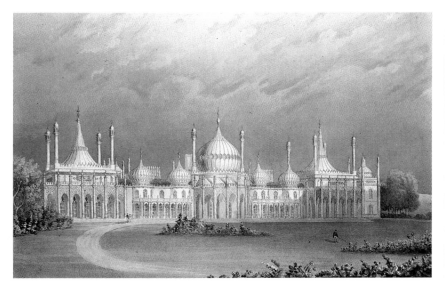

movement, and in assimilating the five equally broad sections of the façade Nash negotiated the dangers of emphasizing the earthbound nature of the building. He imposed a harmony of vertical accents, alternating high and low groups of columns along the façade. The effect is to intensify the upright characteristics, and we find that the sole horizontal element to run full length is the course of Islamic crenellation, a smaller version of that used by Porden on the stable complex.

The Saloon in the centre and the Music and Banqueting Rooms at the ends are, all three, fronted by high colonnades, partly dissolved by one of Nash's happiest introductions, the perforated screen. This is a tracery of quatrefoils rising in a network of graceful double curves, generated by the Islamic arches between the columns. The principle is partly derived from the *jalis,* which provided both shade and ventilation in the hot Indian sun, and is later to be found elsewhere in England in the form of cast-iron *brise-soleils,* notably in the seafront colonnades at Brighton.

Between each of the three lofty single rooms sits a low block of two storeys. Holland's bow fronts remain on the bedroom floor, while below Nash's final sophisticated alteration pulls forward the recessed centre into a straight screen of five almost art nouveau windows, divided by small 'Indian' pilasters; these continue upwards as finials to punctuate a traceried balustrade. In each two-storeyed block the curvature of the Saloon and the straight collonading found in the outer great divisions are thus combined.

The foreignness of many of its features is striking, but transposed into the company of actual Indian monuments the Pavilion would still seem strange. The East Front is dignified but not solemn; it is marked by movement and playfulness, and it is far less Indian in spirit than either Sezincote or Repton's proposed design. For most of the oriental details Nash need have looked no further than Repton's work. Here he could find slender minarets up which no muezzin could climb, octagonal columns, deep eaves or *Chujjahs,* cusped arches, Islamic battlements, leaf capitals, and plinths, brackets and globular ornaments for the cornices. Nash's domes, of three subtly differing profiles, are ultimately derived from Mughal building of the seventeenth and

left
A perspective view of the East Front, from Nash's *Views.*

right
In combining the two bays of each drawing-room into one columnar bay, Nash's work was virtually complete by 1821. The window heads show the Pavilion's 'Indian' style in a highly sophisticated form, a premonition of art nouveau designs seventy years later.

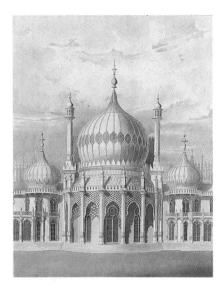

left
Exterior of the Saloon, from Nash's
Views.

right
The graceful tracery suggests Indian
jali work without direct reference to
it. There is also a hint of the draped
nets of cord used in Regency soft
furnishings.

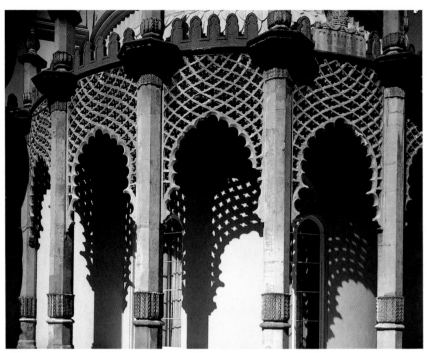

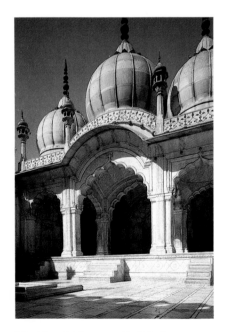

The Pearl Mosque, Delhi. A seven-
teenth-century Mughal model for the
Pavilion domes.

eighteenth centuries, post-dating the Taj Mahal.

It is not a long list, but all these features help to transport us to a
half-sensed distant land of the imagination, more magically and with
more seeming authenticity than if a similar shape and outline had been
achieved with the Perpendicular Gothic and Tudor vocabulary of
ogival domes, spires, chimneys, towers, and tracery that was already
in Nash's repertoire. It is a measure of the unfamiliarity of the shapes
and ornaments that attention is first directed to the variety of the
East Front rather than to its unity, to which the fundamentally archi-
tectural use of embellishment greatly contributes.

There is much here that Nash had already made trademarks of his
architectural practice — the predilection for loggias, the screens with
recessed upper floors, the castellated turrets, the squashed attic lights,
and the broad treatment of ornament, as with the triangular features
which form coronets around the bases of the great dome and the
tent-roofs, and which may owe their inspiration to similar ormolu
adornments on George IV's chinoiserie furnishings.

Holland had made of the West Front something quite different from
the East. Nash made no effort to bring it into line. As we have seen,
he progressively extended the building here until little was left of the
projecting wings. What remained of each terminated in a domed tower
with engaged 'Indian' corner columns continuing above the battlemented
frieze as minarets. At this high level a version of the now familiar
elongated lozenge forms the horizontal window. The towers are repeated
at the corners of Nash's late northern extension, but a corresponding
southern 'improvement' was never executed. To the north of the entrance
group, then, is a seven-bay block with a full-length loggia supporting
a verandah recessed between two towers. A short northern façade
similar to this but without a recess presents that very quality of lightly
elaborated simplicity that many pretty Regency houses possess.

When the metamorphosis of the Pavilion was complete, its appearance to many onlookers was so challenging, so alien, that they found the effort of appropriate response too demanding. It was easier to be facetious, to find in the proliferations of uncompromisingly oriental domes and minarets features which betokened not princely dignity but only a frivolous inclination to what was both otiose and bizarre. In many of the published comments both by uninformed observers and by distinguished figures of the time there runs a strain of moral disapproval, as if the Pavilion had provided a ready symbol of everything in the new King's behaviour that affronted his right-minded subjects.

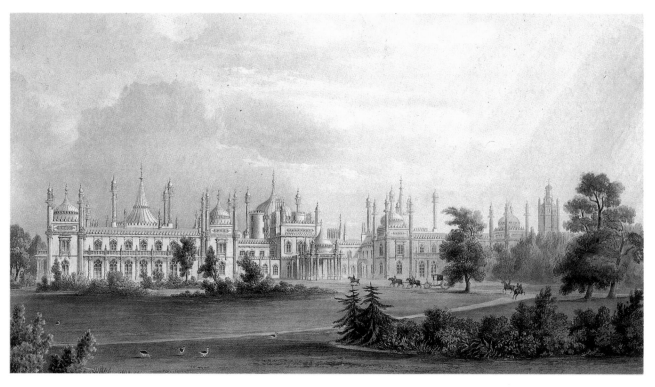

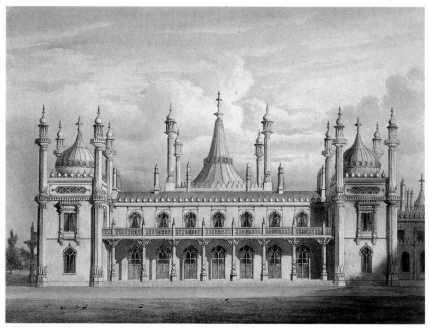

Nash complemented the high romanticism of the West Front with a design for parkland scenery. Repton had considered the grounds too small for such effects, but Nash's brilliant planting scheme provides for a setting of picturesque vistas and an illusion of great extent. From Nash's *Views*.

Facing west, the King's Apartment with household apartments above. The lower room, extreme left, was the King's Bathroom. From Nash's *Views*.

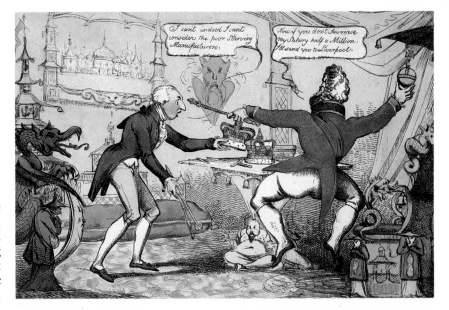

New Baubles for the Chinese Temple . . . (1820). To George IV, much of the charm of kingship resided in an increased income. Knowing perfectly well how he would spend it Parliament, in a time of economic straits, begrudged him his 'reward'.

The short Northern Front which links the King's Apartment to the Music Room on the east, from Pugin's evocative watercolours done in preparation for Nash's *Views.*

The 'Rotas Gur', from the Daniells' *Views of Oriental Scenery.* The combination of loggia and oriel windows may well have inspired Nash's design for the north-west extension.

Within a few years however, these reactions subsided and many more favourable opinions began to be expressed, coincident with the fading hostility to the King, especially where it had been most venomous, in London. The outrage is not so difficult to understand. As the final lotus capitals were being hoisted into place and the last of the domes built over its framework of timber and iron, a severe agricultural depression was gathering force, with all its implications for the economic and social life of a nation already disturbed by the effects of the Napoleonic wars. The dislocation and misery engendered by the furious course of the Industrial Revolution was in turn fuelling the fires of Radical politicians, writers, and agitators. The unprecedented scandal of the King's divorce proceedings and the defendant's unedifying campaign to take her place as Queen of England, to the extent of attempting to gatecrash the Coronation ceremony, were welcome gifts for political opportunists. Nor did it help the King's public face that his architect had himself attracted derision in proportion to the energy with which he prepared his schemes. His showy ingenuity, his entrepreneurship, the scale of his enterprises, his cocky personality — the whole devastating combination signified someone who was too clever

Beauties of Brighton, 1826. George Cruikshank after 'A.Crowquill Esq.' The newly completed Pavilion was naturally seen as all of a piece with such fantastic parades in what was then the most fashionable town in Europe.

by half. Not that the King or Nash had designed to ingratiate themselves with the general public: but even those broadly sympathetic to the King must have reminded themselves of the horrors that, not long before, had befallen another kingdom in which the pleasure principle had been the most conspicuous impulse of its rulers.

Perhaps it is surprising that anyone outside the King's own circle was receptive to what had been created in Brighton. The Pavilion's imaginative and elusive strengths are closely related to those of Romantic poetry (an illuminating insight of Clifford Musgrave, and one of those observations which, once made, seem obvious), although neither Shelley nor Byron would have wished to endorse it (Byron specifically disparaged it) any more than Thomas Daniell might have seen the Pavilion as a tribute to his illustrative work. His verdict in fact was that 'if the architect aimed at an imitation of Oriental architecture, it is to be lamented that he trusted so implicitly to conjecture.'

In the comparative quiet of the next few years, when the carefully coloured stucco still resembled blocks of stone and the golden Bath stone columns and tracery were fresh and crisp, there were those who with curiosity, some knowledge and an open heart, examined the Pavilion from this side and that, in the mysterious light of dawn, in the clear light of the channel sun, and in the glowing colours and shades of dusk, and felt its enchantment. Had they known it ten years before, they would still have recognized the shape of Holland's villa beneath the exotic dress in which Nash the magician had clothed it.

Designers and Craftsmen

The firm of Crace had been associated with the Prince's activities in Brighton from the very first. John Crace was closely associated with Henry Holland, and must have been well acquainted, through him, with the London community of French decorators that Holland cultivated. It was among Whig circles that he found much of his clientele—there was even a family link when his son Frederick married the daughter of John Gregory, Secretary of the Whig Club. His father had been Keeper of the King's pictures and his successors enjoyed prominence as leaders in their field throughout most of the nineteenth century.

It was to Crace that the Prince turned in 1802 when he embarked upon the comprehensive redecoration of the Pavilion in the Chinese taste. Even in this early phase it is clear that the twenty-four year old Frederick was taking a leading part in the work. In the final phases between 1815 and 1822 it was he, as a mature and experienced decorator, who was given an unparelleled opportunity for his formidable and fertile talents. A rich group of coloured drawings in the Cooper Hewitt Museum, New York, shows some of the preliminary work for both phases, much of it never executed and some of it relating to decorations otherwise unrecorded. In these detailed drawings by several hands we can observe the evolution of a distinctive federation of styles, highly tuned to the Prince's requirements, where the bizarre forms and patterns of Chinese decoration are assimilated with the movement and fancy of rococo convention, and with the weightier influence of

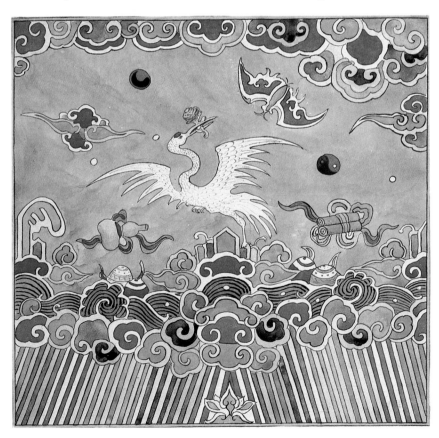

A design from a Crace album at the Royal Pavilion. Many of the preparatory designs seem to derive from Chinese embroidered textiles or decorated porcelain.

68

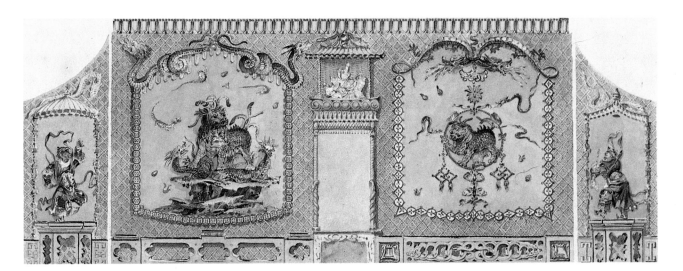

the French Empire style. It was a difficult path to tread, beset with the traps into which much of Victorian decoration was to fall, but the period in which these harmonious schemes were achieved was still one in which eighteenth-century grace and refinement exerted themselves upon interior design. These were the very qualities that all Adam's novelties of colour and archaeological borrowing never obscured, nor even James Wyatt's development of the 'Etruscan' style at Heaton Hall, where Biagio Rebecca's grotesqueries and richly resonating colours in the Cupola Room foreshadow many of Crace's effects in the Pavilion's middle years. Over this treacherous ground the Prince's guiding hand is evident from a comparison of alternative designs; ultimately it was his well-schooled eye which imposed the necessary discipline upon the potentially stupefying variety of new and strange ideas.

Frederick Crace is known to have been an engaging and energetic man, and we may guess that he both inspired the confidence of the Prince and was patient in the face of what must have been infuriating changes of mind, let alone the uncertainty of payment. Even account books suggest the urgency with which he and his assistants were summoned from London to discuss designs and pin patterns to the walls. It was always a collaborative effort. Few patrons can have taken a more active part in the planning and in the fastidious detail of the rooms, but we can only speculate upon the nature of the confabulations between the Prince, Crace, and Nash as the Pavilion took shape in these last years.

The anonymity of most of the executants is regrettable. Especially in the later work, the skills employed were of an impressively high standard. At one point Crace had forty-four assistants working on the complexities of the Music Room, which occupied him from December 1817 to October 1819. Only one name rises a little above obscurity, a 'Lambelet' who worked upon the great red and gold landscapes in the Music Room, and returned to paint replacements when Queen Victoria sold the Pavilion. The name suggests a French origin, and there were perhaps many others of similar background, exiles or sons of exiles. J. Watier, House Steward to the Prince Regent and also a Frenchman, seems to have had the administrative task of arranging the work between the various firms, subject always to the direct intervention of his master.

One of the rejected designs by Crace for the decoration of the Music Room, c.1817.

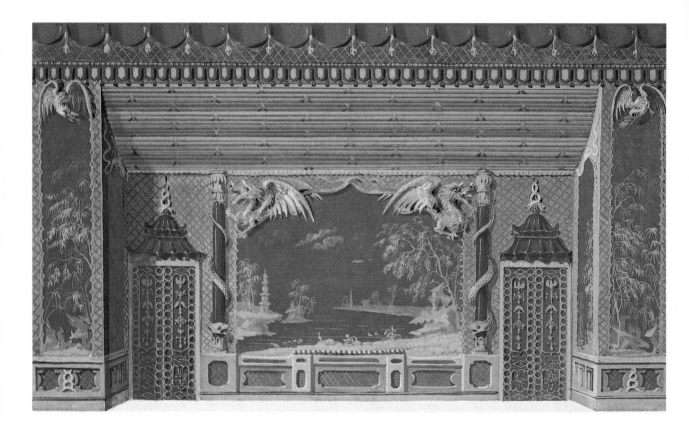

One of Crace's final designs for the Music Room decorations, for which a variety of proposals were made. '. . . the ampleness which [the Chinese style] affords for a display of richness and variety in form and colour unfettered by the severity of rule that pervades all classical art. [It] exercises the imagination of our native artists.' (*The Forget-me-Not*, 1826).

Compared with the 1802-4 period, when Crace had carried out many tasks beyond painting—acquiring furniture, curios, china and pictures, making lanterns, even attending to the fires—there was much greater specialization in the later phase. Besides the gilding of ornaments, Crace offered all the wide-ranging skills of the decorative artist—the flatting or varnishing of painted surfaces, marbling, graining, ornamental enrichment and the deceptive arts of shadowing and *trompe l'œil*, as well as figurative painting.

In the last years Crace was not to have the field of design and decoration to himself. Another figure emerged, shadowy to us, but clearly of outstanding gifts, perhaps greater than Crace's. This was Robert Jones, who first appeared in August 1815, when the Crace accounts record that nineteen panels in the Entrance Hall were applied with painting by 'Mr Jones'; they were almost immediately removed. In December 1817, however, he was summoned with Crace to discuss arrangements for the division of work on the rooms. To him fell the plum commission of the Banqueting Room, followed by the Red Drawing Room, the King's new apartment on the ground floor, and finally the redecoration of the Saloon. Contemporary references to 'Robert Jones Esq.' indicate a high professional status, certainly equal to that of Crace.

It would be satisfying to know more of Jones, whose work in Brighton shows him to be one of the finest and most versatile decorative artists of his time. His name, extraordinary to say, has not yet been associated with any other building. What then recommended him to the Prince? A plausible suggestion made by Clifford Smith is that he may be the 'Mr Jones of Covent Garden Theatre', described by the *Dictionary of*

Robert Jones's signed drawing (1823) for the eastern wall of the Saloon.

Architecture as 'the son of Richard Jones, an eminent architect and surveyor'. This should not surprise us, for a new brilliance in the arts of staging and design attracted artists of considerable gifts to the London theatre community of the time. The Prince's intense interest in the theatre is well known, and it was the scenic staff of Covent Garden who decorated the spectacular Temple of Concord in Green Park in August 1814. There are other possible clues. A Robert Jones illustrated in 1804 a volume of interest to the orientalist, entitled *The Costume of Turkey,* whose engravings hint at the figurative panels in the Banqueting Room. There was also a silversmith of the same name whose dates correspond, and who should be considered. J.J. Boileau, one of Holland's French artists who carried out decorative painting at Carlton House and elsewhere, has been shown to have been a prominent designer of silver. This very versatility is pronounced in Jones, who was as happy in designs for ormolu mounts as he was in figure painting, furniture, and every other ornamental medium. Jones executed designs for much of the work in Crace's rooms that involved metal mouldings, and it was perhaps Jones' powerful sense of modelling that won him the task of designing the Music Room's dragon chimneypiece, a monumental conception in marble and ormolu.

The largest expenditure, inevitably, was with the upholsterers Bailey and Saunders, successors through Tatham and Bailey of Elward Marsh and Tatham who figure strongly in the earlier furnishings of the Pavilion. In an age which witnessed the ascendency of the upholsterer in interior decoration, it was this firm which provided a remarkably wide range of services, either directly or by sub-contract, to designs provided mostly by Crace or Jones. It undertook not only seat furniture, drapery, and carpets, but all the various branches of cabinet makers' and carvers' work, including most of the superb wooden ornaments which the decorators were to gild or paint. Probably many of the designs for the furniture executed by the firm were originated by its own designers.

Other important firms of craftsmen directly engaged by the Prince's Household, most of whom had already worked on Carlton House,

Panel from a door in the Entrance Hall. Graining of great variety and accomplishment is a characteristic feature of the Pavilion interiors.

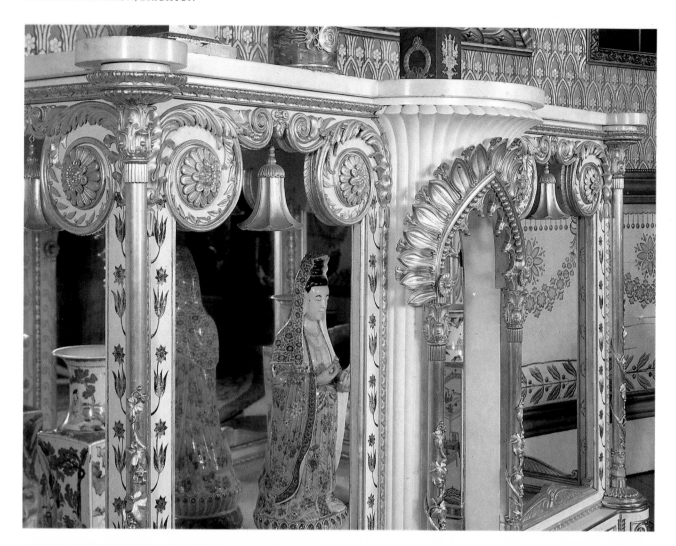

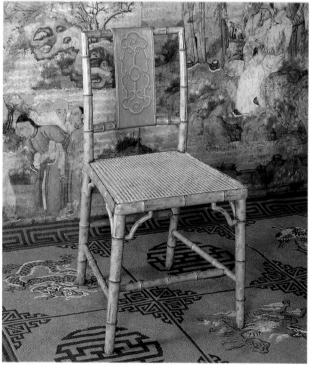

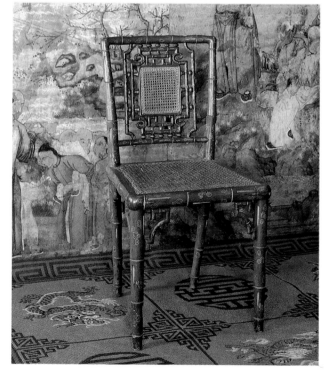

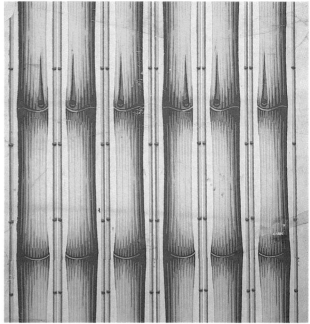

this page
Samples and fragments of wallpapers in many designs have survived; some cannot be associated with known schemes. Designs of bamboo, intended to be cut and applied in strips, were used particularly in the upper rooms.

opposite
A detail of one of the set of cabinets, with mounts in ormolu and carved and gilt wood, and additional orna-ments in glazed colours over silver leaf. Designed by Jones for the final version of the Saloon. (*below left*) A chair in beechwood, shaped and painted to imitate bamboo. The splat imitates leather. These chairs, with tasselled leather squabs, were used in the bedrooms and were probably made for the later, rather than the original, chinoiserie schemes. (*below right*) Another chair in simulated bamboo (colour not original) of a design intended for use as easily portable seating, perhaps in the Music Room.

were Fricker and Henderson, gilders and carvers; Robson and Hale, paperhangers, who supplied an immense variety of wallpapers in patterns from bamboo trellis to floral ornament, especially in the upper rooms of the Pavilion; Perry & Co., who had the daunting job of translating into reality the designs for the lustres (chandeliers) in the Banqueting and Music Rooms as well as others of less complex construction; Vulliamy, clock and ormolu manufacturer; Westmacott, the sculptor, who supplied marble chimneypieces; and Ashlin and Collins, manufacturers, by the laborious and expensive methods of that time, of the Pavilion's many looking-glasses.

The Pavilion Completed

With most of the building works completed, George IV moved out of his lodgings in Marlborough Row ('no bigger than a parrot's cage' said Princess Lieven) and renewed his residence in the Pavilion on 2 January 1821. Still to come were the King's Apartment, the Red Drawing Room, and a totally new look for the Saloon and its flanking drawing-rooms. The new entrance suite was ready, and so were the Music and Banqueting Rooms, where a majestic decorative style fitting to the dignity of the proprietor had been initiated. The King stood at the head of European monarchs, victor of the struggle against Napoleon's imperial pretensions, the sovereign of a world power — ingenious, glorious Britain.

Out, then, went the somewhat hectic gaiety of the earlier schemes, to be replaced by a more strongly modulated drama and an opulence invested with considerable serenity. The punning relationship between indoors and out, the wit, and the affection for the now-transmuted older modes, remained.

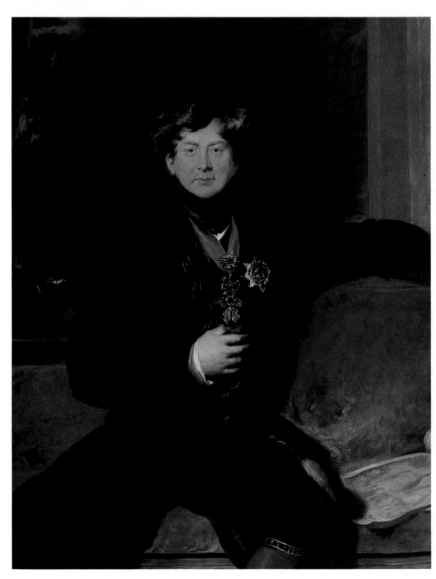

King George IV, by Sir Thomas Lawrence. Several examples of this portrait exist (one in Brighton Museum); this one, done for Nash, is of interest in that it shows a sketch of the Pavilion beside the King.

74

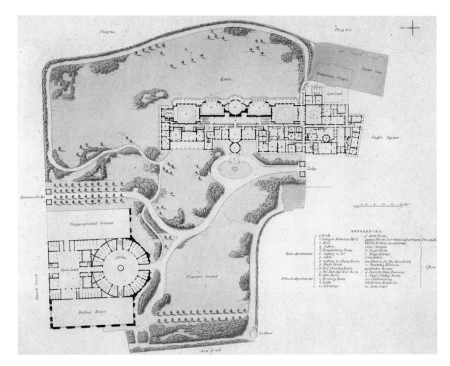

The plan of the Royal Pavilion as completed by Nash in 1822. The buildings not in oriental style, containing offices, services and accommodation, to the right of the red line, were demolished after 1850. From Nash's *Views*.

The Octagon and Entrance Halls

Let us imagine a guest entering the completed Pavilion for the first time, at six o'clock on a summer's day in 1823. The early evening sun has begun to suffuse the stuccoed West Front, its clear, enlivening light enhancing with brilliance and shadows the suggestion of a castle of the romantic imagination, of no specific time or place. The sound of hooves and wheel-churned gravel subsides as the carriage draws up under the small *porte-cochère* and the visitor is helped to alight.

Glass doors admit the visitor to the Outer Entrance Hall, of the octagonal shape frequently used by Nash in his Gothic houses. The simple moulded panels which form the sides and the elaborate reticulation of the cove and ceiling signify that this is a plaster tent, a garden pavilion through whose floor-length windows may be seen the shaved lawns and flower beds and through which the sun floods. It is simply furnished against the pink walls and grained woodwork—a few hall chairs, some painted arm chairs with the rounded edges and solid forms of the better class of Chinese furniture (and probably made for an earlier phase of the Pavilion), a mahogany side-table, and a fireplace of glistening brass. The suggestion of Eastern fantasy is not strong, but the gentle wit of the entry-place stimulates a sense of expectancy.

Through the window-like aperture on the far side, the visitor steps on to the plain grey carpet of the Inner Entrance Hall, completed in 1820. The preceding octagon has ingeniously allowed good lighting through the canted French windows on the near side, supplemented by a long row of painted glass windows at a higher level.

This final version of the Hall, replacing its loftier predecessor with its decoration of imitation Chinese marble in green and pink, is predominantly a cool green box. It has the effect of a peppermint taken to clear the palate. Again there is nothing overwhelmingly strange about it; it could almost pass for the hall of a relatively modest man of taste, although the echo-less softness of fitted carpet and heavy curtains in

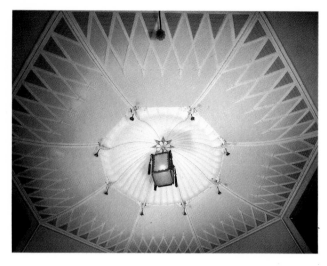

The ceiling of the Octagon, or Outer Entrance Hall.

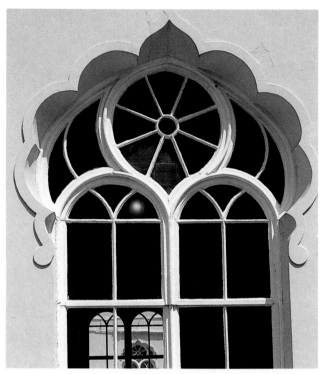

A window in the Octagon Hall.

The Octagon Hall. French windows
give it the character of a comfortable
marquee. From Nash's *Views*.

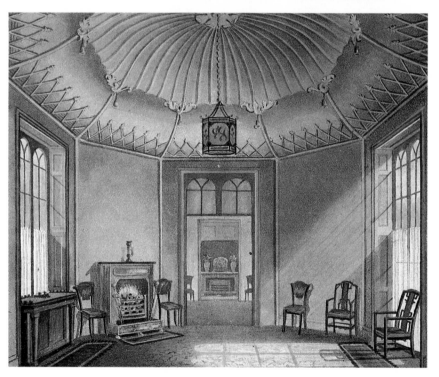

pea-green broadcloth make an early promise of the Pavilion's comforts.

Below the very Nashean cornice of miniature vaulting are the expanses
of the quiet green fashionable in halls of the period, here set off by
superbly grained doors and window cases in imitation of pollarded
oak. Walls of imitation marble perhaps done in scagliola might have
been expected here, but in fact they are surfaced with paper on stretched
canvas, a method used elsewhere in the building. On them appear large
roundels and tall panels painted in relief. It is a kind of grisaille orna-

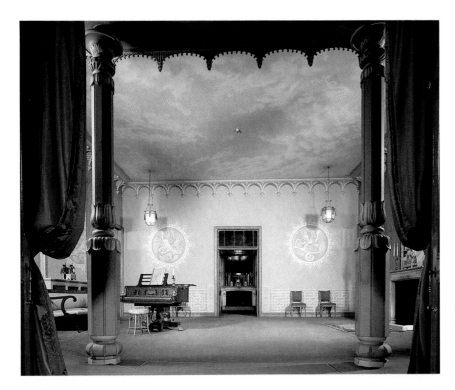

The Entrance Hall without its original furniture, but nevertheless close to its appearance when completed. The missing globe-like lanterns will be reconstructed.

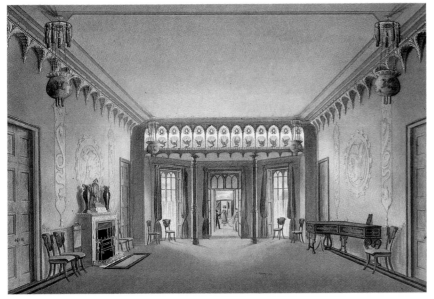

The Entrance Hall, from Nash's *Views*. Such visual records are one of the chief keys to the continuing work of restoration.

mentation, but done in the reticent greens and white of the room as a whole. Some attention is required to perceive in these panels robustly exotic dragons. Painted dragons, too, originally adorned the row of windows above the entrance, and decorated globular hanging lamps at the corners of the ceiling which made another kind of light show at dusk.

Disposed around the edges of the room were a set of particularly luxurious sabre-leg hall chairs with scroll framed backs and upholstered in green leather. Nash's View shows also the finest of the pianos associated with the Pavilion, a Tomkison, exquisitely inlaid with florid buhl work and with elaborately carved supports. One can only imagine on what occasions it was used here, but its presence announces the importance of music in the life of the Pavilion. On the white marble

chimneypiece (the only original to survive *in situ*) carved with chinoiseries by Westmacott, another persistent theme is introduced by the rich *garniture de cheminée* — a pair of oriental vases mounted in rococo ormolu, on each side of a splendid French clock.

The Corridor

The Corridor, or Long Gallery, is a long enclosed space, lit through painted glass skylights by day and painted 'Chinese' lanterns and lamps by night. The largest skylight pierces the upper floor in the centre, and similar ones admit light above the staircases at each end.

Once through the discreet opening from the Hall, the visitor is plunged straight into the most vividly oriental interior in the whole of the Pavilion. It offered at one stroke an elegantly practical access to all the important rooms whilst incorporating Holland's legacy of generally low ceilings. There was a clear division into five compartments by means of narrow trellises of imitation bamboo (still incompletely restored) projecting from the walls and the ceilings.

It could not but have recalled the sixteenth-century long galleries in which contemporary taste was taking a revived interest, but its chief effect was to establish without equivocation the Chinese theme that was played out in so many varieties of scale and feeling elsewhere in the building. The contemporary onlooker would feel as if he had

The Corridor, or Long Gallery. The hexagonal lanterns, with painted ground glass panels, enamelled copper tablets and silk tassels, are close to their Chinese models. Similar lanterns were used in many parts of the building from 1802 onwards.

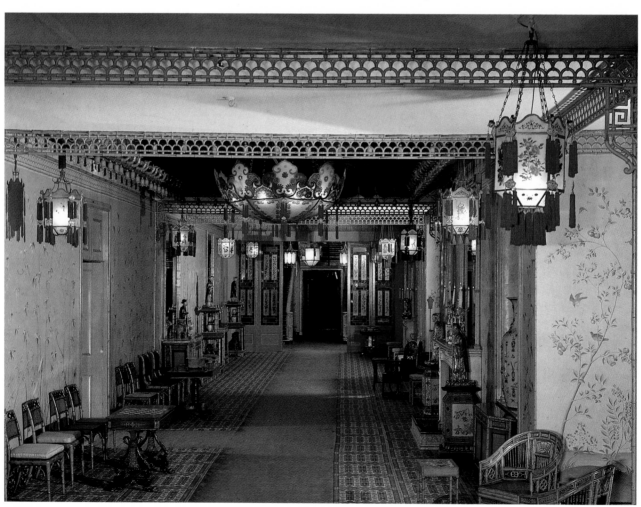

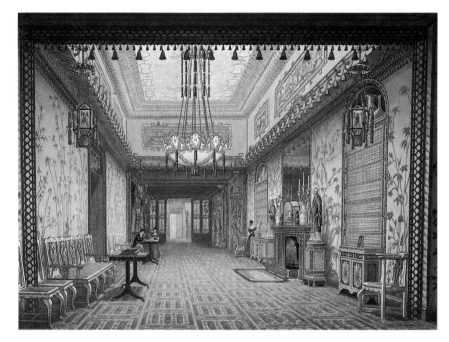

The Corridor in its final phase, from Nash's *Views.*

been transported to a genuine Chinese interior; wherever he looked his eyes would light upon bamboo in an extraordinary number of uses and forms and imitations (most remarkably in the double stair-cases—*tours de force* in cast-iron imitation bamboo), on Chinese porcelain and plaster composition figures, and upon minutely painted Chinese lanterns. The risks of claustrophobia would surely have been more marked were it not for the great length of the gallery and the delightful vistas offered at each end and in the recesses.

A particularly strong recollection which may have come to mind was of something neither Elizabethan nor essentially Chinese but well within the experience of the Prince's own generation of pleasure-seekers. The stretched canvas ground of the walls on all sides was given up to a continuous mural of waving bamboo interspersed with birds and garden ornaments, all in light blue against an intense sunset pink—a bamboo grove gaily lit by lanterns. The scene must have recalled the Promenade Groves of Vauxhall Gardens in which the young Prince of Wales, despite his father's strictures, took such frequent delight. Such a grove, in miniature, had in the 1790s been one of the attractions of Brighton, too, until it was closed in 1802 to make way for the building of the stables. Moreover, the Corridor was an internal promenade.

More remains here of the early chinoiserie flavour of the Pavilion than in any other area, even though the modifications made in 1822 were towards stateliness and greater calm. The real Chinese bamboo chairs and imitation bamboo furniture which had been brought here from other parts of the house when the Corridor was created in 1815 were largely replaced by the suite of Madras-made ivory-faced furniture, of a Chippendale style. The bizarre 'Chinese' standards that held lanterns were banished, the life-sized dressed Mandarin figures that occupied niches beside the three imitation bamboo chimneypieces were replaced by bookshelves. Weighty octagonal pedestals of carved and painted wood, inset with split cane mounts and flat panels of yellow ground Spode china, were substituted for the early flimsy

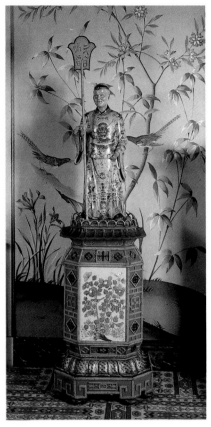

left
One of the six octagonal pedestals in pairs flanking the chimneypieces. The Chinese export mandarin figures are in painted composition.

right
The central compartment of the Corridor ceiling. Similar skylights illuminate the cast-iron 'bamboo' staircases at each end.

'bamboo' stands. On the floor a Brussels weave carpet of geometric 'oriental' design in square repeats brought a greater unity to the whole.

The decorative scheme, however, remained essentially the same. The most prominent feature, the central skylight, eighteen feet by eleven, has its glazing bars arranged in the shape of Crace's Chinese devices, colourfully painted with dragons, flowers, and, in pride of place, the Chinese God of Thunder with all its associations of sublime and thrilling terrors tamed for the purposes of Europeanized decoration. The high compartment created by the skylight is painted in panels of mixed geometric and attenuated foliage patterns in the tradition of eighteenth-century grotesque decoration. It meets the general ceiling level in a Chinese scalloped canopy hung with scrolls and bells.

Some features of the earlier corridor were expanded. In 1815, two large pier tables or cabinets of a basic *Louis Seize* shape in beech 'bamboo' with yellow scagliola tops and red silked panels had been placed opposite the recesses which opened into the drawing-rooms; they had probably occupied another room for many years. At the same date, six smaller cabinets with canted sides were made for or transferred to positions below the niches, and a similar pair, though in satinwood 'bamboo' and of an open type, appeared in the recesses. This arrange-

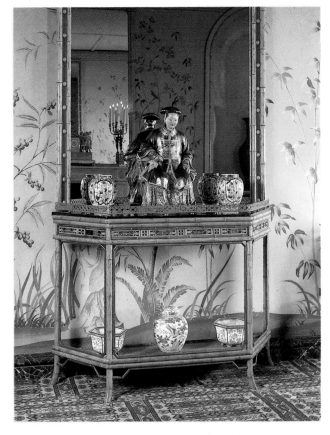

A Chinese split-cane panel from one of the sloping-sided cabinets below the niches in the Corridor.

A small open cabinet in satinwood 'bamboo' with black marble top.

ment was in the last phase pursued by the construction of two more large cabinets surmounted by mirrors to set opposite the fireplaces at each end.

The arrangement of mirrors was calculated to produce a magical dissolution of space and ornament. At four points along the Corridor large opposing glasses created transverse vistas; in each recess a mirrored niche multiplied a tall china pagoda where the lines of sight from one of the drawing-rooms and from the Corridor met; and at the extremities, where the Corridor led into the Music and Banqueting rooms, double-doors entirely faced in mirror glass gave a perspective of infinity to the scene.

In its regularity, its richness of colour, the functionalism of its architecture, its almost cosy comfort, the cultivated novelty of its decorative scheme, and its ingenious special effects, the Corridor is a true product of a Regency connoisseur. Glowing in the fragile light of the lanterns and the lotus lights mounted in Chinese vases, the room must well have answered the host's requirements for an enchanted space in which to disarm his guests.

The Red Drawing Room

In this most light-hearted of all the ground-floor rooms, colour and interest catch the eye at every turn. The mood is set by the way Nash has assimilated the columns resulting from the enlargement of the room. Not only are these dressed up as brightly coloured palm trees (with bamboo trunks!), but they are repeated as pilasters around the walls, linked one to another by beams of the same budding cusp pattern

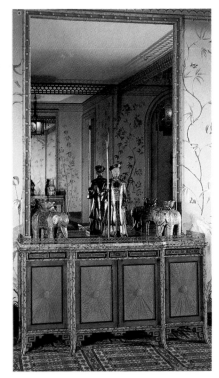

One of a pair of closed cabinets in beech 'bamboo' with scagliola tops and brass galleries.

81

A dragon in satinwood graining on a door in the Red Drawing Room.

as the cornice into which they run. Everywhere are charm and the joy of artifice: it is utterly appropriate to the spirit of this room that the graining of the woodwork is teased into the elusive shapes of dragons.

The chief feature is the wall decoration, a reprise of the design in the silvered background to the Banqueting Room panels in which a medley of Chinese motifs writhe in busy harmony. Robert Jones developed it here into a wall covering of surpassing originality, conceived on a scale which repeats the pattern in sections as large as eighty square feet. The design, originally hand painted, is in white upon a carmine red ground. Below it, the Chinese fret dado in simulated relief seems to be simply yellow upon red, but the richness of its effect depends upon the use of a much more extensive palette.

Everywhere the walls were punctuated by an arrangement of Chinese export oil paintings, twenty-six in all, pasted on to the dragon paper, and framed with elaborate bamboo borders that were partly real but mostly in *trompe l'œil*. Such a use of Chinese pictures had a long history in England, and Jones was simply producing a version of several Crace schemes, from the Pavilion's first Chinese rooms to the Blue and Yellow Drawing Rooms of 1815, though his treatment does not, as Crace's did, employ the vignette and grotesquerie settings of late eighteenth-century practice. The success of Jones' scheme led to the adoption of similar arrangements elsewhere in the Pavilion, for example in the large yellow Ante-Room between the Corridor and the King's Apartment, and in some of the bedrooms. The dragon paper design was also to appear on the chamber floor and in a green version in the King's Apartment

One strong Indian element is found in the shape of the door cases, which rise into pointed Indian arches filled with painted glass, a shape echoed in the panelled armrests of the ottoman that fitted the broad recess. This alcove, like the windows opposite, was draped with a striped silk in green, the secondary colour of the scheme.

The other furniture shown in Nash's View consists of imported

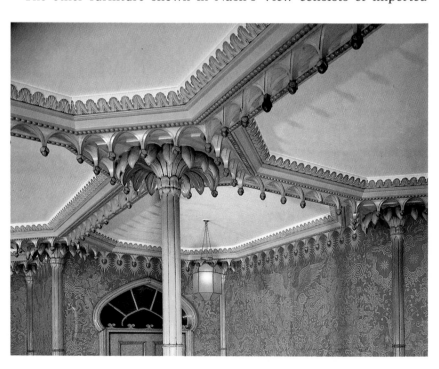

The ceiling of the Red Drawing Room.

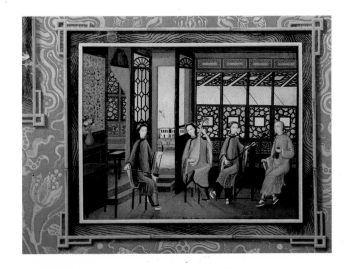

A section of the original Red Drawing Room wallcovering, with Cantonese export oil paintings in *trompe l'œil* framing.

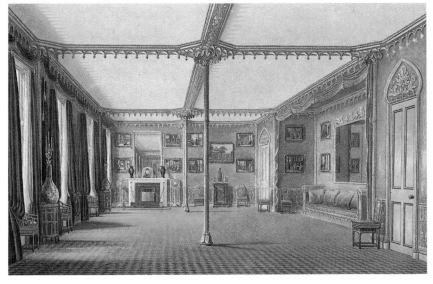

The Red Drawing Room, from Nash's *Views*. Of all the schemes devised after the Banqueting Room of 1817 this was the only one in which the bamboo and porcelain theme of earlier decorative phases was adhered to so closely.

Chinese bamboo chairs and stands no longer required in the now majestic drawing-rooms of the enfilade, and, striking a sonorous note, a pair of narrow *Louis Seize* cabinets incorporating Japanese lacquer panels. Among the mounted china were two enormous bulbous vases fitted for candles, against the window piers, and a pair of deep-blue vases, mounted by Vulliamy as jugs, upon one of the white marble chimneypieces.

The Banqueting Room

It is tempting to imagine the Prince's satisfaction as, accompanying his guests through the simple opening under the Corridor stairs, he observed their reactions to the *coup de théâtre* he had prepared here. It is hard to stifle a gasp on entering his dining-room, or to restrain the eyes from rising, as they might in a Baroque cathedral, to the domed ceiling. The reaction is not so much one of awe as amazement at the virtuosity and singularity of it all. It is meant to surprise. It is extreme and it is fun. The dome appears open to a tropical sky almost filled by a single feature, the crowning leaves of a plantain tree gigantic beyond the realm of dreams, certainly beyond the Hellenistic palm tree ceiling at Palmyra which Robert Adam adopted and made pretty.

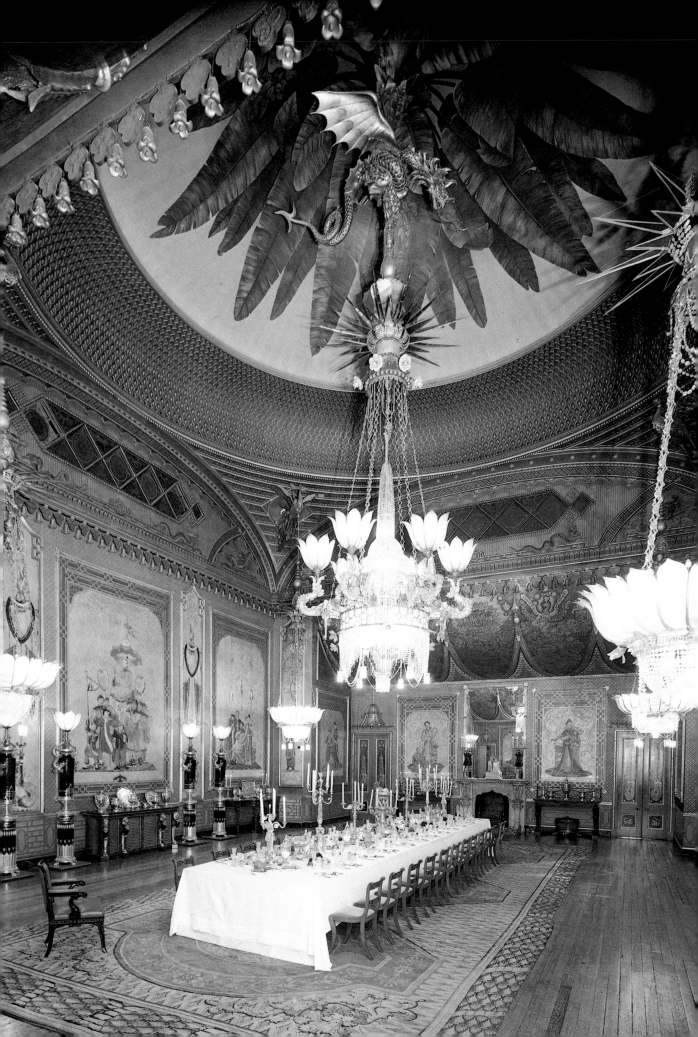

There is a surreal intensity in the scale and lifelike accuracy of the leaves which almost dislocates the imagination.

Hovering at the apex is a carved dragon, painted and silvered, more than equal to its dramatic setting, and, as the handful of travellers who may have seen such devices on Chinese carved ceilings would know, appropriate too. From its claws hangs the great lustre, or chandelier, (fitted for gas light in December 1821) which descends, by way of a mirrored star in cascades of brilliants and bands of tinted glass flowers, to a ring of six silvered dragons spouting lotus petal bowls from their sinuous throats. Subsidiary lustres, lotus bowls dripping with spangles, hang from other inhabitants of the ceiling, the four flying birds modelled on the *F'eng* of Chinese mythology.

It is the work of a great impresario, and indeed this great domed box of a room, extended at each end under canopies, has features in common with the auditorium and its dome on flattened arches of J.V. Louis' highly influential theatre at Bordeaux (1777). In the Banqueting Room there are theatrical stages in all directions, where the motifs which spoke most potently of the orient to the Regency mind are assembled, chief among them the serpent and the Imperial dragon.

The perimeter of the ceiling is occupied by elements filled with Nash's rather strongly-formed mouldings—a circular cove with a diaper relief of overlapping ovals, the four pendentives with bands of blue quatrefoil mouldings, and, between these, four basket arches rising from the corners of the room. These are filled in an unusual manner by a *trompe l'œil* ground of bamboo rods, subsidiary arches, and horizontal painted glass windows like the extended lozenges found in neo-classical mouldings from chinoiserie furniture to ceiling decorations in Harewood House. Even here painted dragons insinuate bamboo poles. There is a cornice of lotus leaves and suspended bells and trefoils.

The canopies at the ends are a striking invention. They resemble great sagging sheets of gilded leather (a de luxe material in eighteenth-century European interiors) decorated with the shapes of fabulous beasts, heavenly bodies and rays, and pinned up by gilded loops so that they show in five huge shield shapes. Below, Robert Jones took

From out of a fountain of glittering spangles, six dragons on the central chandelier seem to launch themselves into the air, heads thrown back to exhale not fire but light. Anything less flamboyant would have seemed a weak support for the enormous glass shades.

opposite
The Banqueting Room, furnished with its display of silver-gilt acquired from great Regency services. Restoration work is beginning on the upper portions of the walls and the ceiling. See Nash's View, which appears on p.121.

A detail of the ceiling cove and clerestory of the Banqueting Room. As yet unrestored, it nevertheless shows the transition between the domed ceiling and the walls.

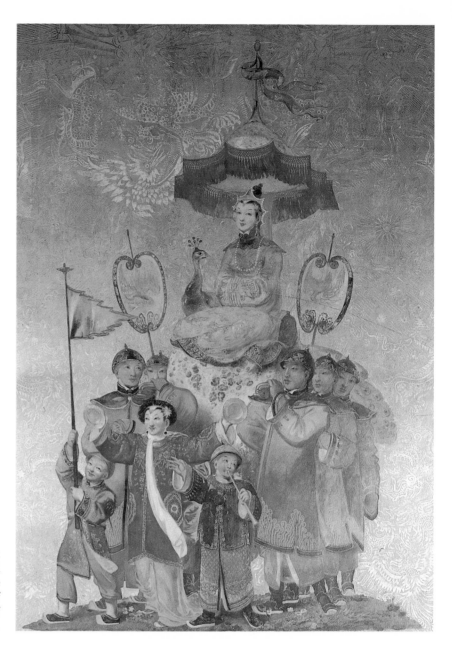

The largest of the Banqueting Room panels, depicting a Chinese bridal procession. The murals give the sensation of a gigantic enlargement of the miniature, magical world of porcelain.

over entirely. His murals took the form of enormous panels reserved against a diaper wallpaper of silver and blue above a red trellis *trompe l'œil* dado. Within frames of gilt mouldings and red trellis borders, the two tallest panels are occupied by Chinese war standards, enlarged reminders of earlier wall decorations in the Pavilion, the rest by groups of costumed figures enacting scenes from Chinese life. In their gentleness and charm they are descendants of Boucher's rococo chinoiserie paintings, but unlike gallery pictures these tableaux are reserved against a luminous ground — an elusive, silvered pattern, like a satin damask, of dragons, stars, and waves, which Jones was later to develop in solid colours as a wall design for other rooms. Early descriptions of the Banqueting Room paintings refer to 'mother of pearl' backgrounds, recognizing in them something like the iridescent pearly wallpapers of the period (whose origins go back to the ways in which earlier chinoiserie stimulated the use of silver and gold in wall coverings).

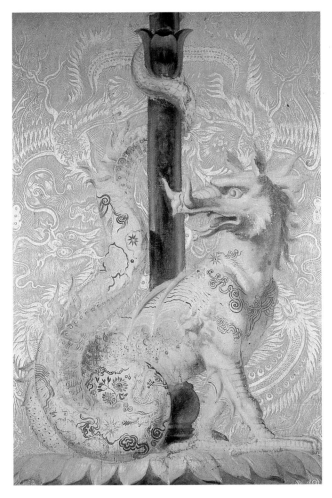

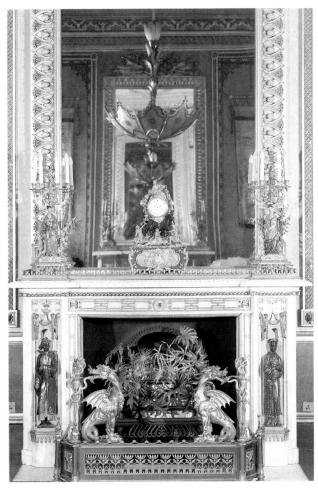

The panels call to mind a whole range of media — pictorial reserves on enamelled porcelain vessels, the little Chinese 'rice paper' paintings turned out for the benefit of Westerners, the painted hangings of gauze which had found their way into European boudoirs. They suggest, too, the images thrown upon the first of the 'silver screens' in the early magic lantern shows, to which the association of Chinese things with enchantment was frequently attached.

On the window wall was a sumptuous drapery hung in gold fringed festoons of crimson satin above piers strained with fluted green silk, and five French windows opened on to the lawns. On the end walls two tall mirrors reflected into infinity, as they still do, the great chandelier between them. Below them, the chimneypieces marked the earliest signs of a return to the fastidious refinement of the Chinese Drawing Room at Carlton House, whose neo-classical chimneypiece with Chinese figures in niches clearly inspired those designed for this room. The fixed embellishments were completed by four double-doors in imitation black lacquer surmounted by pointed arch overdoors of stunning richness, in which seven-headed serpents writhe up from an expanded flower cup. This princely display of carved and gilded wood was continued in the sideboards that lined the west wall and the chimney walls. Veneered in rosewood, with a satinwood fret that is also used on the ebonized dining-chairs, and with each leg encrusted with vigorous gilded dragons carved in the best style, they are among

left
A watchful dragon at the base of a war standard on one of the tall panels. It is of ambiguous substance, a visual pun on several levels, typical of the Pavilion mode of fantasy.

right
One of the two original Banqueting Room chimneypieces. The superb chinoiserie clock which once graced that on the south wall may now be seen in Windsor Castle. (BP)

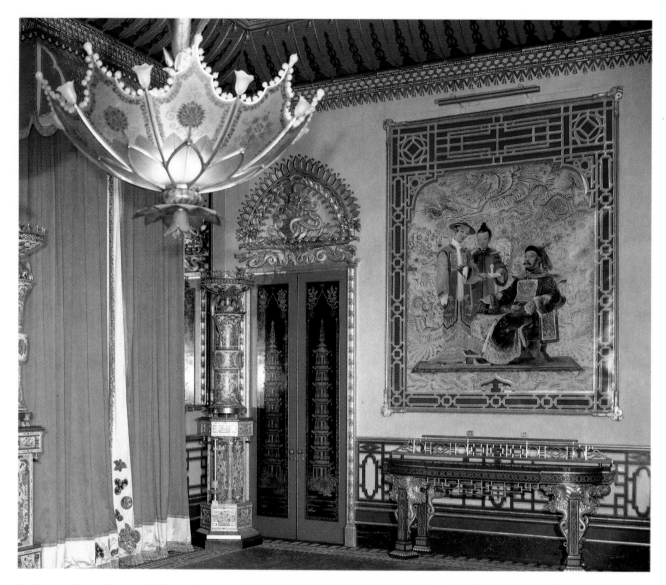

A door and overdoor, a sideboard and a wall panel from the Banqueting Room, now in the Chinese Luncheon room at Buckingham Palace. The torchères, in which Robert Jones' design incorporated vases bearing the Orléans arms, were made for the Music Room of the Pavilion, as was the chandelier. (BP)

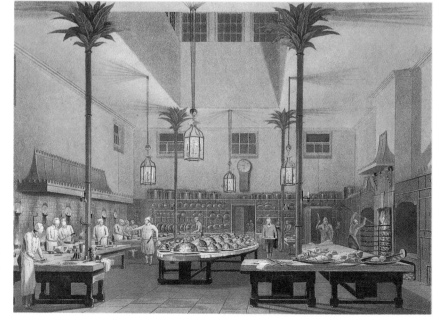

The Great Kitchen, from Nash's *Views*. The centre table was heated by steam. The original arrangement of windows in the topmost lantern section was restored in 1982.

the most important of Jones' contributions to the furniture made for the Pavilion.

Piercing the sideboards on one wall, free-standing on the opposite side, were placed (and still remain) eight lamp standards, which in their assimilation of eclectic elements, in their originality, and in their ingenuity are examples of the Pavilion style at its confident peak. Deep blue cylinders of Spode porcelain, topped by shades of glass lotus petals, are connected to similar drums of painted wood by thin necks of ormolu. The plain surfaces contrast with their ormolu and giltwood enrichments—dragons and dolphins, and formal motifs derived from China, India, and the classical repertoire—while in the precision of the cylinders and their geometric mounts is conveyed a hint of the dawning machine age.

Such audacious variety of associations is typical of the Banqueting Room as a whole, but what makes it unique is the way this variety is deployed, and its informing sense of style.

The Kitchen

The Prince's Great Kitchen was of course something out of the ordinary, not so much for the palm-tree tops to the columns, added probably in 1821, but because of its convenience, comfort, and technological modernity. Built in 1816, long before the Banqueting Room itself was ready for use, it was immediately the source of enormous satisfaction in an owner who placed high value both on the best cuisine and on ingenuity. To those familiar with the dark, stuffy, and inconvenient kitchens in other great houses, it must have seemed luxurious, and among those who were personally conducted around its marvels by the Prince Regent were visiting foreign royalty and ambassadors. On one occasion, mercilessly seized upon by a mocking press, the Regent gave a supper for his servants here. Though this was hardly slumming, it was thought appropriate to lay a red cloth upon the flagstones.

Almost every device then available was provided. A smoke-jack to turn the roasting spits, powered by the rising heat of the fire; ranges of cast-iron stewing stoves, hot cupboards in the corners, dressers neatly stacked with copper utensils, steam dressers and tables, including the oval table in the centre of the kitchen, fed by concealed pipes; sinks with hot and cold running water and every contrivance, in J.W. Croker's words, for 'roasting, boiling, baking, stewing, frying, steaming and heating'. Tent-like copper canopies helped to guide away the excess vapours, but ventilation was well provided for by the high, well-lit lantern roof. Artificial lighting was by hanging brass lanterns equipped with Argand oil burners. Nash's View shows a dozen cooks working here in relative comfort, while a footman comes to take prepared dishes from the kitchen to their final destination.

The Great Kitchen remains almost unaltered, but it was only the most important of a number of culinary offices—the larder giving on to the Castle Square courtyard, the pastry room, the confectionery and the family or household kitchen—all of which except the last were demolished along with the rest of the extensive household offices and accommodation when the Pavilion was bought by the town authorities in 1850.

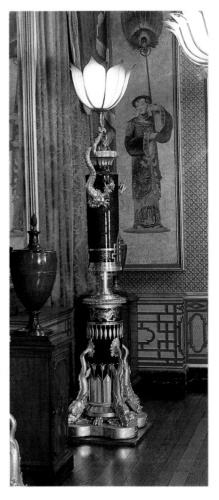

The lamp standards in the Banqueting Room. The ormolu and giltwood mounts, and the Spode cylinders of a luxurious and expensive blue, are of superb quality.

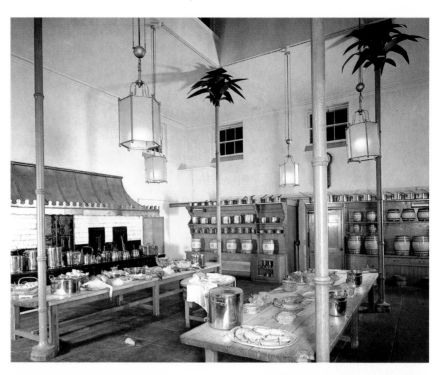

The Great Kitchen.

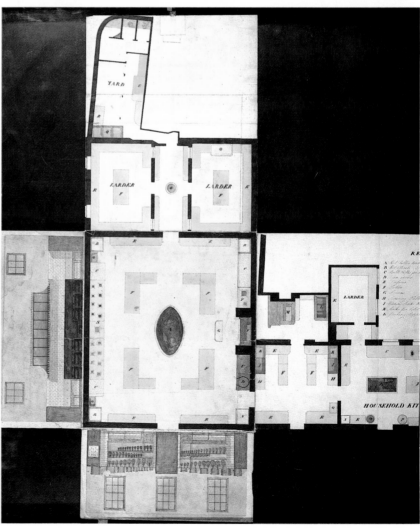

A detailed plan of the Great Kitchen
(after 1840) indicating the functions
of every part.

The Royal Chapel

The final comforts added to the Pavilion by George IV were those of the Royal Chapel, in 1823. Instead of a walk through the western grounds to the Chapel Royal in North Street, all that was required of the King and his guests was to pass along a covered passageway which snaked its way up to the upper floor of the old Castle Inn. Here, the Georgian ballroom, designed by John Crunden, the architect of Boodle's in St. James's, and once the focus of social life for all Brighton's pleasure-seekers, had been converted to religious use by means of rich velvet hangings, golden tassels, and upholstered seats. An illustration of this chapel was to be used by A.W.N. Pugin, the son of Nash's draughts-man and chief artist for his *Views of the Royal Pavilion,* to epitomize everything that Gothic Revivalists like himself considered to be inappropriate to an ecclesiastical interior.

The South Drawing Room

An angled mirror above the door masks the change of height as one leaves the festivity of the Banqueting Room for the relaxations of the first of the drawing-rooms. It is a curious thought that these walls once outlined the entire ground floor of the original house—two rooms and a staircase. The latter disappeared in the alterations of 1801, and sometime in the years before Nash began his work, perhaps under Porden or Wyatt, this part of the building became a single room.

Until the room was given its final form and appearance in 1821, the flavour of Crace's first chinoiserie schemes was maintained, though made both more refined and more lavish in the busy year of 1815, when four fastidious modifications were made to the colour scheme. Pugin's drawings of this penultimate phase show walls applied with an arrangement of Chinese pictures surrounded by painted chinoiserie devices—crossed arrows, musical instruments, torch standards, and hanging lamps—decorations which are clearly a variant of the vignettes amid grotesque borders so fashionable in the late eighteenth century. Chinese fret borders, pilasters, and dado; two arched beams, marking the old room divisions and richly ornamented with key pattern and scrolls; sixteen Chinese lanterns of the type still to be seen in the

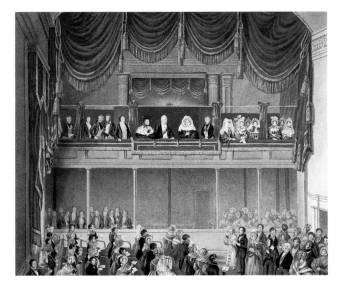

King William IV, Queen Adelaide and other members of the Royal family attending service in the Chapel of the Royal Pavilion, removed after 1850. In its earlier existence as the Castle Inn Ballroom, George IV had enjoyed its secular pleasures on his first visit to Brighton as the young Prince of Wales.

91

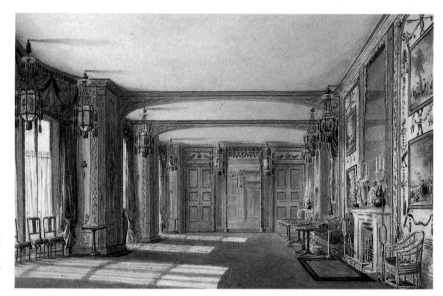

The Blue (now South) Drawing Room, in the scheme of 1815-20, from A.C. Pugin's watercolour for Nash's *Views*.

A palm-tree column in the South Drawing Room. The carved leaves are elegantly luscious, like the carving on much Regency furniture.

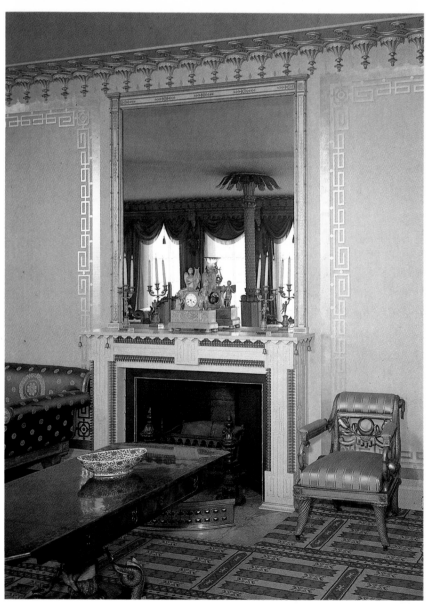

The South Drawing Room at its northern end. The chimneypiece is a reconstruction.

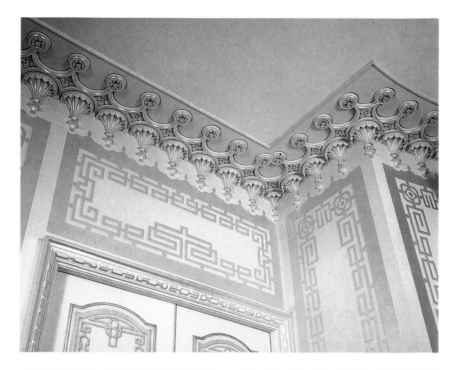

Gilding to the cornice and walls is deployed in a strong yet sophisticated manner.

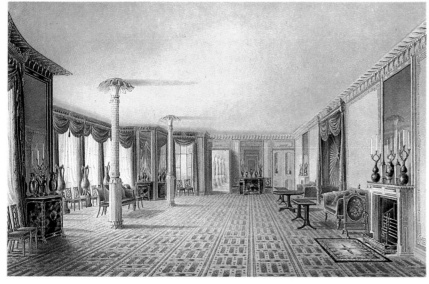

The South Drawing Room, or Banqueting Room Gallery, from Nash's *Views,* showing the complement of superb furniture carefully assembled by George IV.

Corridor; and a richly draped recess as a centrepiece compounded the densely patterned setting, to which the imitation and real bamboo seating and rosewood tables were simply tactful accompaniments. The two white marble chimneypieces fitted with bells, discs, and fret pattern in ormolu were, with the meandering mirror frames, the only features which survived this scheme.

It was inevitable that radical changes should be made as soon as the Banqueting Room was completed. In line with the careful stage management of the sequence, a pronounced contrast of mood was now sought, and was established in an interior that is gracious, calm, and relaxing without being informal. One large window bay has partially replaced the two bows, producing an articulated wall of glass—mirrored piers between French windows—draped in embroidered green silk. Two columns now support the floor above; these are called into service

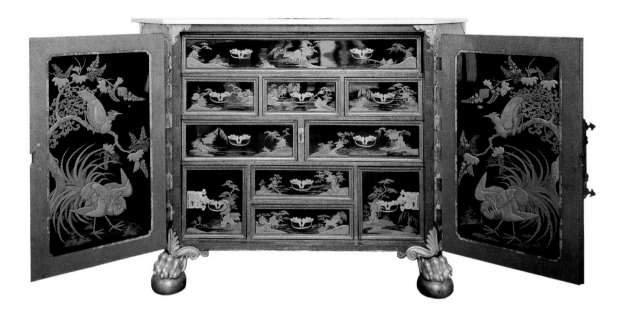

One of the four cabinets incorporating Japanese lacquer, originally in the South Drawing Room. (BP)

as palm trees with leafed tops of sensuous and delicate outline.

A drapery, matching the curtains, frames the recess on the west wall. Here, with an expanse of radial pleating above a comfortable banquette, dignity was asserted amidst the chink of coffee cups. The recess and the two fireplaces punctuate the long length of the wall with effective simplicity. Between, and throughout the room, the flat surfaces are painted 'flake white' and narrowly bordered with Chinese fret, gilded and shadowed. As for the low ceiling, inherited from the farmhouse, no decoration whatsoever interrupts its broad expanse of light pink; attention is reserved for the Nashean cornice of tiny Gothic fan vaults picked out in gold.

Such a setting, with its cool colours and sensation of ill-defined space, corroborated by the strip pattern pink and drab carpet of the type used in the Corridor, must have served very well the relatively flexible requirements of the small groups which withdrew here from the rich decorative menu of the Banqueting Room. Nor could there have been a better foil for the costume of the 1820s. Pugin's illustration in Nash's *Views* shows a probably temporary scheme of seat furniture, with two splendid sofas each side of the recess 'borrowed' or copied from the Hervé suite in the North Drawing Room. Clearly depicted, however, is an oval panelled cheval screen of *Louis Seize* form, and it is known that by 1826 there were here a sofa and two double armchairs (*têtes à têtes*) of matching design. The fourteen rectilinear giltwood chairs with wreath and arrow backs, misleadingly depicted in the aquatint, would have accorded well with these: it is thought that they had been in Carlton House since the early 1790s.

Below the mirrors at each end of the room and at the angles of the window bay were placed four magnificent cabinets of Japanese lacquer with canted sides and doors enclosing drawers and mounted with gilt metal hinges and locks, modifications of a style of cabinet which had been familiar to Western collectors since the seventeeth century. The

cabinets had probably been in the Library of Carlton House until 1815, and two of them appear to have been used for a time in the Saloon, between the windows. On each, and on two other lacquer cabinets of French design, stood choice Chinese vases, some of them mounted as candelabra; in the long window bay four enormous Chinese vessels stood sentinel, richly mounted on gilded stands.

Generally, however, the Chinese theme is strikingly dimmed. The furniture notably re-establishes the mark of *Louis Seize* delicacy and, in the use of the cabinets, a recollection of an era of European interest in the Orient that was in the more distant past. The King, for so he was when the South Drawing Room took its final form, had broadened and developed his conception of the Pavilion. His taste for the best of what we should call antique furniture was beginning to find expression in his Brighton fantasia as well as elsewhere.

The Saloon

In the eighteenth century, the Saloon was usually the principal, the most spacious, and the loftiest room in a great house. In the original Pavilion it was certainly all these things. At that time it was the only reception room, but for all the changes and additions that were made to the building it was never dislodged from its high status. The finest workmanship and huge sums of money were lavished upon its decoration in all its successive forms. Its shape, however, did not alter. The Saloon remained as Holland had conceived it: a high domed, circular room extended by two semi-circular apses with concealed half domes.

When Robert Jones brought about its final transformation in 1823, in the last of all the great changes in the Pavilion, he swept away the colourful trellis cornice hung with network and pendants, the large panels of blueish Chinese garden wallpaper, the Chinese lanterns and painted columns, all the ingredients which had with occasional modi-

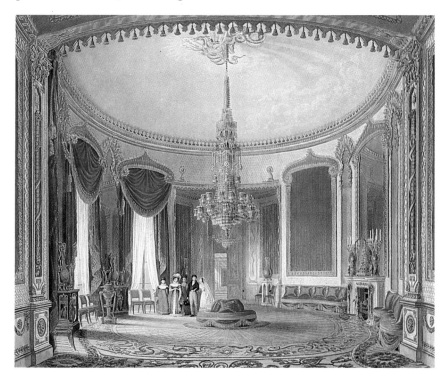

The Saloon in its final phase, from Nash's *Views*.

95

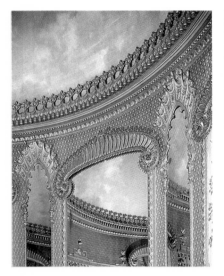

Gilded crestings of attenuated lotus leaves play a harmonizing role in the Saloon decorations.

The Saloon, looking through the apsidal recess to the North Drawing Room. The background wallpaper is reprinted from the original blocks— the Chinese paper, probably used once before in the Pavilion, was given by the late Queen Mary. The chairs shown are not from the Pavilion, but were once in the English home of the exiled Louis XVIII.

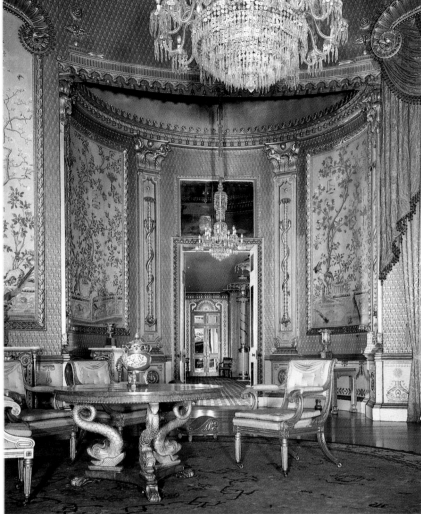

One of a set of single chairs originally in the Saloon. By the time the Saloon was last furnished the Chinese inspiration no longer dominated. (BP)

fications since 1803 provided the scene of a charming circular arbour. In its place he introduced within this lovely neo-classical volume an interior of striking maturity—integrated, confident, and romantic. It was a notable example of the way in which the eighteenth-century heritage disciplined Regency design.

Jones brought together the elements that reflected not only the developments in his patron's taste for the exotic, but also the splendour and dignity of the Crown itself, symbolized perhaps by the recurrence here of the sunflower motif. There is a rich ornamental vocabulary developed from a number of sources, but nowhere in the Pavilion are the elements more harmoniously integrated, so that furniture, furnishings, and architectural adornments firmly support each other at every point. Here even the ubiquitous dragons behave as disciplined and discreet servants of art.

The most noticeable change in feeling lies in the passage to India that has taken place in this scheme. Great gilded cresting pieces to the three French windows and to the chimney glass and silk panels that face them—flattened ogival arches filled with serried lotus leaves and scrolling down to dragon-head roundels—speak of the Mughal Empire. The motif is richly echoed in the ormolu mounts to the superb

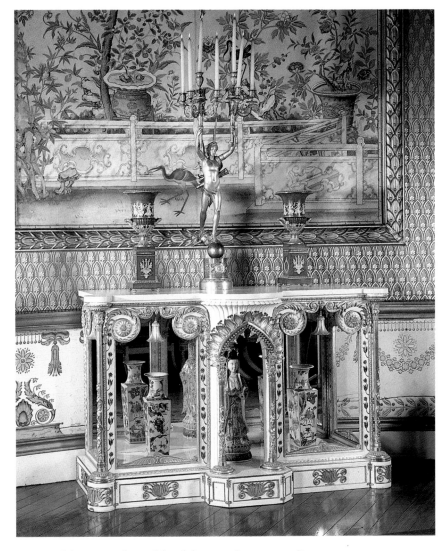

One of the open cabinets which completed Jones's highly integrated Saloon decorations. The porcelain and candelabrum are substitutes for George IV's own pieces.

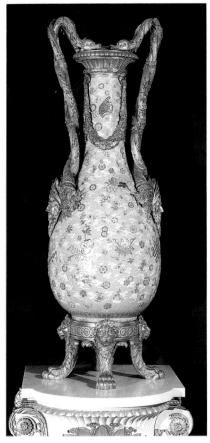

One of the large porcelain vases mounted in English ormolu which once stood on the cabinets in the Saloon. (BP)

open cabinets and marble chimneypiece *en suite.*

Another change was in the abundant use of satin, of a gold-enhancing crimson patterned in yellow with flowers and birds, in the opulent window drapery, the great and small wall panels, and in the upholstery to the chairs and the three ottomans. Two of the ottomans curve in cushioned comfort at each side of the chimneypiece; the other, alike in its gold fringed silk upholstery, occupies the central circle of the carpet. The twelve single chairs are model combinations of richness and simplicity, in which a basic Regency type is embellished with the most refined gilded carving. They answer both to the soft furnishings and to the open cabinets—two long ones for the mirrored window piers, two pairs of upright form for the recess. It is the most remarkable set designed for the Pavilion, and not only for the quality of its ormolu and carved, gilt ornament upon ivory white frames. Backed with looking glass, their basically neo-classical shapes are made into little oriental shrines for some of the more important pieces of porcelain in the house. Similarly, the niches of the matching white marble chimneypiece house standing Chinese figures, richly coloured; on the shelf above them stood two candelabra of sumptuously mounted Ch'ien Lung vases and the fabulous 'Kylin' clock, in which the not

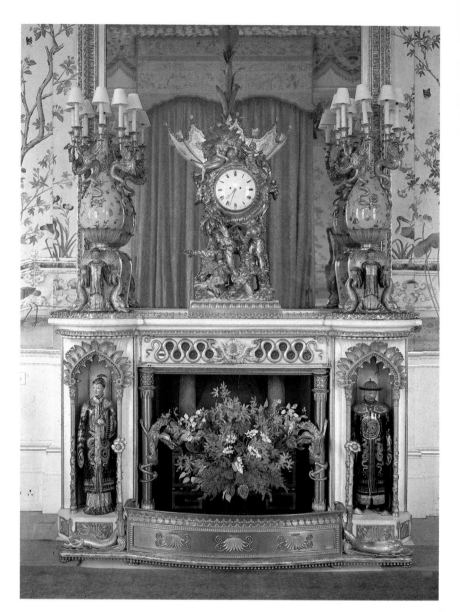

left
A detail from one of the exquisite raised lacquer panels, in imitation of oriental work, from the double doors of the Saloon.

right
The chimneypiece and candelabra originally in the Saloon. The 'Rock' clock shown here formerly stood on the Music Room chimneypiece, illustrated on p. 107. The 'Kylin' clock seen there is from the original saloon ensemble. (BP)

uncommon combination of pieces of Chinese porcelain with lush metal foliage was taken to an extreme of rococo fantasy.

There was fantasy indeed in the midst of this strictly ordered room. The most striking *jeu d'esprit* was above. At the apex of the ceiling, which was all dome and entirely filled, as before, with a clouded sky, Jones' spectacular skills brought to life in *trompe l'œil* painting a fairyland dragon whose transparent wings are restrained by coiling serpents. The rays of the sun issued from behind this vision, so different in character from the Banqueting Room ceiling. An immense chandelier hung down, as in that room, but here largely composed of cascades of spangles on ormolu mountings, and well within conventional Regency taste. Smaller versions hung in the recesses.

Not the least effective element in the Saloon was the tufted Axminster carpet (a fragment of it has survived) of strong design. A broad circular band of sun rays encircled by a ring of dragons, stars, and sunflowers followed by borders demarcating the formal positions of the furniture filled the floor to the skirting of frosted gold. The white dado painted

with classical swags, the silver and blue leaf-pattern wallpaper, and the exquisite double-doors in imitation raised lacquer on a white ground completed the scene.

The Saloon is a room of considerable grace, not, surely, designed for the occupations of a drawing-room, but in its formality the perfect reception room for the most important dignitaries. Though not the largest or most spectacular, it is in every sense the central room of the Pavilion, as indeed it always was. Moreover, in each of its three very different incarnations — Adamesque, the Chinese garden, and finally Imperial splendour — it was the key to the whole show.

The North Drawing Room

The main outlines of this room were formed when the Eating Room and Library of Holland's Pavilion gave way to the first Chinese Gallery in 1802. Its present appearance dates from 1821, like that of the South

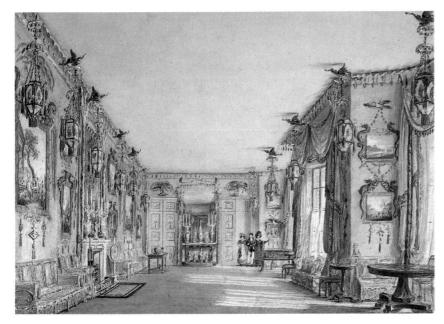

The Yellow Drawing Room (now North Drawing Room) in the scheme of 1815-20 from A.C. Pugin's water colour for Nash's *Views*.

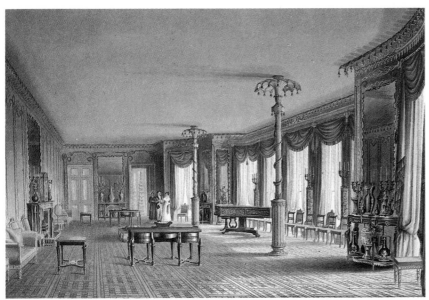

The North Drawing Room, or Music Room Gallery, from Nash's *Views*. Here was a concentration of some of the finest furniture within the Pavilion.

99

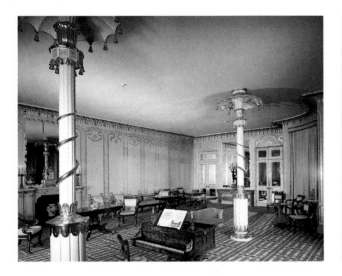

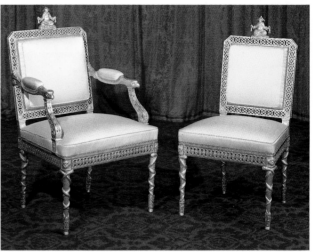

left
The North Drawing Room. Much of the seat furniture shown here was originally in Carlton House. The piano, presented by the late Queen Mary, is a Mott Sostenente Grand, very similar to the example in Nash's View.

right
A *bergère* and a single chair from the set by François Hervé, brought from Carlton House to the Royal Pavilion where the upholstery was in striped yellow silk. (BP)

Drawing Room, which it resembles in decorative tone. It, too, had last been redesigned in 1815, in an elaborate scheme rich with Chinese effects, though the background colour was yellow rather than blue.

In this former incarnation as the Yellow Drawing Room a large expanse of wall on each side of the single fireplace was left free for arrangements of applied Chinese pictures. One large painting was flanked by pairs of smaller ones, each with gaily-painted surrounds of lively dragons and Chinese ornament, all linked by garlands to the fabulous hovering birds which appeared to suspend them in mid-air. The panels in the window recesses were similarly decorated, and the fabulous birds reappeared above all four doors. At each major division of the walls there were shaped columns, painted with climbing foliage; on the window side these held the draperies of fringed yellow silk. There was an unusual cornice, preserved in the final scheme, consisting of a narrow concave canopy curving outwards and downwards in broad tongues, from which little painted tablets hung. Perched upon it were dragons in carved and painted wood, holding Chinese lanterns in their claws and casting dramatic shadows upon the ceiling.

In Pugin's illustration of this phase it is interesting to see among the predominating furniture of imitation bamboo—single and arm chairs and comfortable ottomans hung with rich fringe—a pair of rosewood tables with interlacing crossrails and inlaid brass decoration that refer not to China but to the *Louis Seize* style. It is an indication of the increasing scope that was being given even in the Pavilion to the Prince's appreciation of French eighteenth-century furniture. Indeed, when this room was remodelled in 1821 it became the setting for the remarkable group of furnishings originally assembled for the Chinese Drawing Room at Carlton House, and subsequently added to with great care for harmony, in 1790. Most was of French origin or influence.

These rich furnishings, which included candelabra and vases, were given full value by the serenity of the new wall decorations. There was the same combination of 'flake white' and gold as in the South Drawing Room, the same technique of shadowed gilt pattern, but here arranged in tall panels with divisions marked by a trellis-like strip of interlocking and overlapping circles. The effect is not only wonderfully sympathetic with the ormolu mouldings and inlaid brass of the furniture, but gently

recalls the carved and gilded *boiseries* of *Louis Quatorze* panelling.

The existing cornice, refined now by the substitution of gilt pendants for the painted tablets, was echoed in the umbrella-like canopies to the columns. Like those in the South Drawing Room, these columns force themselves upon our attention. It is not hard to detect here the advice of Nash, who was ever the man for attacking an awkward problem and making of it an assertive and witty feature. Winding down the column shafts are gilded serpents, a visual reference, no doubt, to serpent-coiled legs on the large suite of furniture brought from Carlton House. Most of this furniture, consisting of chairs, armchairs, *bergères,* and sofas, had been made for Carlton House by François

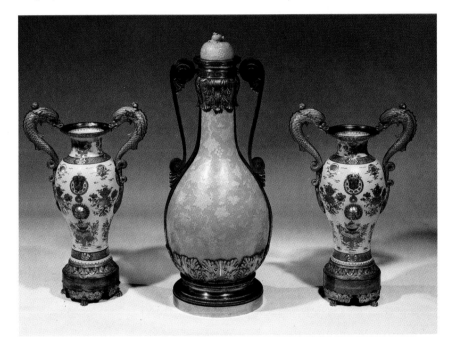

This illustration assembles the three mounted porcelain vases, including a pair from the Orléans collection, which stood on top of the cabinet when in the Royal Pavilion. (BP)

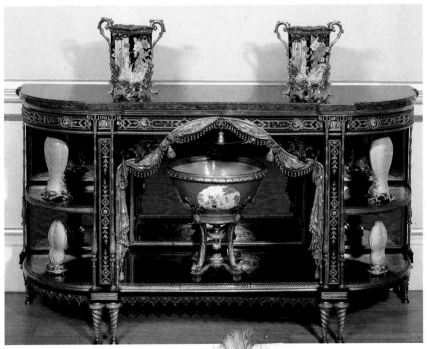

One of the two Weisweiler cabinets formerly in the South Drawing Room, both of which were duplicated by Bailey and Saunders before coming to the Pavilion. On the central shelf is the same mounted porcelain bowl shown there in one of Pugin's drawings. (BP)

101

En suite with the cabinets was this superb chimneypiece, also from Carlton House. (BP)

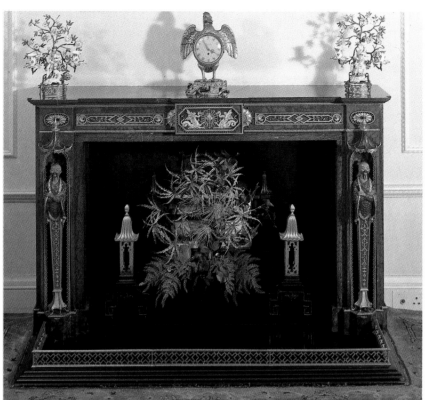

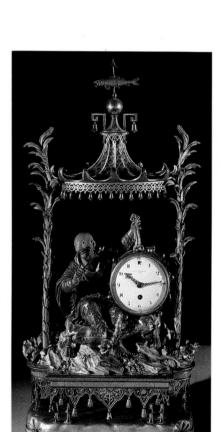

The 'Chinese Drummer Boy Clock' from the Carlton House scheme, the stand and base made by Vulliamy in 1811. When in the Pavilion, to which it was brought in 1819, it was apparently not placed in the North Drawing Room. (BP)

The other cabinet by Weisweiler, upon which are shown a pair of gilt and enamelled bronze candelabra from the Carlton House scheme that were placed there when in the Royal Pavilion. (BP)

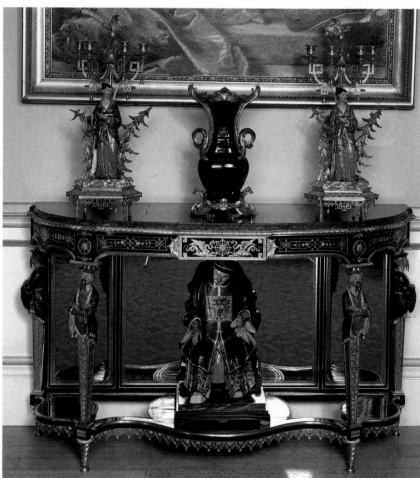

Hervé, a cabinet maker of French extraction working in London. Remarkable for the way the framework is pierced and gilded in the form of a Chinese trellis, and the sitting Chinese figures on the toprails, these pieces, were, with their striped yellow silk upholstery, as harmonious in Brighton as in their first setting.

The most luxurious and distinctive pieces, however, were the pier tables in ebonized wood, richly adorned with chinoiserie mounts in ormolu and supporting red marble shelves, which provided such exquisite settings for the Chinese figure candelabra and the choice mounted porcelain vessels. Two, of different patterns, had been in Carlton House. On being transferred to Brighton, each of them was faithfully duplicated by Bailey and Saunders, but the originals have been shown by Geoffrey de Bellaigue to be French, probably by the great ébéniste Weisweiler. In one of the patterns, the central opening is framed by a shaped ormolu drapery hung with bells; in the other the shelf is supported by brilliantly coloured Chinese caryatids, similar to those in the jambs of the matching chimneypiece of red verona marble. It is these mounts, inventive, rich in variety, and of outstanding workmanship, which provide the key not only to the decoration of smaller pieces in the group, such as the candelabra, but to that of the North Drawing Room walls and even to some of the architectural mouldings of the Banqueting Room. As de Bellaigue has shown, the preservation of the highly successful group from Carlton House through many years and several different settings indicates a consistency and attachment in the Prince that is both surprising and significant. It could well be said that these pieces were the seeds from which the Prince's enthusiasm for chinoiserie, and with it the whole Pavilion enterprise, had grown.

Other pieces also came from Carlton House—a pair of smaller pier tables with dragon supports, and sabre-legged gilt chairs from the dining-room. Especially made for Brighton were the four striking candelabra placed in front of the Corridor piers, each of six branches rising from tall hexagons of Chinese porcelain, decorated in brilliant colours with grimacing dragons and clouds.

Nash's View also shows a pair of mazarin tables, richly inlaid with buhl work. They had been made in *Louis Seize* style by Louis le Gaigneur, a London cabinet maker, and represent a taste which the Prince was to cultivate in his many purchases of fine French pieces in the buyer's market which followed the defeat of Napoleon.

Of all the rooms in the Royal Pavilion, this lovely drawing-room shows the most sophisticated command of the art of furnishing. Against a thoroughly integrated background of furnishings and decoration are assembled pieces of varying periods and inspiration with confidence, flair, and civilized discretion.

The Music Room

It took more than two years of intensive work, by day and night, to bring about the most ambitious set piece of all. The Music Room is in many ways the consummation of George IV's vision and of the last, romantic, phase of chinoiserie. Struggling somewhat for words, contemporary descriptions compared it to the enchanted palaces of the Arabian Nights. It is a room conceived for evening use, for music and

Original to their present position in the window bay are four torchères—hexagonal porcelain pillars fitted with luxurious English ormolu mounts and standing on painted and gilt wood stands.

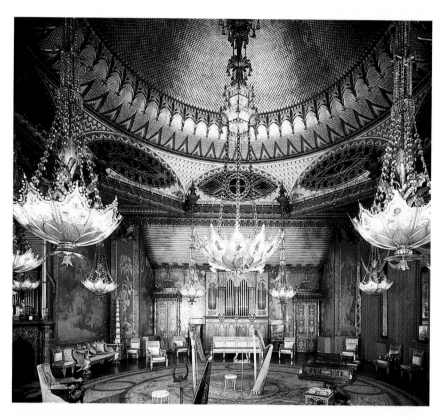

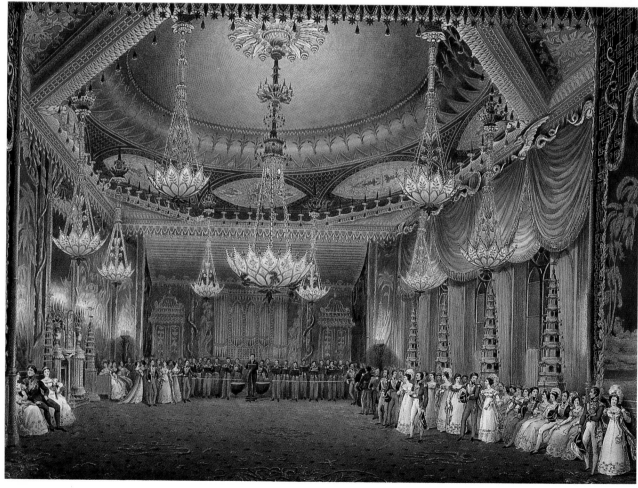

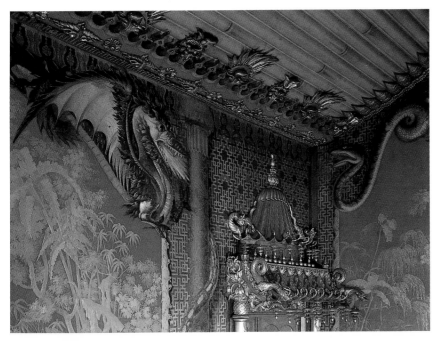

A detail of the south-west corner, in the recess.

dancing and sparkling artificial lights where, stationed below the most powerful organ in the land, a Lincoln, the King's wind musicians beckoned guests into a self-contained fairyland world. This setting, Crace's masterpiece, is dominated by the glowing carmine red of its murals, canopies, and doors, which give it a sense of enclosure very different from the Banqueting Room with its festive use of colour.

The enormous Chinese landscapes which fill the walls form an interior whose unusual associations must have been immediately recognizable to its first visitors. Firstly, it conveys the impression of a gigantic red lacquer cabinet, outside in, with designs on its panels done in the traditional yellow and gold. Also, the panels, though not illusionistic, virtually constitute the scenic walls of a panorama room, a mode of decoration in which mural paintings or panoramic wallpaper extend the actual limits of a room into apparent exterior space. Although such a device had had a long history, it was then receiving new stimulus from the presentation of scenic painting as public spectacle, sometimes suffused by dramatic coloured lighting. The Music Room landscapes have something of the quality of an exotic panorama show, but there is a curious twist in their presentation, whereby the usual natures of frame and image are reversed. The scenes of palm-fringed lakes, pagodas, egrets, and fishermen are stylized, whereas it is their stagey framing which deceives the eye — a painted mythology of columns coiled in realistic serpents, bizarre dragons, and edgings of luscious golden foliage. The details of the landscapes, partly taken from Alexander's *Views of China,* have some pretensions to accuracy, but they present not a surrogate China so much as a true realm of the imagination.

The upper reaches of the Room assert themselves in a splendour of gilding, colour, and almost encyclopaedic ornament. What sustains this exotic display is neither the mannerliness of even the most elaborate of eighteenth-century English ceilings, nor the pretty *trompe l'œil* fancies of Crace's earlier work, but a confident and majestic authority. Above a cornice of shields and hanging stars, a red octagonal canopy,

opposite above
The Music Room, before fire damage in 1975. A full and scholarly restoration is now approaching completion.

opposite below
The Music Room from Nash's *Views.*

105

'The South Gate of the City Ting-Hai', from Alexander's *The Costume of China, 1805.*

Many of the details of the Music Room murals are taken from William Alexander's aquatinted illustrations, see page 30 and above.

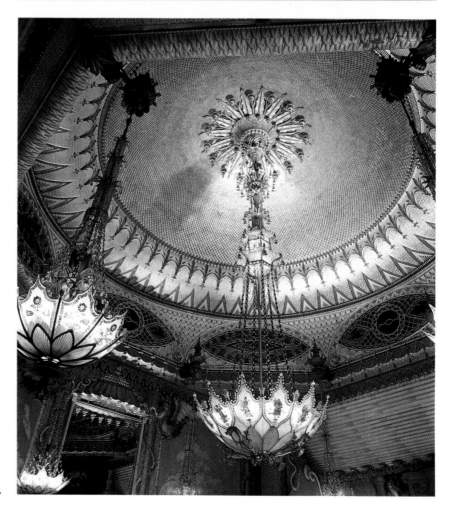

The Music Room ceiling before 1975.

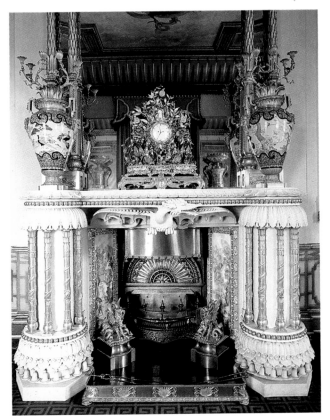

Detail of the gigantic pelmet (before the restoration which followed the fire).

The original Music Room chimney-piece, marble with ormolu mounts: a facsimile is now in its place. (BP)

One of the six Yung-chen porcelain pagodas originally in the Music Room. (BP)

scalloped and outcurved in Chinese style and 'held up' by gilded ropes, is cast into shadow from the hanging lights. The next architectural element is a band of eight elliptical windows in stained and painted glass. Artificially back-lit at night, they alternate with the pendentives that complete the transition from square to circle.

A blue convex cove, embellished with bullrushes upon a gilded trellis pattern with a margin of large 'Vandyke' triangles, supports the dome. Using a device employed by Nash in his own house on the Isle of Wight, the dome is clad in diminishing plaster scallop shells, from which the ethereal brilliance of green gold issues and shines. The sources of illumination are nine lustres of translucent glass—hemispherical bowls where lotus leaves transmute into pearl-fringed shields painted in flowers or Chinese figures. The largest hangs from a ceiling centre of formal ornament radiating with spiky leaves, all in painted and gilded wood, and connected to it by thirty feet of carved ornament and spangles upon a metal framework.

On the window wall, huge silvered dragons and serpents hold up a drapery of blue and crimson satin fringed with gold tassels, while before the window piers, fluted with yellow silk, once stood four porcelain pagodas twelve feet high. Two smaller pagodas flank the white marble and ormolu chimneypiece, where a flying marble dragon supports the shelf. Here stood the 'Rock' clock and two large Chinese vase candelabra. Here too is the largest mirror in the Pavilion, capped by a swelling red and gilt canopy, almost as encrusted with carving

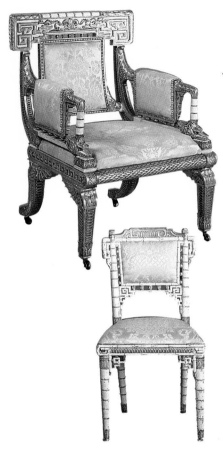

Two of the remarkable suite of chairs designed for the Music Room and made by Bailey and Saunders. The decoration of the smaller was originally of a lilac ground colour. (BP)

as the four doorcases under the great bamboo rod coves in each recess.

The Music Room is a showpiece for the highest skills in carving and gilding. There is an extraordinary variety of gilded ornament—fabulous beasts, seed pods, pendants, foliage and rosettes, balls and finials—yet it is so judiciously concentrated and disposed as to produce a spectacle of imperial magnificence.

For seating, new groups of furniture were commissioned from Bailey and Saunders. The most important constituent, the four armchairs, angular and opulent, owed much to the French Empire style established by Percier, though here the decorative elements include dragons' heads and wings, palm tree trunks, and Chinese fret in imitation of bamboo or metalwork. The upholstery was in golden silk, and where the carved frame was not gilded, it was picked out in lilac. Among the other seats there were twelve single chairs to correspond, eighteen others less elaborate, and three large ottomans similarly treated, which stood against the dado—a *trompe l'œil* balustrade in lilac relieved in yellow. In the corners of the room were placed four large Chinese jars bearing the arms of the Duc d'Orléans, showily converted to candelabra in a design by Robert Jones.

Completing the comforts was an Axminster carpet, not geometric as in the Banqueting Room but of a deep-blue ground sprinkled in profusion with Chinese devices and creatures about a star roundel inhabited by a dragon; a sort of mythological Chinese sky under the feet.

The firm of Crace alone employed a large team of men on this room, not including those who executed the wall paintings in a London warehouse. Temporary decorations made possible a limited use of the room at certain times before its completion. J.W. Croker saw it lit up with hanging lamps brought from the Gothic Dining Room in Carlton House in December 1818. He refers somewhat sceptically to a new theory of acoustics that had influenced Nash's design of the ceiling, and we know that the Prince had commanded certain modifications to be made after some concerts earlier in that year. But it was not until 1820 that the decorations were complete, and 1821 that the new lustres were first lit by jets of gas.

The King's Library, from Nash's *Views*. On the chimneypiece of the ante-room beyond can be seen the Apollo clock (page 9).

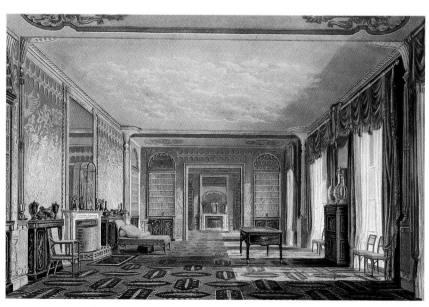

The King's Apartment

The King's Apartment looks out upon the western lawns through French windows and a shady loggia. It is part of the last additions, built without the restraint of predetermined ceiling heights but limited by the need to provide additional stairs and passages between it and the Music Room. Access from the Corridor was through a large yellow ante-room, from which one door opened into the staircase to the new bedrooms and the other into the vestibule of the King's Apartment.

To enter this secluded suite is to realize how far the Prince's ideas had moved since the first introduction of the Chinese taste within the Pavilion. The lingering influence of rococo prettiness is gone, the fantasy grown more studious. Its decoration was conceived just before that of the two principal drawing-rooms, but this is a private apartment attuned to the requirements of a man nearly sixty years old. The King was too heavy to climb stairs with ease, frequently disabled with dropsy and gout, and increasingly reclusive in his habits. It is a place that speaks not of the gaiety of society, but of introverted reflection; the apartment of a rich, cultivated gentleman.

One of the black Sèvres chinoiserie vases, with a design in platinum and gold, made in 1792 and acquired in 1812 for Carlton House, from where they were brought to the Royal Pavilion (King's Library). (BP)

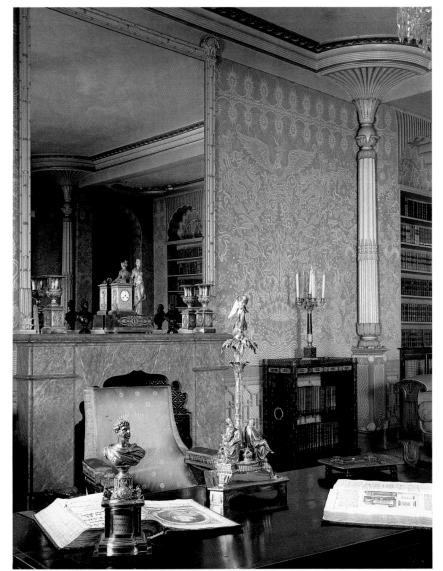

The King's Library today, furnished with sumptuous and exotic pieces of Regency furniture. The open chinoiserie stands against the wall are original to the Pavilion. An ormolu bust of George IV, commemorating his coronation, and a palm tree ink-stand in silver-gilt, a gift of his to Lord or Lady Conygham, stand upon the writing table.

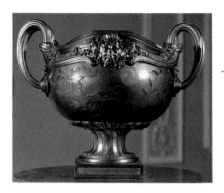

Among the outstanding pieces of Japanese lacquer in the Library was this bowl with French mid-eighteenth-century mounts. (BP)

For all the mixed oriental decorations, which abound here no less than in the other rooms, the general impression is one shared by many late Regency interiors—deep, restricted colouring, a love for arched niches and square openings, simple doorcases, rich draperies, mirrors rising to the level of a narrow cornice, and a collector's sense of furnishing. That libraries were becoming important and much-used rooms in houses of the period no doubt contributes to the feeling of a convergence with one of the main currents of contemporary taste.

The narrow vestibule or ante-room where visitors would wait for a private audience is really a part of the library, with which it is linked by a centred opening, ample and squared, in such a way that the vestibule chimney glass reflects the draped recess at the opposite end of the library. Cusped arched niches in both sections held bookshelves and fitted cabinets by Bailey and Saunders that incorporate panels of Japanese lacquer. In the library there were also two such cabinets, free standing, with exquisitely mounted Japanese lacquer vessels displayed upon them, and also the pair of black Sèvres chinoiserie vases that had earlier been mounted to accompany the furnishings of the Chinese Drawing Room of Carlton House.

The architectural embellishments range far and wide in their associations: at the edges of the ceilings are found Gothic-cum-Indian compartments, which in the library assume the shape of the cusped niches below. Again in the library, the four corner columns are truly eclectic inventions. The spears encircling the fluted yellow shafts are of Empire inspiration, but the general shape and most of the leaf mouldings are Indian, and the columns fan outwards to meet the ceiling in an Egyptian manner. Whether or not these are Nash's work, we know that the rest of the decoration throughout the suite was entrusted to Robert Jones. Continual refinement of the details occupied him during 1821 and 1822. It is a scheme which relies on the extraordinarily effective wall-covering design of dragons and clouds, first used in the Red Drawing Room, but in this case in white on a ground of slightly bluish-green. This ground colour, enlivened by yellow in the carved mouldings and trellis dado and originally relieved by yellow merino damask draperies in the windows and recesses, com-

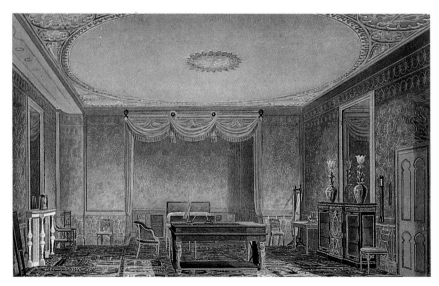

The King's Bedroom, from Nash's *Views*.

 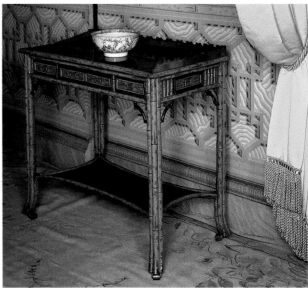

pletely dominates the rooms. It is quiet but opulent. Blocks for the printing of the dragon design were certainly made about this time. Printed samples survive, and the design was used in other parts of the Pavilion, but the paperhangers' accounts suggest that here it was hand painted: '310 breadths of dragon green in satin pencilled by hand'.

Jones painted each of the ceilings with a clouded sky and, in the coves and smaller compartments, serpents and sunflowers. The design of the carpet was probably his work too, a stepped design of alternating vertical and horizontal reserves, the whole densely patterned and Persian in effect. Nash's Views show some of the bamboo pattern chairs and armchairs last used in the old Yellow Drawing Room. In the library they were accompanied by a matching chaise-longue, well bolstered, with a reading-stand at arm's length, and by a bamboo-pattern ottoman in the recess from which the view is taken. A secretaire of *Louis Seize* shape set with lacquer panels stands against a window pier. Near it is a luxurious but simple English Regency writing-table.

Pride of place in the bedroom belonged to an elm-veneered writing-table with a sliding top and supported on gilded lion monopodium legs connected by shields and spears. Not only was it a fine example of one of George IV's favourite French cabinet makers, Georges Jacob, but it had also belonged to Napoleon, which must have given it a particular relish for the King.

A long ormolu-mounted display cabinet veneered in ebony and incorporating much outstanding *Louis Quatorze* buhlwork stood against a wall. The central door was mounted with a large ormolu panel representing Pharaoh's dream. A smaller buhl cabinet was probably between the windows.

The bed itself stood, with old fashioned ceremony, within a deep recess elaborately framed with yellow drapes. It had a carved mahogany frame, panelled at head and foot in lilac silk, yet none the less of a simple shape. The costliest and softest furnishings—satin covered bolsters filled with the 'best Dantzic feathers', 'four very large super-fine swan-skin blankets', a white Marseilles quilt, and so on—were provided for the bodily comfort of the ageing and often pain-wracked King.

left
The bedroom ceiling and the draped recess.

right
The gib door in the King's Bedroom recess. A private stair rises from behind it. A bamboo pattern table with a rosewood top conceals the fittings of a wash-stand.

111

Lest its occupant might need the ministrations (though surely not passionate attentions) of the confidante of his latter years, Lady Conyngham, she had only to descend a small stair from her own apartment and open a gib door. His valet entered from another such door.

At the extremity of the apartment was a dressing room, a page's room, and the most splendid bathroom, all marble and mahogany, whose water supply was pumped directly from the sea. No less than five different kinds of bath were provided.

The chamber floor

Until such time as it is more fully restored, it will be difficult to visualize the original appearance of the upper, or chamber floor. Its exceptional comforts impressed every visitor, regardless of his or her decorative tastes. Before the addition in 1819-20 of the northern extremities and the space above the Entrance Hall, accommodation was scarce indeed. The principal bedrooms, including the original Prince's Apartment, opened out of the galleries that Nash had built over each end of the Corridor in the initial scheme of improvements. These charming galleries, or lobbies, double at the south end, single at the north, are gained from the Corridor by the iron bamboo staircases. In the decoration they partook of the pretty, fulsome chinoiserie of the middle phase and continued the spirit of the great Corridor. It was one of these lobbies that Lady Ilchester describes delightedly as a 'centrical common room'.

Each ceiling was almost entirely occupied by a skylight, whose ground glass panels were painted with a variety of Chinese devices and scroll work in blue, yellow and red. There were no windows. Between the door cases, flanked by round trellis-painted pilasters with capitals in the shape of comically fearsome monsters, the walls were given over to a ground of cerulean blue applied with a complex trellis. It was a pattern formed from cut strips of bamboo print paper, a technique much used in Crace's work at the Pavilion. The total effect was true to one of the most persistent conceits of the chinoiserie movement—that of a light garden structure. Here the outside world has been reduced to a single

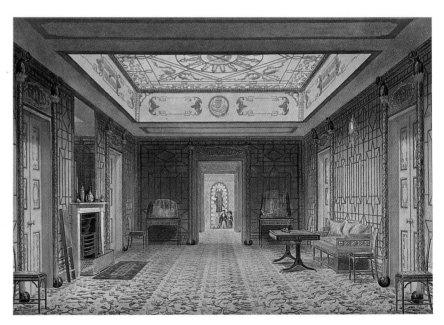

The double lobby or gallery (South) above the Corridor, communicating with guest bedrooms on the right, and the Prince's Apartment on the left. The structure of its northern counterpart has survived intact.

essence, the heavenly blue of an ideal cloudless sky as if seen from the top of a lofty bamboo tower.

Appropriately, most of the furniture repeats the bamboo theme, genuine and imitation. Plentiful small beech chairs, turned and painted to simulate bamboo, with blue leather squabs and tablet backs imitating leather, were placed both in these lobbies and in the bedrooms. Wherever space was available there was well-chosen porcelain and, on tables fitted with glass covers, exquisite ivory models of Chinese junks equipped for war or pleasure. The north lobby was also furnished with bamboo-pattern bookcases and small cabinets in rosewood and Japanese lacquer. Throughout, a pretty Brussels-weave carpet designed with strewn flowers filled the floor with horticultural colour.

Generally, the bedrooms contained a mixture of furniture in satin-wood, rosewood, mahogany, and painted wood in simulated bamboo. Those of secondary status, to the west, had canopied beds draped with chintz, and dressing-tables and wash-stands of a chinoiserie design

left
A table made from real bamboo, with a pine top. Page 112 shows two such tables with ivory Chinese junks upon them.

right
A bamboo-pattern chair of a type used in the bedrooms.

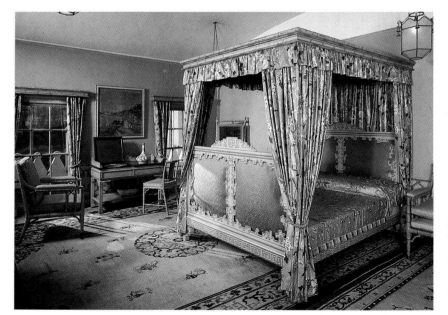

A bedroom opening to the west of the North lobby (at present the North Gallery) now known as Queen Charlotte's Bedroom. The bed, *bèrgere* armchairs and bedroom chairs and wash-hand stand are original to the Pavilion.

113

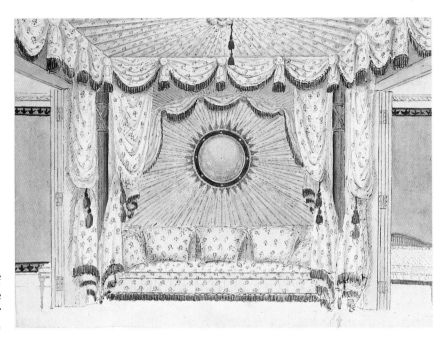

A design by Crace for the recess of the tent-draped boudoir in the Prince's Apartment on the upper floor.

The Prince's Apartment — a detail from Nash's *Views*.

in painted wood. The apartments of the Dukes of York and Clarence were naturally somewhat more luxurious. Each had a small adjoining bedroom for a personal servant, and contained a splendid French bedstead in satinwood or mahogany, from which the occupant might rise to observe not only the morning sun and the promenade upon the Steine, but walls richly adorned with Chinese pictures, watercolours in one apartment, oils in the other.

The Prince Regent's apartment, which probably achieved its final form in 1815, consisted of a bedroom, boudoir and dressing-room *en suite*. The upholstery and drapery throughout, except that of the windows of the dressing-room (which, in its Chinese pattern brocade and painted fringe valance, repeated, and probably utilized, the material of the old Chinese Drawing Room at Carlton House) was of a white ground calico sprinkled with blue convolvulus flowers. This material, together with fluted blue silk, was used to drape the boudoir entirely, forming what must have been one of the most sumptuous tent rooms of the period, in which a cushioned banquette extended opposite the window. The other two rooms were adorned with Chinese watercolours upon the walls and plentiful furniture. In the bedroom this was chiefly in satinwood with simulated bamboo mouldings, but there was also a pair of ormolu-mounted French *encoignures* (corner cabinets) incorporating Japanese lacquer, and a splendid Manière clock. Among the porcelain and mixed furniture of the dressing-room stood an object of service to the Prince whenever he wished to observe the passing parade upon the Steine — a handsomely mounted telescope.

Life in the Royal Pavilion

What would we not give to be the proverbial fly on the wall of the Pavilion, to see the show in performance, the combinations of etiquette, gusto, humour, and sentiment, or to hear the music-making and the gossip and the flap of playing cards and the rustle of silk? The social events were recorded in the local and London press, but however detailed, these notices are outlines only. It is in the journals and letters of a great age of memoirists that it becomes possible to discern the fragmented picture of how the famous rooms were peopled, used, and thought of at successive stages in the creation of the Pavilion. An immense variety of observers — Greville and Croker, both civil servants; Creevey, a minor politician with one of the most vivid pens of the time, and Mrs Creevey; the mischievous and brilliant Princess Lieven, wife of the Tsar's ambassador; Lady Harriet Granville Leveson Gower, sharp-witted and clear headed; clergymen, musicians, and lesser lights of society — all help to convey the flavour of the gatherings, sometimes in evocative vignettes but also in the perfunctory observations that almost unwittingly preserve what is so easily forgotten.

Of life in the original Pavilion there are the scattered accounts which picture a kind of undergraduate bravado, pranks, and dissipation. What was not outrageous made less impact. But the building was small and unfitted to anything more than small groups of friends. The extensions and alterations of 1802, coinciding with the change in fashion from public assemblies to private parties, provided three large rooms in addition to the Saloon, and thus the possibility of entertainments of some scale — in other words, 'society'. There was now, in Mrs Fitzherbert's second reign, a preponderance of decorous dinners and gatherings; and whilst the Prince kept many of his old associates, among them Richard Sheridan, The Hon. George Hanger, and George 'Beau' Brummell, his guests were drawn from a net cast more widely than before. Moreover the Pavilion, from being an elegant base from which he could step out to enjoy Brighton's pleasures, had become an object of unique interest and fascination in its own right with the installation of Crace's decorations.

Even the new, more sober, society took this full-blooded Sinomania in its stride, more so in fact than the ultimate decorations, which though more majestic and refined might not have appeared to be such obvious fun. 'The Pavilion is fitted up in the Chinese Style and is very beautiful:

The unusual cross-section acquatinted for Nash's *Views.* Prepared in about 1823, it shows the Pavilion in its completed form, and provides a unique record of many features of its construction.

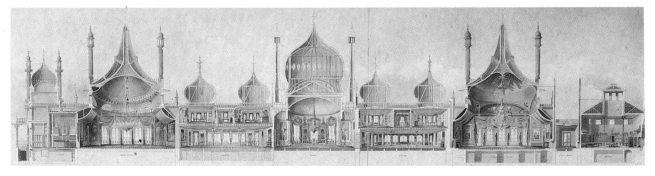

The Brighton Cup for 1804, won by the Prince's horse Orville. A representation of the contemporary Pavilion is shown in relief. The cup was acquired for the Pavilion in 1952.

it puts me in mind of descriptions in the Arabian Nights,' writes Mrs Creevey in 1804. Lady Bessborough in 1805 found it beautiful too: 'I did not think the strange Chinese shapes and columns could have look'd so well. It is like concetti in poetry, in outré and false taste, but for the kind of thing as perfect as can be.'

Diversions in these years included a phantasmagoria (a coloured light show) described by Mrs Creevey in 1806, which was exactly the kind of thrilling and ingenious spectacle the Prince enjoyed. Another probably at this period was the practical joke, recounted in Lamb's *Essays of Elia,* in which the dining-room was darkened to show an illuminated transparency lettered 'BRIGHTON – EARTHQUAKE – SWALLOW-UP ALIVE'. The Prince, like Sheridan, who abetted him in such things, retained his ebullient spirits long past the prime of youth. We are told even of target shooting, with air guns, inside the rooms.

The progress of the Napoleonic wars was followed with the aid of maps rolled out on the Pavilion tables. By virtue of its geographical position, Brighton received much of the war news before the rest of England. It was here that the Prince was told of Nelson's victory and death at Trafalgar, and was much affected by it. Soon after, an Inhabitants ball and dinner for 150 was held in the Pavilion. For some of the balls in these years, the Chinese gallery (the present North Drawing Room) was used for dancing, 'devices' being chalked upon the floor by Crace's artists.

A pattern developed in the celebrations of the Prince's birthday each year on 12 August in the form of a sham sea-fight presented by the Navy, and a military review in full and gorgeous uniform on Race Hill. 10,000 troops participated in the 1810 review. There usually followed a grand ball at the Castle Inn and a night of fireworks and illuminations in the town. Sometimes there was another birthday ball, a few days later, at the Pavilion. At one of these in 1808 Lord Byron, yet to develop his antagonism towards the Prince, was among the guests.

The Prince initiated a second Brighton season at Christmastime,

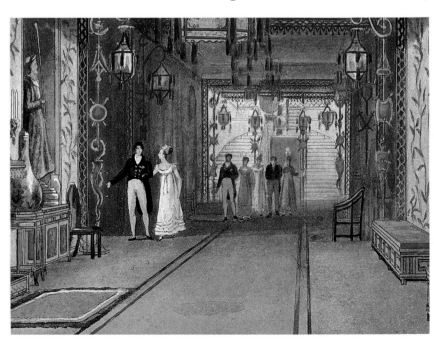

The Prince's guests in the Corridor. The decorations in this, the 1815 version, retained some of the barbaric quality of the first 'Chinese' phase.

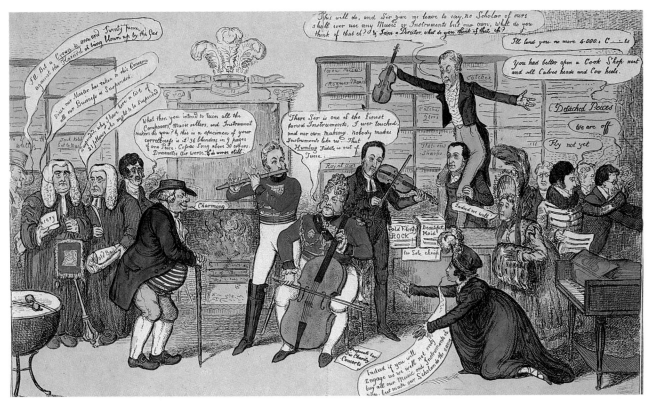

which was followed by 'the fashion', but the general regime during his sporadic residences was one of card parties, convivial dinners, and the musical performances which he took such care to arrange. At many of these musical evenings he himself participated, either on the cello or with songs in his expressive, if not fine, bass voice.

The best guarantees of a successful party are still careful preparation and the solicitude of the host. The Prince brought civility and attentiveness to a proverbial pitch. Those who were won over by his manners (and they were hard to resist) could forgive him much: even his opponents allowed him the title of 'the most accomplish'd gentleman in Europe'. Even when his habitual cordiality deserted him, as it increasingly did in the last fifteen years of his life, his guests were scarcely less charmed. He was graciousness itself, with a conviction and presence that made ridicule unthinkable. 'Powers of Heaven!' said a Brighton observer, 'there never was such a bow. It was a bow, Sir, which concentrated in itself all the grace, all the elegance, all the easy pliability which can be seen elsewhere in the three kingdoms.'

According to the Comtesse de Boigne, writing of the Pavilion in 1817, 'No householder could be more careful than the Prince Regent or more prodigal in small attentions when he wished to please. No detail was too insignificant for his care. As soon as anyone had dined with him three times he knew his tastes and took much trouble to satisfy them. Such attentions from people in high station are always impressive, especially upon those who make a point of displaying their independence. I never met anyone who was not speedily conquered by this means.'

Guests invited to stay at the Pavilion were asked for a certain number of days, rarely exceeding a week. The guest arrived in time to dress for dinner and found his rooms arranged with a care which respected even

The Prince delighted in performing on the cello at his musical evenings.

117

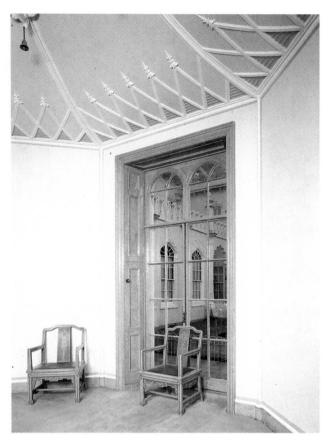

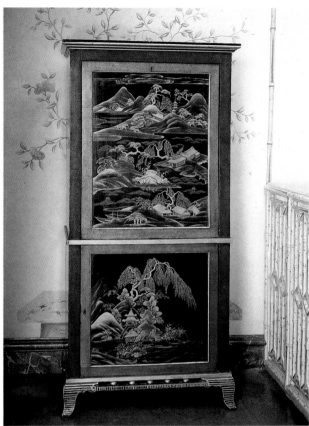

The Octagon Hall. The armchairs are in their original position.

A secretaire of Regency form, made for the Pavilion, has panels of Japanese lacquer with aventurine lacquer borders.

his personal habits, these having been ascertained by discreet enquiries. House and dinner guests, to the number of thirty or forty, met at six o'clock punctually for dinner, probably in the South Drawing Room. John Wilson Croker, writing in December 1818, said 'The etiquette is, that before dinner, when he comes in, he *finds* all the men standing, and the women rise', although Madame de Boigné has it that 'the royal host was almost always in the drawing-room before any one else'. She, however, was there with her father, the French Ambassador.

Croker again writes: 'He speaks to everybody, shakes hands with newcomers or particular friends, then desires the ladies to be seated. When dinner is announced, he leads out a lady of the highest rank or when the ranks are nearly equal he takes one on each arm.' Both of these accounts refer to a time before the present Banqueting Room was in full use, but whatever the setting we may be sure that dinner at the Royal Pavilion offered a performance of the gastronomic arts as carefully considered and as brilliant as the decorations and the music. It is well known that French *emigrés* at this period transformed the understanding of cuisine in England. The Prince sought out its secrets even before the Revolution, and ever after took a lead in the enlistment of French cooking as one of the great arts of civilization. Consecutive dishes of great elaboration were handed round *á la Russe,* each course accompanied by an appropriate wine. The traditional display of meats was relegated to the unrefined past. Some of the Prince's most valued servants had been cooks by origin — Weltje's culinary excellence was his original recommendation; Benois, another servant of reliable taste in furniture, had been a pâtissier. O'Bryne, a knowledgeable gourmet,

was introduced to the Prince by the Duc d'Orléans and became a valued friend. Never before in royal circles had such significance been attached to the preparation and excellence of food and to the status of the chef. The greatest cook of his day, Antonin Carême, was captured for a few months in 1816-17. We owe our knowledge of one of the most elaborate meals served in the Pavilion to Carême's record of his own creation — the dinner in honour of the visit of Grand Duke Nicholas of Russia, later Tsar Nicholas I, on 15 January 1817. The Grand Duke and other guests, among them the Ambassadors of Austria, Russia, France, Holland, and Spain, enjoyed a choice of no less than thirty-six entrées and thirty-two entremets. Among the confectionery set pieces were 'La ruine de la mosquée turque' and 'L'hermitage chinois', made of icing sugar. That even the Prince Regent could not prevail upon Carême to stay must have been a stinging disappointment.

At table, we are told, conversation and behaviour were conducted with a decorum that could satisfy the most correct ecclesiastical company: 'One is on a sort of tiresome good behaviour' says Croker, although conversations later in the evening were usually of a racier tone. Some guests enjoyed the continual music from the band in an adjoining room — certainly the Prince did, seen on one occasion to beat time on the dinner gong. Others were irritated by it.

Depending on the occasion, dinner could last from one-and-a-half to four hours, the ladies retiring, English fashion, a little earlier for coffee in a drawing-room. Generally other guests arrived at this point. The Prince would talk to everyone, then perhaps show some of the company new delights of decoration or furniture, before guests settled down to a musical evening or made up parties for games of cards, chess, or backgammon. Lady Ilchester, companion to Princess Charlotte,

left
One of two elbow chairs supplied with a set of thirty-six dining chairs for the Banqueting Room in 1817 — ebonized wood, with satinwood and brass details.

right
Copper fish-kettles, pans and divided herb trays — part of a *batterie de cuisine* that furnishes the kitchen almost as richly as the gilded decorations do the State rooms.

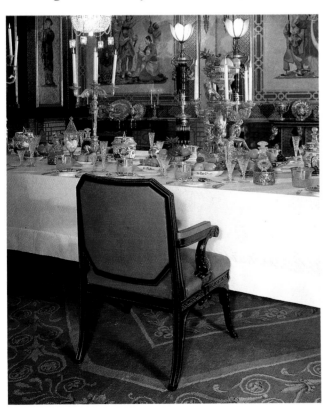

119

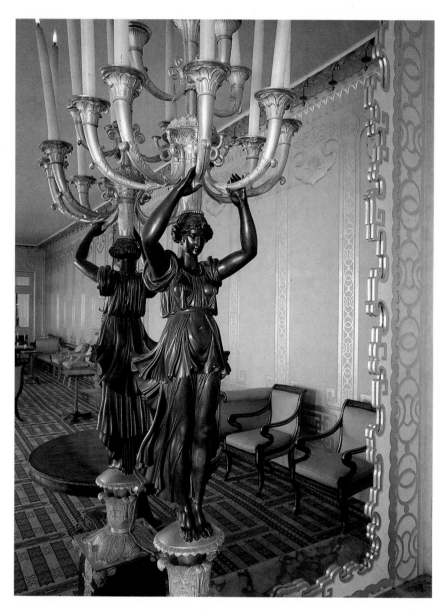

A view of the North Drawing Room reflected in one of its many looking-glasses. The frame, but not the candelabra, is original to the room.

says that 'walking up and down the gallery [the Corridor] was the favourite lounge.' Very often the guests were encouraged to join the Prince in making music themselves—songs and accompaniment, and chamber music.

At other times the band performed during card parties and *causeries*. There must have been many occasions when the Prince retired towards eleven o'clock with a few specially invited companions to another drawing-room where, over a cold supper and relaxed by wine, he could throw off all reserve. Madame de Boigné relates how 'he monopolized the conversation. He had a marvellous knowledge of all the stories of gallantry of the court of Louis XVI . . . [and of England] . . . and related them at length.' His jests were not always in the best of taste and 'these evening parties, which went on until two or three o'clock in the morning, would have seemed desperately wearisome had they been given by a private individual, but the enchantment of the Crown kept the whole company awake, and sent the guests away delighted with the conde-scension of the Prince.' Most commentators mention this condescension.

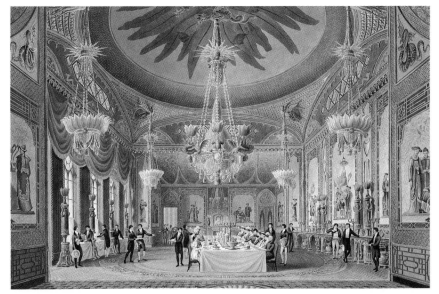

The Banqueting Room, from Nash's *Views.* A superb hand-tufted Axminster carpet, reflecting the architectural form and its complex decoration, was fitted to the floor, in tune with Regency ideas of comfort.

It is not to be taken in its modern sense, but as something remarkably gracious. It was important, however, never to presume upon the Prince's good nature. Sheridan was one of his closest intimates, yet Creevey 'never saw him take the least more liberty than if it had been the first day he had ever seen him.' Only true courtiers could have been entirely untroubled by the tense mingling of *vieille cour* etiquette and good-humoured informality that prevailed as the Prince grew older, even on the most relaxed occasions, but 'proper subordination' was the price to be paid for entering into the painstakingly constructed artifice of the Prince's world. Once paid, the host's performance could be enjoyed for the phenomenon it was, full of jokes, brilliant mimicry of celebrities and characters, astute comments, and attentiveness. Occasionally, however, he became so involved that intelligibility suffered.

There was always music. In the afternoon the Prince's band of wind instruments played upon the lawns. It was noted for the excellence of its German musicians and was considered by visitors to the town to be one of the enhancements of the promenade upon the Steine, where the band of the 10th Hussars also performed. In the evening, the Prince's band played in the rooms wherever it was required. To some the sounds were almost frighteningly loud. For the great occasions, the birthday celebrations, the visits of foreign royalty or ambassadors, and the betrothal of Princess Charlotte and Prince Leopold in 1816, it provided concert programmes and music for dancing.

After Princess Charlotte's death there was an unusual silence. A local paper reported that 'the Pavilion continues to preserve an atmosphere of sadness. There is no music, of which the Prince is so rapturously fond.' The silence was short lived. No better illustration could be given of the status of music in the Pavilion than the great Music Room, built in the year of this tragic episode. The bandmaster of the thirty to fifty instrumentalists was Christian Kramer, from Brunswick, who managed to run a china emporium in Brighton as well as arranging and conducting pieces by his master's favourite composers. Besides Bach, Haydn and Beethoven, the Prince was particularly fond of certain Italian composers such as Corelli, Paisiello, Cimarosa, and

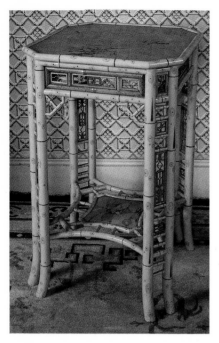

The bamboo-pattern style stimulated designs for the many types of tables and stands required in the private rooms.

Cherubini, the sweetness and gaiety of whose melodies was much in demand.

Among all the musical evenings, the concert performances, the informal occasions when the royal host might sing some such song as 'Life's a Bumper' to an accompaniment by Lord Ravensworth's daughters, one stands out — the visit of Rossini on 20 December 1823. Rossini, whose presence at the Pavilion had come about through the agency of Princess Lieven, created a stir not only on account of his celebrity but by the free and easy manner of his behaviour towards the King. He sat beside him, twirled his round hat upon his finger, and spoke without inhibition. The King himself was delighted. Rossini said later that 'it was scarcely possible to form an idea of the charm of George IV's personal appearance and demeanour.' The King took Rossini by the arm to the dazzling setting of the Music Room and introduced him to the members of his band, their blue, scarlet, and gold uniforms resplendent beneath the gilded pipes of the organ. When he commanded the concert to begin, the whole imaginary Chinese world of red landscapes and lily-like chandeliers resounded with the sounds of the overture to *The Thieving Magpie* and 'Buona Sera' from *The Barber of Saville*. Rossini was greatly impressed, and astonished that wind instruments alone could have produced such brilliant effects. Seating himself at the pianoforte, he continued the concert himself, and sang 'Salce' from his own *Othello* and one of his comic arias.

It was this Christmas week which Lady Harriet Granville Leveson Gower describes in her memoirs:

> The King is all gaiety, graciousness and nimbleness. I never saw him in such health and spirits. He scarcely ever sits down or is still but allows us. The company assembled were the Duke of York, who adores us, breakfasts *en trio* with us every morning, says Wherstead is the best house in England, and my toilette the most perfect. Partiality could no further go. The Duke of Clarence, the Duchess, a very excellent, amiable, well-bred little woman, who comes in and out of the room *à ravir* with nine new gowns (the most loyal of us not having been able to muster above six), moving *à la Lieven,* independent of her body. Lord and Lady Erroll with faces like angels, that look as if they ought to have wings under their chins. She is a domestic, lazy, fat woman, *excedée* with curtseying and backsliding. Lord and Lady Maryborough, a very agreeable woman, with a fine back and very plausible ugliness. The usual Dukes and gentlemen-in-waiting. Lord Exeter, who pays no attention to Lady Exeter, who, nevertheless, is as handsome and as delightful as ever. I think her out of spirits, and the wonder would be were she not.
>
> On Christmas Day we processed into the chapel, where the service was really divine, but what with heat and emotion very overpowering.
>
> I went after it to Lady Conyngham, and saw her Christmas gifts, which made my mouth water, and made me almost wish for a situation. A magnificent cross, seized from the expiring body of a murdered bishop in the island of Scio. An almanack, gold with flowers embossed on it of precious stones. A gold melon, which upon being touched by a spring falls into compartments like the quarters of an orange, each containing different perfumes. I returned like Aladdin after the cave, only empty-handed, which, I believe, he was not.

Breakfast could be taken in the bedrooms, especially by older ladies, like Lady Hertford, who would not be seen except in artificial light. Madame de Boigné found a breakfast-table laid in one of the lovely toplit communicating galleries on the upper floor. 'The effect of this centrical common room is very good,' says Lady Ilchester. 'There was in it an excellent fire and books and newspapers.' From the northern set of rooms to the southern was a private passage making it unnecessary to go down one staircase 'to get up by the other to the Queen's apartments from ours'.

The mornings were entirely free of court restraint. The Prince placed horses and carriages at his guests' disposal. He himself kept to his private rooms until three in the afternoon, when he habitually took a drive or, if sufficiently fit, went riding into the sea breezes or on the grassy downland that was still so easily accessible. In this manner, half-way between the lifestyle of an eighteenth-century French prince's *pavillon* and the great house parties of nineteenth-century England, recipients of the Prince's widely distributed favour passed days of such comfort that Princess Lieven could write 'I do not believe that since the days of Heliogabalus there has been such magnificence and such luxury. One spends the evening half-lying on cushions; the lights are dazzling; there are perfumes, music, liqueurs.' She detected an effeminacy which, she said, disgusted her but which did nothing to keep her away from the Pavilion. Though she was a sneerer by nature, others who stayed there also often experienced a sense of surfeit and *ennui*. It is paradoxical that for all his efforts to entertain his guests, and to entertain them with unexampled consideration, excitement, and plentitude, this extraordinary building could never mean as much to any of his acquaintance as it did to the King.

The Pavilion and the courtly pleasures he staged there were to the Prince part of an undivided whole, in which he was always dominant. For his subordinates there was none of that mental freedom which a setting of relatively conventional magnificence, however constraining the etiquette, allows. The Pavilion's interiors, superb, original, and enchanting as they were, must have served to compound the monarchical

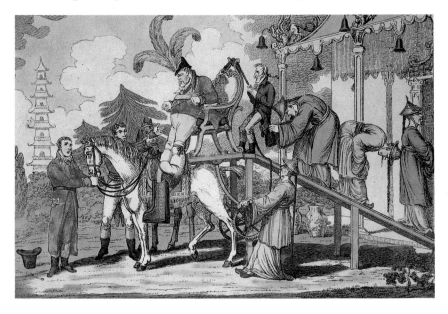

By Royal Authority. A new way of mounting Horse in spite *of the Gout!!!* (*c.*1816). The dignified figure on horseback was sometimes achieved by extraordinary means. The incident was observed at the Pavilion, though the Chinese details are sheer invention.

123

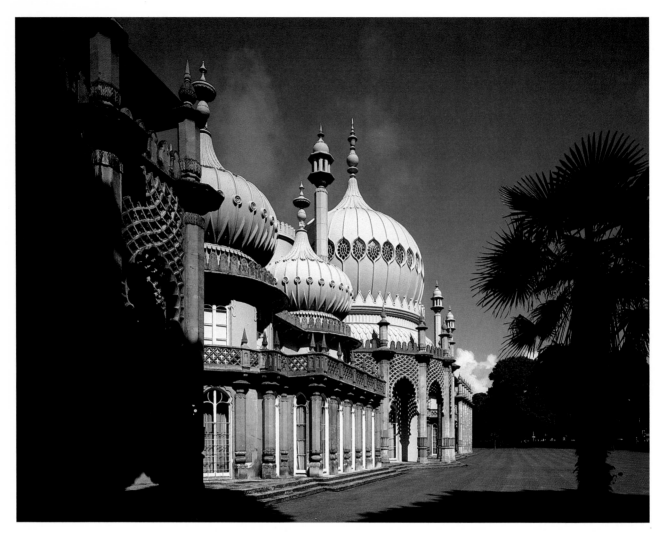

The East Front.

assault upon personality and senses alike. Enjoyment of this highly particular fantasy was clearly displayed by its creator, but although it was offered to all who attended him it could never perhaps be perfectly shared by those who knew him as Regent and King. And which of his guests genuinely wished to understand the sources of his dreams, the romantic yearning, the nostalgic recollections, the historical make-believe? The elapse of time since then has at least given us the advantage of a long perspective — an imaginative space which we, to whom even the ordinary things of the past can seem as strange as the Pavilion, are sometimes moved to try to fill. Such a process might bring us closer to an active understanding of the Pavilion than most of its privileged house guests.

Greville says that the Pavilion was 'not furnished for society', and complains of evenings tedious with *longueur*. 'They say the King is anxious that form and ceremony should be banished [but] who can feel at ease who is under the external constraint which etiquette and respect impose?' But while he was prepared to accept hospitality, he was neither sympathetic to the Prince nor affected by the Pavilion's peculiar magic. In a negative way he identifies for us the essential nature of the house, something quite distinct from that of a setting for court life or a nobleman's seat. It was much more personal, and

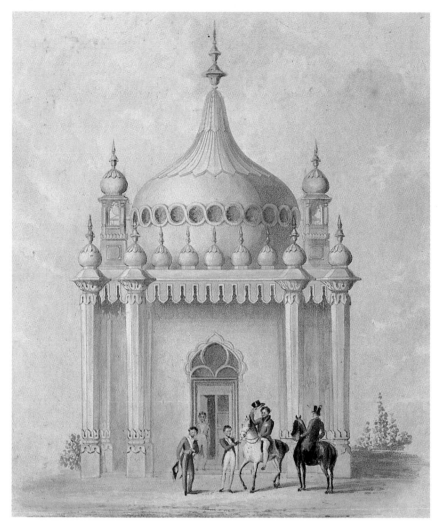

The porte-cochère, from Nash's
Views. It was built in the form
of an Indian temple or shrine in 1819.

though its purpose was always the delight and enchantment of the
Prince's chosen guests, much more demanding. He had since boyhood
been accustomed to subduing people with his charm and graces. The
Pavilion was an exquisite instrument fashioned to that end, but if,
like Greville, you would succumb to neither the pipe nor the piper nor
the tune, there was nothing for you here.

The Pavilion Survives

The Pavilion that is proudly recorded in the aquatints of Nash's *Views of the Royal Pavilion,* the last of which is dated 1824, had achieved a harmony which it would have been truly frivolous to disrupt. The forces of imagination which George IV had unleashed had by then completed their course to the satisfaction of their patron, and as a certain melancholy inevitably attends the satisfaction of an appetite, so it was with the Pavilion. Between 1825 and his death in 1830, the King paid but a single visit. It is true that he was growing more ill and more reclusive, that crowds were becoming disagreeable to him, and that Lady Conyngham was widely disliked (the Duke of Wellington ascribes the King's loss of interest to some offence given to her), but also that his indomitable desire to create splendid settings for himself was directed, in his last years, to seats of an ancient or metropolitan majesty—the inheritance of Windsor Castle and its outposts, and the new Buckingham Palace. It was in these that the superb furniture he was avidly acquiring from the Parisian sales was placed, not in the Pavilion.

Other members of the royal family continued to make good use of the building, but Brighton sensed it was losing the King's blessing. Significance was attached to the despatch in 1824 of a quantity of wines from the Pavilion's cellars. Following a brief visit in 1827, the Pavilion was several times made ready to receive him, but he was never to return: eventually his failing health made the journey impossible.

The social attractions of Brighton were by this time fully automonous. The 1820s saw the greatest building boom so far, with the construction of terraces of grand houses for the fashionable élite of Britain and

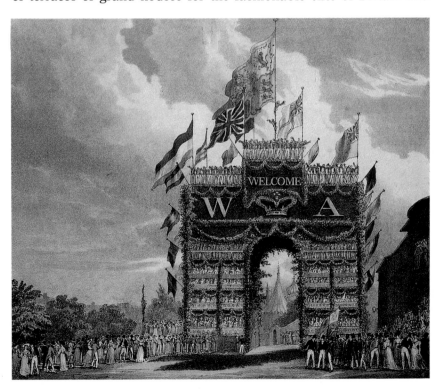

William IV's first official visit as King was celebrated with a massive triumphal arch in front of the entrance to the Pavilion grounds.

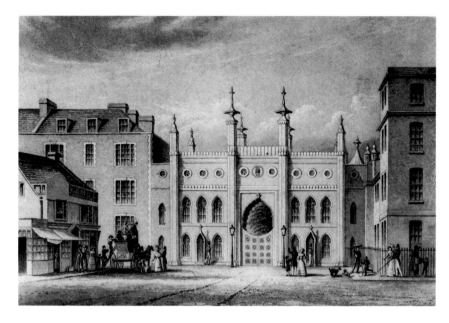

The South Gate, facing Castle Square; demolished after the Pavilion estate was purchased by the town in 1850.

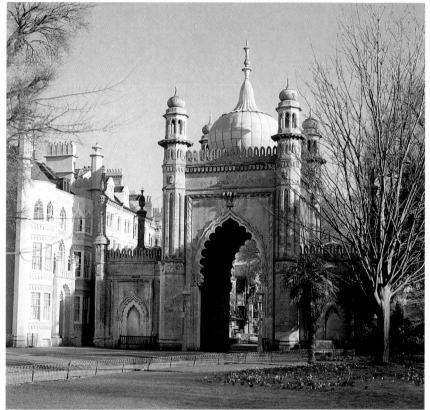

The North Gate. Built in 1832 by William IV, it fulfills George IV's plans for a magnificent entrance to the grounds. North Gate House, on the left, was preserved as Royal Household accommodation and 'orientalized' the same year.

post-Napoleonic Europe. Nevertheless, it was an anxious town that delivered a royal address to the new King, William IV, who as Duke of Clarence had had his own apartment within the Pavilion. His response, 'tell the inhabitants of Brighton I shall soon be with them', was received with relief. A crowd of 80,000 greeted him and Queen Adelaide on their official entry at the end of August; the carriage passed through a gigantic arch decorated with foliage, bunting, and seventy sailors. A fortnight before, the King had made a private visit to discuss with Nash his own building requirements, although Nash was only an

adviser now. The official architect was Joseph Good, and since the Pavilion had been given the status of Royal Palace, the improvements were commissioned through the Office of the King's Works and not the Royal Household.

William IV's priorities were an increase, long overdue, in the provision of rooms for visitors and servants, and the erection of gatehouses. By 1832, the last chapter in the story of royal building in Brighton was ended. To the south of the western lawns was a serviceable range of 'dormitories', a portion of which survives. Between it and the Pavilion proper, East Street was closed off by a massive stuccoed gatehouse with oriental windows and minarets and sixteen bedrooms. The principal gatehouse, a distinguished and worthy northern entry to the Pavilion grounds which still stands, was made possible by the removal of a blacksmith's shop whose owner had resisted all pressure by George IV's agents. Built of Bath and Portland stone and surmounted by an oriental copper dome, it augments the Indian vocabulary used in the main buildings and is quite the tribute to his brother's achievement that the new King intended it to be. The adjacent house, all that remained of Marlborough Row, was orientalized in sympathy, while behind it, to the east side of the great stables, the shell of the proposed tennis-court was fitted with stabling for the Queen's horses. There was to have been, in the north-east corner of the grounds, a separate guest house in a compatible style.

William IV possessed a personality as gauche and ungifted as his brother's was polished and imaginative. It is a trifle strange that he enjoyed his frequent residences at the Pavilion so much, in view of his declared opinion that a house should be plain and, above all, should have no touch of gilding, which he disliked, he said, extremely. 'Knick knackery' was his term for the fruits of his brother's connoisseurship. But his philistinism was happily inactive; during his reign the Pavilion remained unmolested, whilst in its maintenance Robert Jones himself was recalled to restore his own work.

Queen Victoria's last residence in Brighton in 1845 was partly snow-bound. The scene was more like something from a Russian fairy tale than an English seaside town. Contemporaries often referred to the Pavilion as 'The Kremlin'.

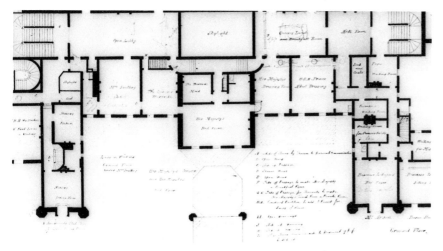

Detail of an accommodation plan of the upper rooms, made for one of Queen Victoria's last visits. Several rooms were devoted to the needs of the royal children.

The new King had always liked Brighton. He was embarrassingly gregarious and, having made a career in the Navy, felt happiest near the sea, two characteristics symbolized by his daily walks on the new Chain Pier. Princess Lieven said 'he was adored by the mob'. Certainly he held no charms for the cultured and fashionable circle which had surrounded George IV. Though the Pavilion had never been more intensively used, the tone was set by family festivities of every kind, largely for the benefit of the Fitzclarences, the King's numerous progeny by Mrs Jordan, and by young people's balls for the local gentry. Greville writes of 'a court very active, vulgar and hospitable', and mentions the 'tagrag and bobtail' who appeared at the royal table, culled from hotel visitors' lists to feast upon what Lord Dudley remembered as 'cold pâté and warm champagne'. At least, at Queen Adelaide's insistence, the guests were respectable, and when they ate it was in perfect safety, for after a premonitory nightmare of hers the great dragon gasolier was removed from the Banqueting Room.

One proud survivor of the old days received her invitation to the Pavilion with good grace. After assiduous coaxing by the King, who wished to pay her the honour everyone knew she was due, Mrs Fitzherbert, now in her seventies, was welcomed into a Pavilion in which all she could have recognized after an absence of twenty years would be a few pieces of furniture and the spirit of her impossible husband. She accepted royal livery for her servants, but declined the title of Duchess. Of the Pavilion's occupants she said 'They lead a very quiet life.'

One more royal proprietor of Brighton's extraordinary palace — its creator's niece, the young Queen Victoria — paid her first rather bewildered visit to the Pavilion in October 1837, four months after succeeding to the throne as a girl of eighteen. She was rapturously welcomed; the floral architecture erected for her entry outdid everything seen before. During her six-week stay, the Queen and her mother sang operatic airs at evening parties in the Music Room. How different it must have seemed from the days when the great voluptuary was host! The surroundings her uncle had spent a lifetime devising were quite foreign to her experience and represented a style of life which she was neither inclined, nor encouraged, to pursue. Except for Christmas 1838 she did not return until Prince Albert and her first two

With the arrival of the railway in 1841, Brighton became accessible to thousands of ordinary Londoners. Its fashionable status entered a decline and the press of the crowds soon made life there intolerable for the Royal Family.

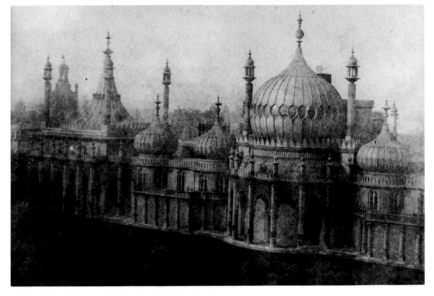

The only existing photographs of the Pavilion when still a Royal residence were taken by Edward Fox Talbot in 1846. The clock and water tower on the left survived until the end of the century. It is just possible to make out the shutters on the windows, and a sentry box.

children accompanied her to Brighton in 1842. Nursery adaptations were made upstairs, including a miniature kitchen range for the the edification of her growing family.

It was in the Pavilion that the children awaited their mother when she disembarked at the Chain Pier after her visit to King Louis Philippe in Normandy in 1843. Her return was the last great royal occasion for which the Pavilion was used. A large party, including the Prince de Joinville, was accommodated, and the great Banqueting Room gasolier reinstalled for the occasion. In 1845 Brighton saw the last of Queen Victoria. A snowy February, occupied in family sleigh rides within and beyond the Pavilion grounds, ended in the Queen's departure on the new railway which had at one stroke brought Brighton within reach of the London masses. Neither she nor Prince Albert, as is often supposed, disliked the Pavilion itself (indeed the extensive re-use of its most characteristic furniture and decorations in Buckingham Palace suggests otherwise), but Osborne in the Isle of Wight, acquired that year, offered the privacy the family needed.

Comforts and convenience had been improved but there had been few decorative alterations. Dr Reid, best known for his work in the Houses of Parliament, devised a new ventilation system. Window awnings were fitted, and on the chamber floor communications between

the rooms were modified. For the rest, as a contemporary Housekeeper's book shows, everything was scrupulously maintained. The most elaborate carpets were rejuvenated by shearing, though others were replaced in designs that reflected new tastes, and some of the soft furnishings were dyed.

The announcement of the intention to sell the Royal Pavilion to recoup part of the costs of the extensions to Buckingham Palace came in August 1846. It was the end of Brighton's glittering place in the life of the royal court and almost the death knell for the Pavilion, and the town knew it. A committee was appointed by the Town Commissioners to seek a means of averting the sale, but until November 1848 no firm statement emerged from the Government Department responsible, the Office of Woods and Forests. Curiously, the Department kept the structure in meticulous repair, while the Lord Chamberlain's Department gradually emptied the Palace of its contents until even the brick walls beneath the painted wall coverings and the marbled skirting boards were left naked. The delicious cabinets and richly ornamented chairs, the ormolu-mounted china, the French clocks and Boulle furniture, all the brilliant treasury of objects and decorative schemes that George IV had assembled in a unique and fantastic harmony, were piled on to carts bound for the royal palaces in London. The journey kept a local carrier busy for nearly two years.

Before the Bill to enable the sale was brought before Parliament in June 1849, the Town's Pavilion Committee had spent several months preparing its case for purchase at an agreed price to preserve the Royal Pavilion and its grounds as an asset, rather than see it sold as a site for speculative building. The resourceful leader of the campaign was the Town Clerk, Lewis Slight, whose powerful vision secured the preservation of the Pavilion by the Local Authority. When the Bill was tabled its terms confirmed Slight's worst fears—demolition and sale, free of all restrictions on the use of the land. But Slight had the shocked support of nearly 7,500 petitioners and of Brighton's two

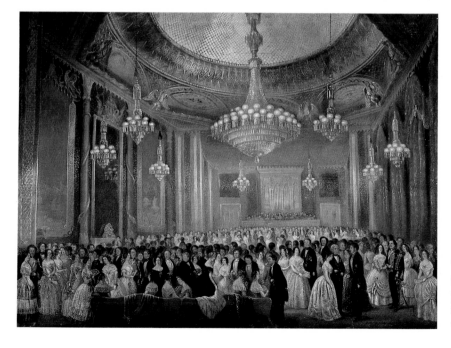

The Music Room on the night of the town's inaugural ball, January 1851, painted by W. Penley. The original murals and detachable ornaments were not to return until 1863.

131

MPs. In the face of such opposition the Bill's second reading was postponed. An official deputation secured promises of the desire to sell the Pavilion to Brighton, and of the intention to respect the legal restrictions. A price of £53,000 was agreed. The Bill was dead, but the bird was not yet in the hand. Local opposition to Slight, much of it motivated by personal malice, gathered force during discussions on the draft contract. On 20 December, when a town meeting received the draft of a new Parliamentary Bill enabling the sale, Slight produced a contract which he had signed the previous day. He was accused of overreaching his powers, and it was only after a narrowly-won referendum on 22 December 1849 that the matter was successfully settled. Royal Assent to the Bill was given the next May.

As well as being an opportunist acquisition by a town deficient in magnificent rooms for public use, the purchase of the Royal Pavilion was a remarkable early instance of municipal conservation. There had been real horror at the prospect of losing something so distinctive, so palpable a memorial of royal patronage, a building whose development had gone hand-in-hand with that of Brighton itself and which was permeated with the very spirit of the place. Many of the townspeople who had seen the Pavilion in its full glory had a firm grasp of its significance. The *New Monthly Magazine* ascribed the following view to Slight and his supporters: 'We don't want to buy the Pavilion for ourselves, but for our visitors . . . we must make the Pavilion our shopfront, and then people will come to look at what's in the place.'

When Slight at last received the keys of the Pavilion in June 1850, he was appalled at the devastation within its walls. The decorations of the great ceilings were intact, but almost everything else had been taken—chandeliers, chimneypieces, the stretched canvas murals and carved ornaments, even the skirting boards were gone. It is a tribute to the confidence of the period that by the following January, when a grand reopening ball took place, the repairable losses had been made good. The designer was Christopher Wren Vick, who had been employed in the Pavilion while it was still a royal residence, and whose thorough knowledge of the decorations enabled him to devise, on what was even then a sparing budget (£4,500), a scheme which respected and, where possible, reproduced the work of George IV's craftsmen. Many of these replacements are still to be seen, most noticeably (since they share least in the spirit of their predecessors) the robust stone chimney-pieces by John Thomas. Vick's careful drawings show that in 1850 the ceiling decorations still retained their former brilliance, a standing example for the town to follow.

It remained to demolish the Royal Chapel and the large complex of service buildings which stretched south and west of the Great Kitchen to the edge of Castle Square. Except for the southern gatehouse and the clock tower, which survived in heightened form until 1898, none of these adjuncts resembled the main body of the Pavilion, and so it was decided to exploit the value of the site for building leases. By this stroke almost enough income was generated to make the interest payments on the purchase price. Every kind of use was found for the Pavilion's rooms, from flower shows to artists' studios, from lectures to charity balls and concerts. A museum was initiated in one section. The Great Kitchen was adapted to the needs of an art school. When

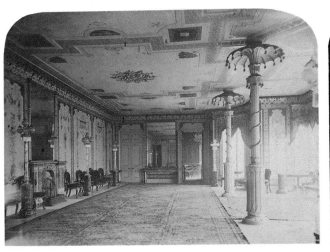

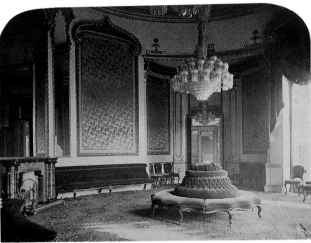

convenient the public were admitted to tour the interior for a fee of sixpence.

Francis de Val, who had been apprenticed in the china shop run by George IV's bandmaster Christian Kramer, was the Royal Pavilion's first curator. To his persistence we owe the successful application to Queen Victoria in 1863 for the return of a large proportion of the dismantled decorations. It had become clear that a scheme more permanent than Vick's efforts was now necessary. What emboldened de Val to seek out the original material, which he knew lay in the bowels of Kensington Palace, was probably the disturbing prospect of an entirely new and characteristically mid-Victorian scheme sketched out by J.G. Crace, Frederick's son. In the event, Crace found the Council's terms unacceptable, and when the redecorations were put out to tender, de Val's dream of reinstating the major proportion of the glories of the Music Room, Banqueting Room, and Saloon was assured of fulfilment.

A French expatriate artist, Tony Dury, was commissioned to fill, so to speak, the gaps. His most ambitious task was to execute replacements for ten of the eleven largest figurative panels in the Banqueting Room. Working from designs believed to be based on costumes from the French opera, Dury achieved effects that bear close comparison with Robert Jones' original canvases. The drawing-rooms, however, were less respected. Their place in the sequence of interiors was ignored, and it was instead felt necessary to diminish the contrast between them and the great rooms. In the North Drawing Room colourful borders framed wall-panels sprinkled with ornament. Angular patterns of embossed strips appeared on the low, once plain ceilings. It was a literal conception of 'applied art', a Victorian term which seems inappropriate for even the most richly ornamental parts of George IV's Pavilion.

This departure in taste and feeling began a lengthy decline in the integrity of the rooms. With hindsight we can see how peculiarly vulnerable the Royal Pavilion is to intrusions of an alien spirit, let alone the normal processes of age and decay. A medley of Arabesque, Pompeian, and Chinese motifs was let loose, uninformed by the original romantic bravura in which eighteenth-century decorum was always implicit. Even if these restorations lacked the scrupulousness of our

left
The North Drawing Room in 1866.

right
The Saloon in 1866.

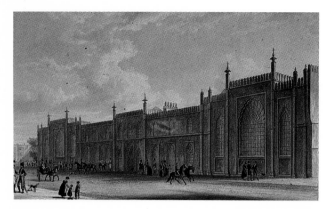

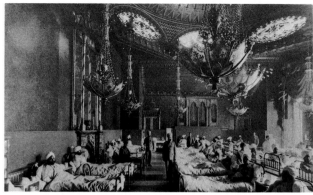

left
The Stable Front, Church Street, from Nash's *Views*. After years of military use, the buildings were converted to cultural purposes. The Concert Hall (1867) was followed in 1873 by a museum, art gallery and library.

right
The Music Room as a ward for wounded Indian soldiers (1915).

own day, the Pavilion interiors, empty save for a few conventional sofas and chairs, stood the town's social life in good stead for thirty prosperous years.

With the Pavilion refurbished, the domed stables were vacated by the army and transformed in 1867 into an impressive Moresque concert hall. Queen Adelaide's stables were converted in 1873 into a forerunner of the present Museum and Art Gallery, though eight rooms in the Pavilion itself remained crowded with museum exhibits. Bedrooms were combined to form large Masonic rooms, while the need for cloakrooms and service bars led to the further disappearance of many interesting minor rooms downstairs. In 1887 the town, a pioneer in electrification, fitted light bulbs to the Pavilion's famous chandeliers.

Victorian Brighton welcomed potentates and dignitaries from the four corners of the world. The Emperor of Brazil, the Shah, and the Sultan of Zanzibar were all received in the Royal Pavilion. The thoughts of the Chinese Ambassador, a visitor in 1877, have unfortunately not come down to us.

Among the visitors in 1896 was the Prince of Wales, like his uncles a lover of raffish, exhilarating Brighton, where one of his friends, of the fabulously rich Sassoon family, built a Pavilion-style mausoleum behind his Brighton seafront home. The Prince, perhaps recalling infant memories of the Pavilion in its pristine brilliance, remarked upon how dingy it had become. Copious varnishing over the years had not only dimmed the decorations, but actually altered with a browning yellow film the complex harmony of colours, making nonsense of the decorative schemes. This kind of 'patina of age' was valued by many for its own sake, and was even imitated in new work. The Pavilion's magic could never survive it. Large sums were now spent on new restoration, but there was a great deal of overpainting on the mural panels, and new decorative painting moved one stage further from the original conception. Frederick Crace's grandson J.D. Crace was responsible for much of it, including a Moorish treatment in fretted wood and lincrusta relief of the South Drawing Room. Royal interest brought the return of a batch of lanterns and other ornaments in 1898, but the reputation of the Pavilion continued to sink.

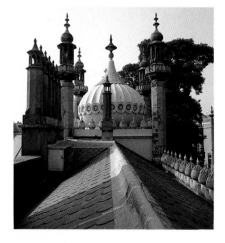

The roof over Nash's northern extension to the Pavilion—looking toward the north-west tower.

However, a new breed of style-makers, nurtured by the influence of Oscar Wilde's circle and by the hedonistic ethos of Edwardian society, now began to reconsider George IV and his works unimpeded by the moral disapprobation of preceding generations. Max Beerbohm's

comment on George IV in 1904, 'His life was a poem', was provocative in its sympathy. A Regency revival style in furnishing made an appearance. Though the Royal Pavilion was no longer star of the show in Brighton, and the focus of high society's seaside relaxations had moved to the South of France, there were at last some stirrings of enlightened appreciation before the First World War conscripted the Pavilion for a role as bizarre as its most fanciful dragons. From 1914 to 1920 it was in service as a military hospital, latterly for limbless servicemen, but initially, at King George V's suggestion, for Indian soldiers alone. The Great Kitchen became an operating theatre. Catering and water supplies for the various castes and religions were kept distinct, and in the splendid chinoiserie rooms of this *ancien régime* pleasure house, rows of iron bedsteads were occupied by puzzled combatants from the lands of a real orient.

left
Carved gilt pilasters from the Saloon were returned to the Pavilion by King George V.

right
A seven-light candelabra in silver-gilt by Paul Storr, 1814, made for Lord Stewart (later Marquess of Londonderry) when he was Ambassador in Vienna. Part of the Londonderry Collection secured for the Royal Pavilion in 1982.

A soup tureen in silver-gilt, by Paul Storr, 1813. Part of the Londonderry Collection shown in the Banqueting Room.

As a mark of appreciation, the King presented the Banqueting Room's eight original standard lamps, the first free-standing pieces to return. Hard negotiations by Henry Roberts, the first Director of a combined Pavilion, Museums, and Library Department, secured a large sum from the Government towards making good the depredations of military occupation. But work on the Pavilion went far beyond this. Between 1920 and 1934 extensive and costly repairs were made to the fabric of the roof, where minarets, crenellations, and cracking stucco on the domes all required attention. The use of inappropriate materials created future troubles, but the need for maintenance was firmly acknowledged. In the Music and Banqueting Rooms Roberts removed much of the disfiguring accretions. After 'toning down', however, the jubilant colours then revealed soon dimmed again, but despite some unsatisfactory methods the effort was admirably conscientious, based on a belief in the value of the Pavilion not merely as a set of magnificent

Post war restoration painstakingly revealed the enchanting landscapes of the Music Room murals after decades of obscurity.

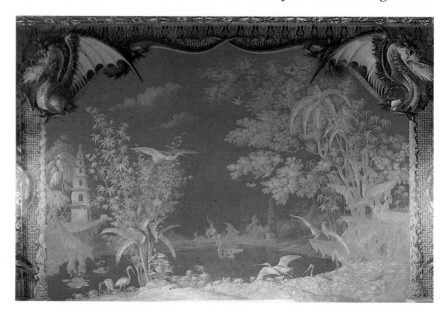

public rooms but as an historic monument. In this the guardians of the Pavilion were greatly aided by personal royal encouragement.

Queen Mary, grand-niece of George IV, had begun forty years of active interest in the Pavilion's welfare in 1912 with a gift of original mouldings from the Royal stores. The significance of her patronage throughout a period of uncertainty and threat should not be under-estimated. Her numerous gifts of exhibits and fragments encouraged the notion that the Pavilion should be properly restored and furnished when the local will was weak. Till the end of her life she would make visits at the shortest notice to see what had been done in the building she understood more than did most of her generation.

When Roberts retired in 1935, Osbert Sitwell and Margaret Barton brought out their book *Brighton,* which, expressing the fascination which Regency life exerted upon many of their contemporaries, enormously influenced the reading public's conception of the Pavilion. It is not extravagant to say that from that moment it began to assume its proper place in the collective imagination, while the malignant bigotry towards George IV's creations, which led *The Times* in 1930 to regurgitate the bile it had expressed in his obituary notice, began to wane. The proposal in 1935 by the much admired Alderman Carden to demolish the Royal Pavilion in the interests of a 'modern' Brighton was rejected. Shortly before the war, the Moorish tea-room effect in the South Drawing Room gave way to something approaching the original scheme, and the Saloon was much improved by the reinstate-ment of its decorated white lacquer doors (one pair a copy), its pilasters, and Queen Mary's gift of Chinese wallpaper.

left
A wardrobe of orthodox appearance, now in the King's Bedroom. One of the original pieces that has come to light on the market.

right
One of the many stands in simulated bamboo. The Queen's loan represents many types of furniture originally in the Royal Pavilion.

137

The Pavilion survived the bombing, but the war took its toll. Maintenance was basic and restoration abandoned. Buffeting by beer barrels and a thickening film of exhaled nicotine hastened the rooms to a state of saddening decay. The return of peacetime was perhaps the most perilous period in the building's history. In one direction lay public indifference and the threat of demolition. Its deteriorated appearance had lost the Pavilion its place in local pride, and its protection against a post-war mood of reconstruction and the 'clean sweep'. A longer path led eventually towards the faithful recovery of its early integrity.

Several propitious factors now combined to favour the latter course. In 1945 a local Regency Society was formed to safeguard the town's historic character, and the Pavilion was one of its chief interests. In 1946 there was a 'Regency Exhibition' in the Royal Pavilion, devised by a formidably well-connected private committee to raise money for charity. Among many generous lenders, King George VI sent stunning pieces of original furniture. Three members of the royal family paid visits. To an austerity-weary public the spectacle of the hitherto bare Pavilion fleshed out with sumptuous furnishings was nothing short of a revelation. The most important development was Clifford Musgrave's appointment as Director of the Royal Pavilion Estate; his unflagging resourcefulness and vision established the Pavilion over the next critical years as 'one of the great showplaces of Europe'. With a tiny staff, including Roy Bradley, an artist-conservator of rare talents who could absorb the spirit of the original, Musgrave initiated a restoration based upon sound scholarship, authentic methods, and patient scientific care. In the Music Room the new thoroughness unexpectedly revealed the original murals beneath dense overpainting. Test scrapes from woodwork and plaster throughout the building suggested the extent of what had remained hidden for generations. Such physical evidence and the superb aquatints and preparatory drawings for Nash's *Views* were to be the chief sources for subsequent work. The objective was

left
A Music Room pelmet ornament is prepared for its surface of colour-glazed silver leaf.

right
The regilding of wood and metal ornaments from the Music Room. A reconstruction of the design for the carpet may be seen in the background.

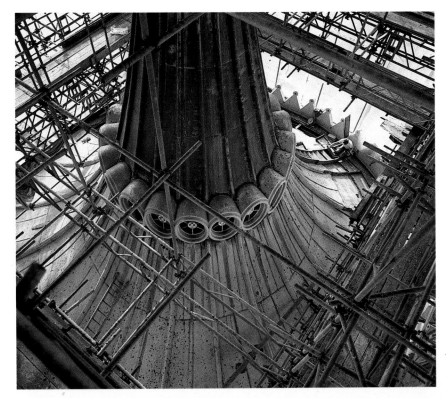

The Banqueting Room roof in the course of restoration, 1982. Work included the replacement of the minarets (previously substituted in fibreglass) in Bath stone to an authentic design, and the elimination of serious dry rot.

Restoration work on the cove of the Music Room ceiling. The high standards and characteristics of the original work are strictly adhered to.

139

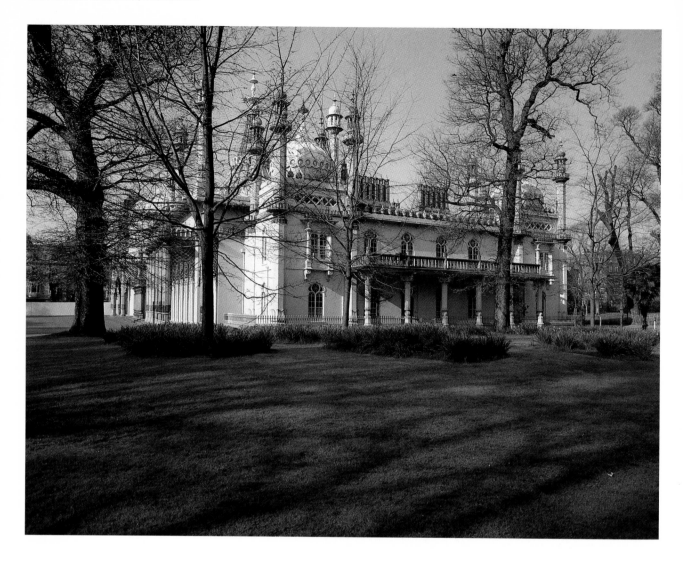

The North Front — before repainting in the original stone colour.

unusually clear — a return to the Pavilion in its completed state of 1823.

Increasingly ambitious exhibitions were held in 1948 and 1951 under the auspices of the Regency Society, each attracting intense national interest. In 1950, the centenary of the Pavilion's purchase, the exhibition was sponsored by the town council, which in agreeing to buy two of the original porcelain pagodas for the Music Room began the Pavilion's own permanent furniture collection, as essential to the Pavilion's revival as its decorative restoration. From that year onwards, at least during each summer, the Pavilion has been a furnished palace.

In every subsequent exhibition visitors would see some new, often dramatic improvement: a whole room returned to something near its original appearance, or a more appropriate selection of furniture, borrowed or bought. Somehow the work progressed despite intensive public use of the rooms. The continuing success of this policy helped to scotch serious attempts to convert the building into a casino and to build a conference hall on the western lawns. By 1955 the vanished wall-coverings of the King's apartment had been exactly reconstructed, and the same process was approaching completion in the Corridor. That year, the present Queen, in a signal act of confidence, returned on permanent loan many pieces of the original furniture. The reappear-

ance of cabinets and chairs conceived for George IV's schemes extended immeasurably the Pavilion's authenticity.

In the next phase, earlier compromises in the Banqueting Room were righted by scientific cleaning of the paintings and the renewal of wallpaper and dado mouldings to the correct design and colour. The entrance rooms and Red Drawing Room were transformed by removing dark layers of overpainting and varnish, and the North Drawing Room wall pattern and decorative mouldings brilliantly regilded. What Sir Harold Nicolson a few years before had seen as a 'battered kiosk illustrating the tragedy of decay' seemed to be conquering the deadening hand of time. By the late 1960s, the permanent collection, though continually refined, required few supplementary loans. Most of the building was furnished throughout the year, and the public had daily access.

Clifford Musgrave's remarkable achievements have been continued since 1968 under John Morley. The authenticity of many of the interiors has been enhanced, facsimiles of original chimneypieces have been reconstructed, and close carpeting rewoven to the early designs has reintroduced a vital element of comfort. Most important of many acquisitions was the purchase in 1982 of the Londonderry silver-gilt collection, displayed on loan in the Banqueting Room since 1952.

An expansion of the Conservation section in personnel and equipment has brought new challenges within compass. When the Music Room, newly restored in part, suffered grave fire damage in 1975, the task of carving, gilding, and decorative painting on an unprecedented scale was not only within the staff's capabilities but such was its tradition of excellence that no outside team could match the specialized requirements. An almost complete restoration of the room to its original specifications will, when finished, make quite clear what remains to be done throughout the Pavilion and that many decades of such work lie ahead. The same exacting standards have for the first time been applied to the restoration and conservation of the stonework and structural fabric in a massive programme (begun in 1982) undertaken without demur by the Council. Goodwill is abundant as never before. The problems now are those which attend success and the high expectations aroused by it.

The Royal Pavilion is still being revitalized as one of the world's most distinctive, enjoyable, and brilliant works of art. Over 400,000 visitors come each year to see its resuscitated splendours, compared with the 10,000 who viewed its pre-war bareness. It is busy with film-makers, scholars, interior designers, and manufacturers seeking inspiration. For those who respond to such things, it is impregnated with the personality of George IV, its extravagant, fastidious, infuriating, totally charming creator. He is still making impossible demands. We cannot expect easily to find resources to replace the luxurious drapes of brocade and rich silks, or the precious ormolu-mounted porcelain which stood on almost every cabinet and stand. Yet the example of the Prince whose yearning for the marvellous never faded makes us, too, believe that dreams can, after all, be made real.

Brief Chronology

1762	Birth of George Augustus Frederick, Prince of Wales, on 12 August.
1783	First visit to Brighton by the Prince of Wales.
1785	The Prince's clandestine marriage to Mrs Fitzherbert.
1786	Brighton House leased on behalf of the Prince.
1787	Henry Holland builds the Marine Pavilion, incorporating Brighton House.
1793	Revolutionary France declares war on Great Britain.
1795	Marriage of the Prince of Wales to Caroline of Brunswick.
1801	Significant extensions to the Pavilion.
1802	Introduction of 'the Chinese taste' to the interior decorations.
1805	Humphry Repton proposes designs for an Indian exterior.
1811	Prince of Wales created Prince Regent.
1812	Prince Regent given the full powers of a constitutional monarch.
1813	Death of James Wyatt, chosen architect for the development of the Pavilion.
1815	John Nash's transformation of the Pavilion begins. Initiation of the second-phase chinoiserie interiors by Frederick Crace. Final defeat of Napoleon.
1817	Death of Princess Charlotte, the Prince Regent's daughter.
1818-19	Transformation of the East Front of the Pavilion.
1820	The Prince Regent succeeds to the throne on the death of King George III.
1822	Completion of the exterior of the Royal Pavilion.
1823	Completion of the final phase of the interior of the Saloon.
1826	Publication of Nash's *Views of the Royal Pavilion at Brighton*.
1827	King George IV's last visit to Brighton.
1830	Death of King George IV.
1837	Death of King William IV.
1845	Last visit to Brighton by Queen Victoria.
1850	Town of Brighton purchases the Royal Pavilion Estate.

Acknowledgements

The Royal Pavilion is a subject which touches so many others that
the long list of authorities I have consulted cannot be given space here.
There is room, however, to say how grateful I am for the kind help
of Geoffrey de Bellaigue, CVO, Surveyor of the Queen's Works of Art,
and his assistant Mrs J. Harland; the staff of the Royal Library;
the late Clifford Musgrave, who has been a constant inspiration and
encouragement, and his wife Margaret; and of Patrick Conner, Keeper
of Fine Art at the Royal Pavilion, Art Gallery and Museums. My
thanks are also due to Julian Rogers, Principal Keeper of Conservation
at the Royal Pavilion, Art Gallery and Museums; Eileen Baird,
formerly of Brighton Reference Library; John Harris, Keeper of the
RIBA Drawings Collection; Angelo Hornak, a most understanding
photographer, and my successive editors Judy Spours and Kathy Elgin.
I acknowledge my gratitude to John Morley, Director of the Royal
Pavilion, Art Gallery and Museums, who gave me an entirely free hand,
and to the Borough of Brighton, for permission to write the book.
Most kind and helpful of all has been my wife Camilla.

The Photographs

The photographs were taken by Angelo Hornak, with the exception
of the following, for which we are grateful to the museum or
institution concerned: The Victoria & Albert Museum, London, p.13,
p.31; *Interiors Magazine* (photographer Fritz von der Schulenburg), p.27
(below); Museum Boymans-van Beuningen, Rotterdam, p.28;
The National Trust, p.29; The Cooper Hewitt Museum, New York,
p.36, p.69, p.114 *(above)*; The Museum of London, p.47 *(below)*;
The British Museum, London, p.48, p.50 *(below)*; The National
Portrait Gallery, London, p.17 *(above)*; *Country Life,* p.50 *(above)*;
Science Museum, London, p.130 *(below)*;

We are especially grateful for the following, which are reproduced by
gracious permission of Her Majesty the Queen: p.9 *(below)*, p.12
(below), p.14 *(left)*, p.25 *(below)*, p.27 *(above)*, p.35 *(above and
centre)*, p.51 *(below)*, p.87 *(right)*, p.88 *(above)*, p.94, p.96 *(below)*,
p.97 *(right)*, p.98 *(right)*, p.100 *(right)*, p.101 *(above and below)*,
p.102 *(above, below and left)*, p.107 *(above left, and below)* p.108
(above), p.109 *(above)*, p.110 *(above)*.

The portraits of John Nash (p.51) and George IV (p.74), and the
painting of the Hotel de Salm (p.19), are in private collections and we
are grateful to the owners for permission to photograph them.

Index

Figures in italics indicate illustration pages